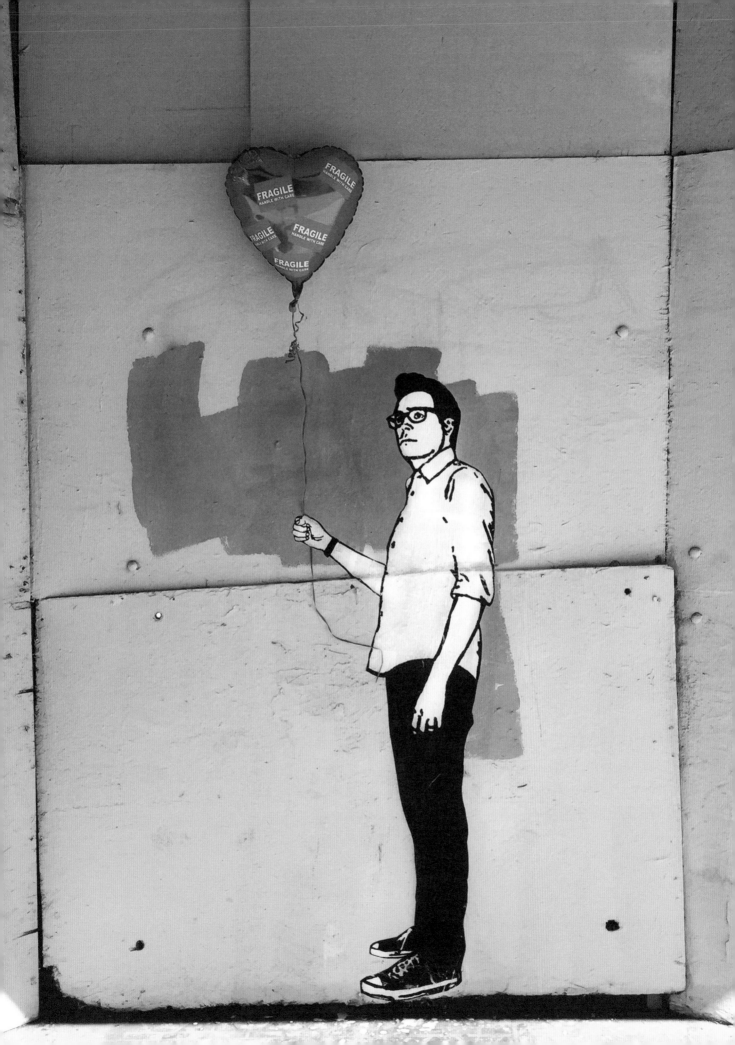

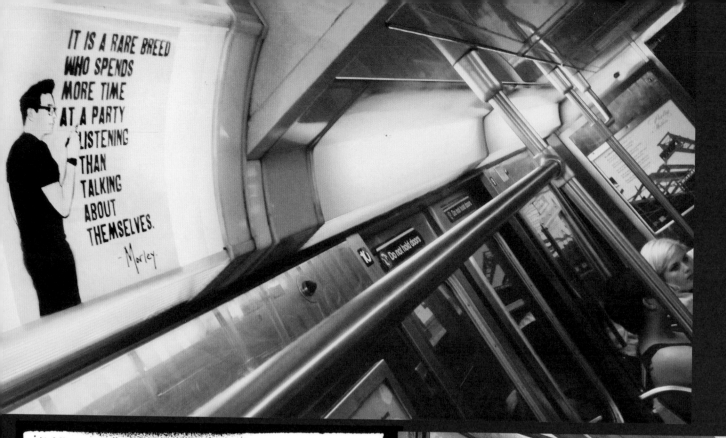

IT IS A RARE BREED WHO SPENDS MORE TIME AT A PARTY LISTENING THAN TALKING ABOUT THEMSELVES.
—Morley

ARTWORK, TEXT AND BOOK DESIGN BY: **MORLEY**

FOREWORD BY: **ART ALEXAKIS**

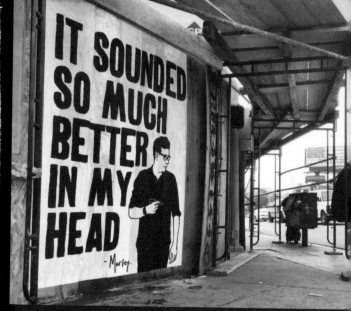

IT SOUNDED SO MUCH BETTER IN MY HEAD
—Morley

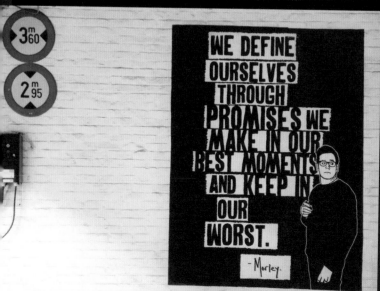

WE DEFINE OURSELVES THROUGH PROMISES WE MAKE IN OUR BEST MOMENTS AND KEEP IN OUR WORST.
—Morley

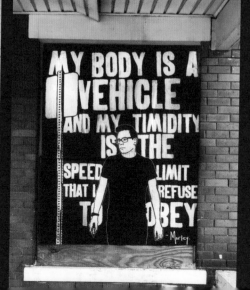

MY BODY IS A VEHICLE AND MY TIMIDITY IS THE SPEED LIMIT THAT I REFUSE TO OBEY
—Morley

LET'S BURN THIS MOMENT DOWN TO THE FILTER

LET'S BURN THIS MOMENT DOWN TO THE FILTER

Text © 2018 Morley
Foreword © 2018 Art Alexakis
Photographs © 2018 Morley, unless otherwise noted
(see page 239)

Library of Congress Cataloging-in-Publication Data
available.

ISBN: 978-1-944903-40-4

10 9 8 7 6 5 4 3 2 1

Printed and bound in China

CAMERON + COMPANY
149 Kentucky St, Suite 7
Petaluma, CA 94952

www.cameronbooks.com

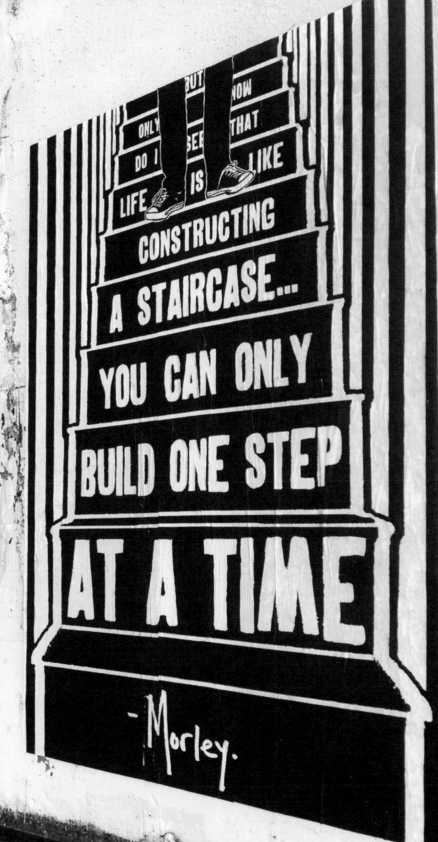

ONLY BUT NOW DO I SEE THAT LIFE IS LIKE CONSTRUCTING A STAIRCASE... YOU CAN ONLY BUILD ONE STEP AT A TIME

-Morley.

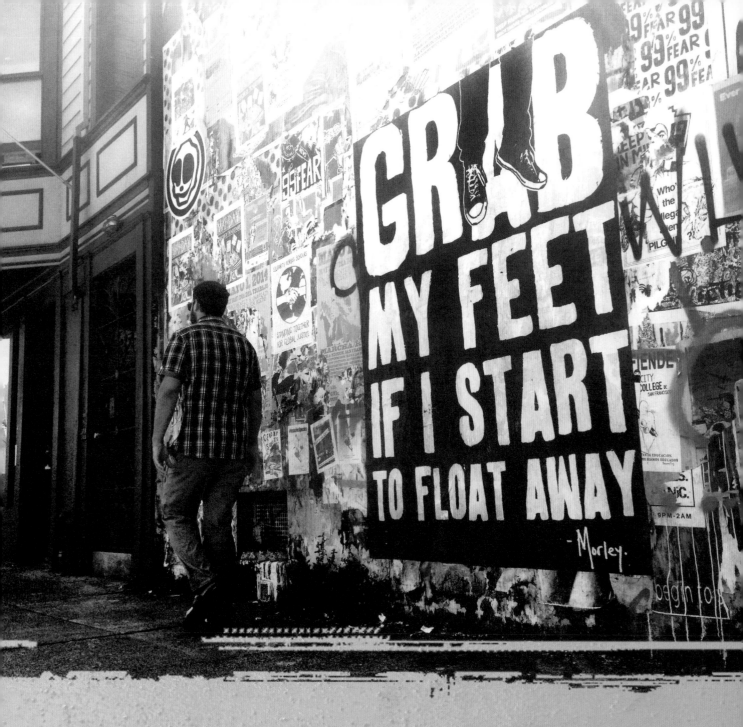

DEDICATION

To my parents **Nadine** and **John**, who've always kept me grounded.

I am the art that your love produced. You painted me into existence and so you are at least
partially responsible for every word I've scrawled and pasted. My accomplices, as it were.

I believe the police would like a word with you.

And to my son. I can only hope that the artistry of MY love will produce something
far more impressive than anything in this book.

CONTENTS

FOREWORD

Growing up in LA, I was in the minority of kids in my neighborhood that were actually born in Los Angeles. Being from here gives you a pretty twisted and contradictory view of the world. In one sense, we are totally fucking jaded, everyone's scamming you—all the time. Everything costs more than it's worth, and everybody's house is in danger of becoming a mini-mall. On the other hand, we are incredibly open-minded, entitled, and (in a very depressed way) eternal optimists.

People who move here generally don't get LA; they tolerate it. They make apologies to their friends back home for living here, but the sad truth is they don't see the balance in all the contradictions of light and dark. They don't appreciate the tolerance and tension of living in a multicultural pressure cooker. But of the transplants that do get it, very few can explain, define or communicate the wonderful weirdness that is Los Angeles. Morley can, and he does it in a way that defines and redefines itself (and the city around him) from piece to piece, and from book to book.

Poster and graffiti art both have a long and tumultuous history in Los Angeles, generally being specifically political, culturally ethnic, and combative in a uniquely Southern Californian way. They've historically drawn battle lines and helped foster those uncomfortable conversations that nobody wants to have, even though we know we need to. That is, until Morley's self images started showing up.

Sometimes whimsical, often upbeat, and unusually intimate in a way that only a stranger can embrace, Morley's work has evolved in its content, but is always intelligent, always compassionate, and always communicates something that is very LA. He has the ability to keep multiple emotions in the air at the same time and is able to tie them all together with one voice. It's what we do here every day.

This book you are holding in your hands takes that voice to a new, and sometimes seemingly darker, place. Even though his "voice" looks a lot like it always has, it is more complex and more ambitious, and not just in the scope of communicating and understanding. It also has that most rare of attributes that every Angelino truly cherishes: Acceptance.

If you give these images a chance, you will see the contradictions of fun and pain, simplicity and pretense, and the feeling that it all makes sense in its own weird way . . . just like Los Angeles.

> **—Art Alexakis**
> songwriter and frontman of the
> Grammy-nominated band Everclear

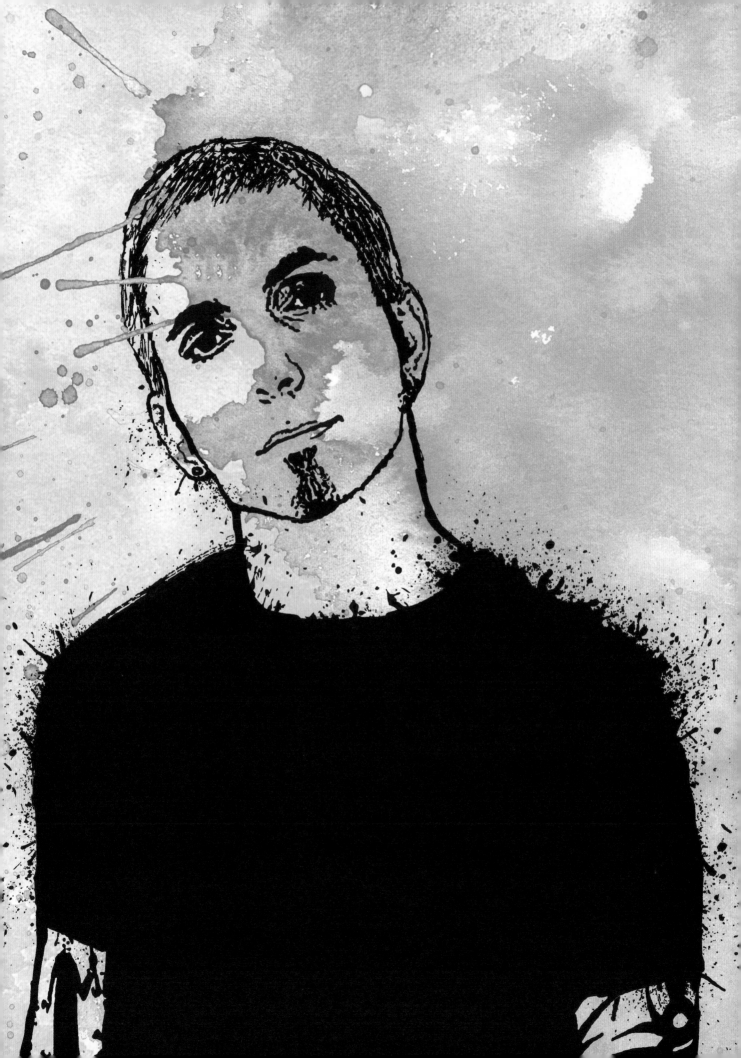

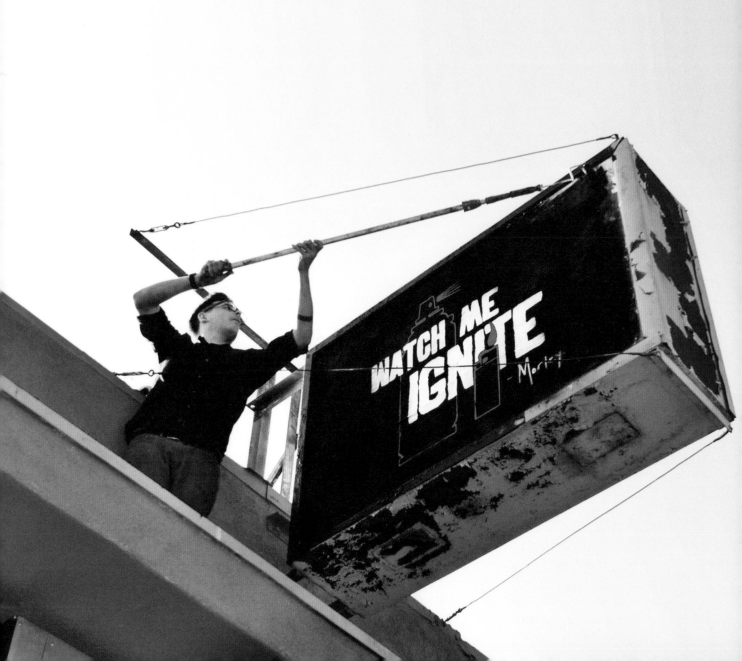

FIRST THINGS FIRST...

I have to confess; I never thought I'd have a book. I hoped, *wished* even, but never thought it would actually come to pass. People who have books have accomplished great things, notable things, or at least have been on a reality show where they had to sing a medley of Bon Jovi songs. In any case, I assumed I probably wouldn't make the cut. Then the unlikely happened and someone wanted to let me put my words into a book and put that book on a shelf, in a store. My first book was called ***IF YOU'RE READING THIS, THERE'S STILL TIME***.

Organizing all the stuff I've done over the years was a thrill, and I tried to put everything I had into it.

As it turned out, however, I had a lot more to say. More of the same? Perhaps, but I also know that I've grown as an artist and a person since the publication of that book. I've seen the "flavor-of-the-month" status of street art come and go. I've dipped my toe into small-time notoriety and turned what was once just a hobby into something resembling a career. In the past, I've spoken about my aspiration to create a relationship with the people who might stumble over something I've done. I want them to see me not only as the "text" guy, but also as a friend and fellow soldier in the day-to-day battles of life. The thing is, friendships grow and evolve over time, and the kinds of things you struggle with become more diverse. Old friends watch each other stumble and fall, face unexpected tragedies, and finally confront the fears they let metastasize over the years. You grow up together. I can only hope that my posters have reflected a similar progression.

When I started this it was a way to express myself to a world that didn't seem interested in what I had to say. It was a way to bypass the cultural bouncers, the middlemen that want to keep the methods of being heard carefully curated. I wanted to offer a hope that might not have been on trend or in fashion to the *people* that weren't on trend or in fashion. I did this with a little paste and paper. I still hold the same aspirations, but now I feel obligated to do this with the slightest measure of nuance. Will I ever impress the intelligentsia with what I do? Probably not. After all, I'm lucky if I can steal five seconds of attention from someone on their way to work—lucky if they glance over at a poster of mine, let alone read the message.

So I deal in brevity, in jamming a complex idea into a sentence or two. This means what I can't fit on a poster the person has to fill in themselves, with their own details, their own bits of emotional DNA. This makes the reader an active participant. It's me and them on that poster, which is why I include a drawing of myself in most of my pieces. What I do doesn't come from a brand or a logo, it comes from a person. Someone just like you, and we're in this thing together.

So here we go. Book two. You're probably one of four people:
1. Someone who likes what I do and wanted to see what I have to offer this time around.
2. Someone who hates what I do and are only reading this to confirm that I deserve the status of "insufferable sentimentalist" that you've assigned me.
3. Someone who has never heard of me, but if given enough time, could potentially transition into either of the first two options.
4. A spy, who, while tailing someone for information, randomly picked up this book to cover his face when the "target" looked in his direction.

Well, to the first three, I give thanks and appreciate you taking the time to read this many of my words consecutively—even if you are still sticking with "insufferable sentimentalist." While the quality of any piece of art is subjective, the intention of the artist is not, and my intention with the content of this book has and will always be to be a positive voice that offers the relief of knowing that someone else out there gets it. That someone else out there thinks it and feels it and fights it, just like you.

I hope you enjoy this thing in your hands. May it serve you well.

Oh, and on the off chance that you are, in fact, a spy, you can put the book down now. They stopped looking.

Sincerely,

— Morley.

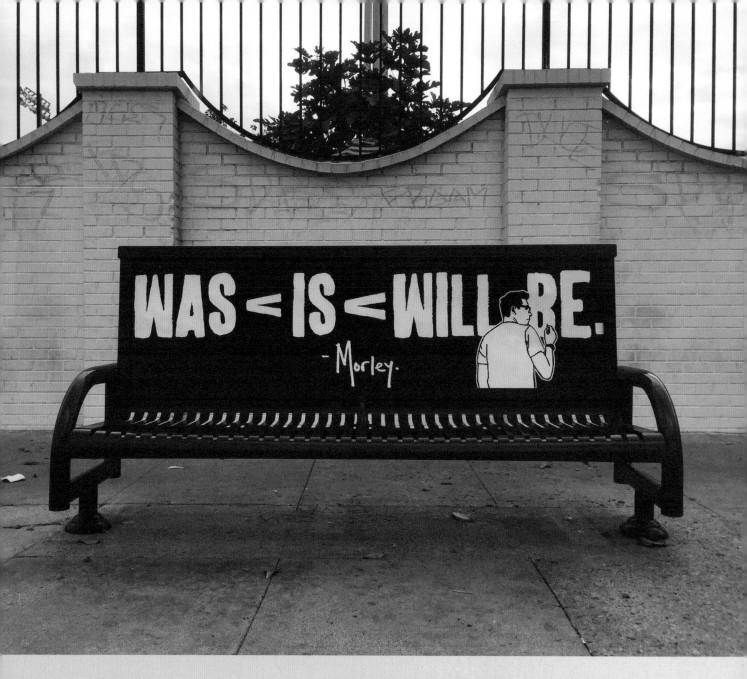

[fill in the blanks]

My name is _Morley_, I am a _Street Artist_. I am _50_% dreamer and _50_% doer.

I would describe myself as _a Frustrated Idealist_

and I am most inspired by _People unafraid of looking uncool._

I dream of _Making a lot of small differences in People's lives that add up to Something resembling a legacy_

and I will do that by _Showing them that they are not alone_.

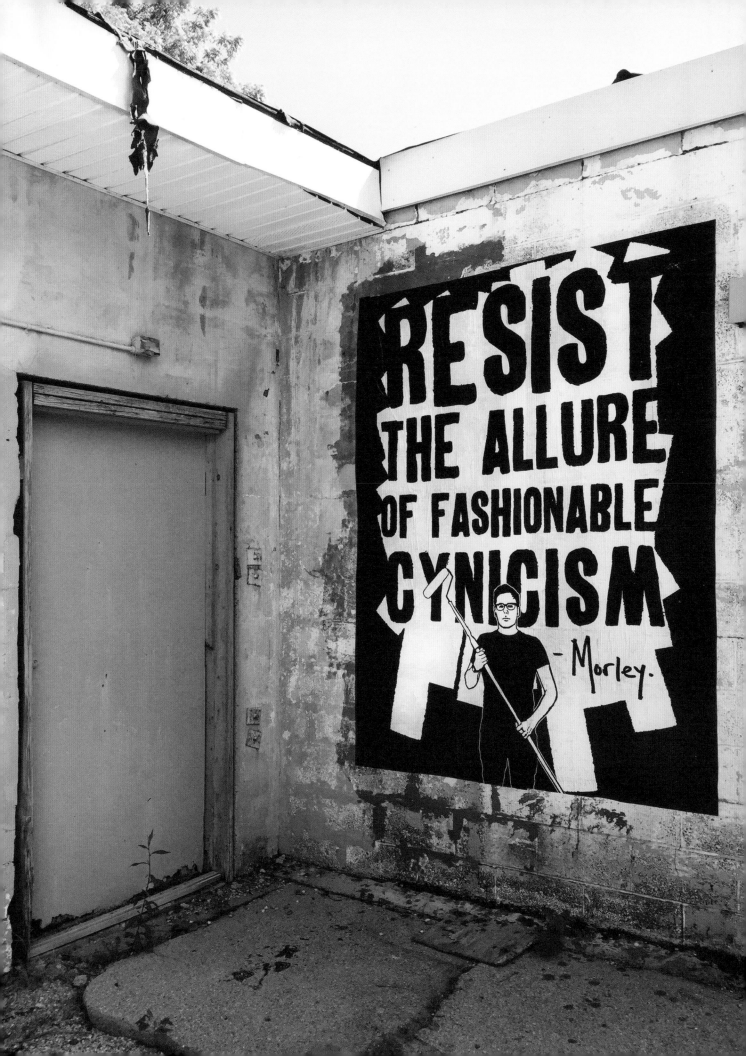

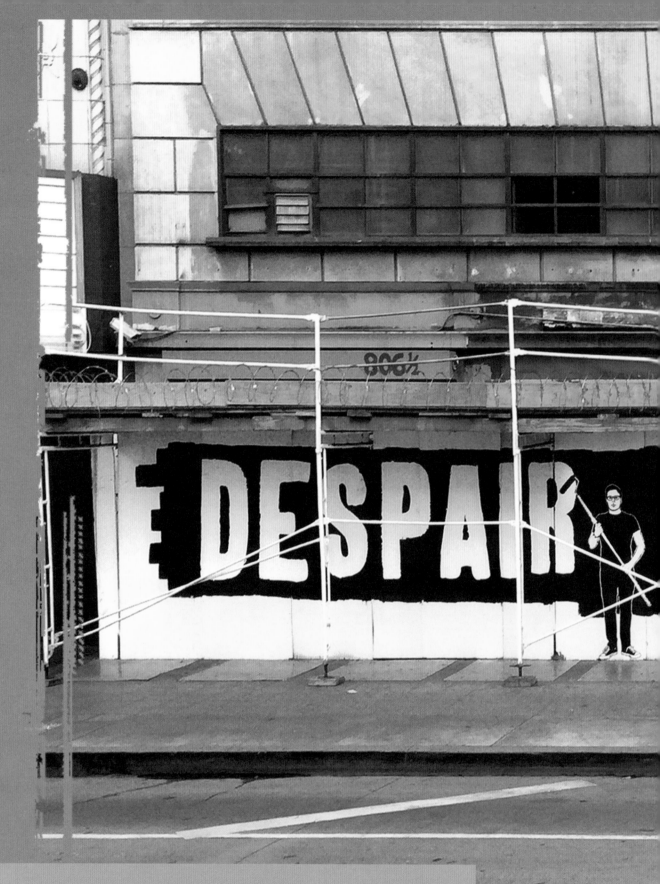

"COURAGE IS NOT THE ABSENCE OF DESPAIR; IT IS, RATHER,
THE CAPACITY TO MOVE AHEAD IN SPITE OF DESPAIR."

— ROLLO MAY

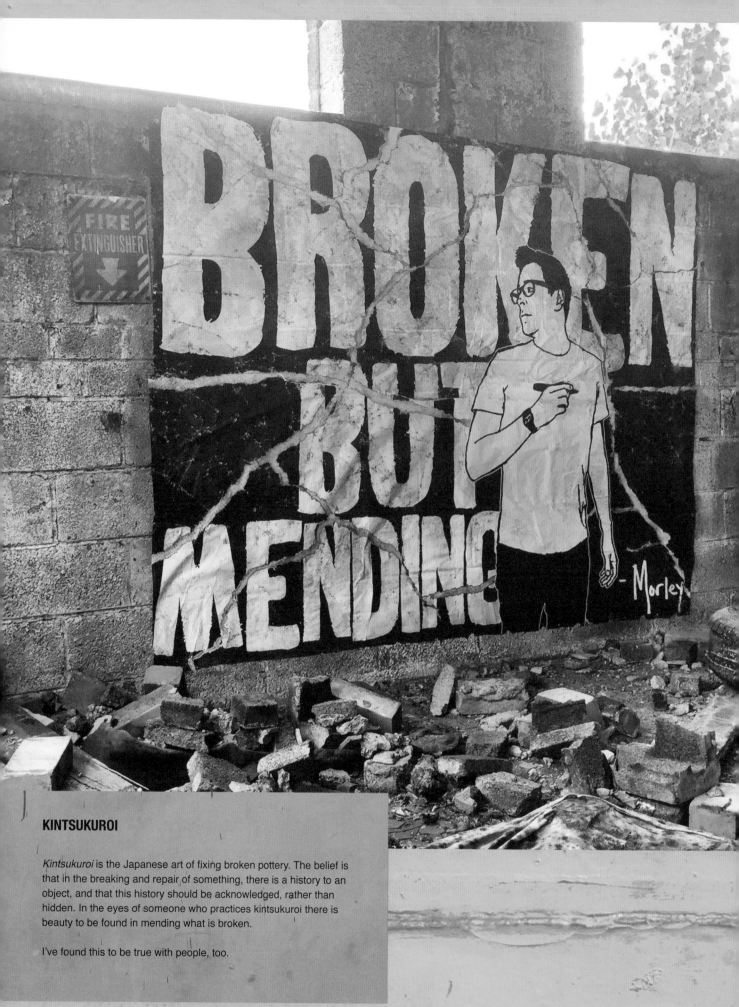

KINTSUKUROI

Kintsukuroi is the Japanese art of fixing broken pottery. The belief is that in the breaking and repair of something, there is a history to an object, and that this history should be acknowledged, rather than hidden. In the eyes of someone who practices kintsukuroi there is beauty to be found in mending what is broken.

I've found this to be true with people, too.

IN CASE OF
EMERGENCY

THE PROMISE
THAT EVEN THIS
CAN BE FIXED
- Morley.

BREAK
GLASS

I am always looking for new ways to stretch my creative expression in different directions. The goal is always the same: to use the public space as a place to offer people an idea that could offer edification. Sometimes the offer comes in the form of a message; sometimes it comes through a more tactile method: An object that carries an idea.

I put a series of these boxes on the street. Each encased something, but also carried the association that people have with these boxes that usually contain a fire extinguisher or some other safety tool. The hope was to raise the level of importance of these objects and thus the ideas they contain.

Needless to say, they didn't last too long on the street.

THE LAST LAUGH

When I look back at my childhood, so much of it is the sense that every emotion I was experiencing was cranked up to eleven. The teachers I viewed as fascists, the opinions on art and culture that I felt EVERYONE needed to share, the heartbreak I thought would define me for the rest of my life. Looking back now, I see how silly all of it was. Part of me misses the beauty of the raw passion, unfiltered by perspective and wisdom. Part of me misses the depth of emotion and its catastrophic effect on my world, and yet, it's such a relief to not feel like a slave to it. Growing up and navigating life is like learning to drive in a Formula One race car that goes from zero to sixty in three seconds.

Eventually, you have to figure out how to slow it down. As an artist, I put a premium on my emotions. I value them highly and in the analysis of them I find treasures that inform my work and draw me closer to others who share them. But that doesn't mean that I shouldn't discard a fraudulent notion in my head telling me that all is lost; that I shouldn't jettison sooner rather than later the feelings that will eventually whither and die. A hurtful comment from someone whose opinion I don't value can cut in the moment, but days later be exposed for what it is: something to laugh at. It's good to look back and laugh I think, because hopefully our laughter is a promise that someday, maybe someday soon, we'll look back at today and laugh even harder.

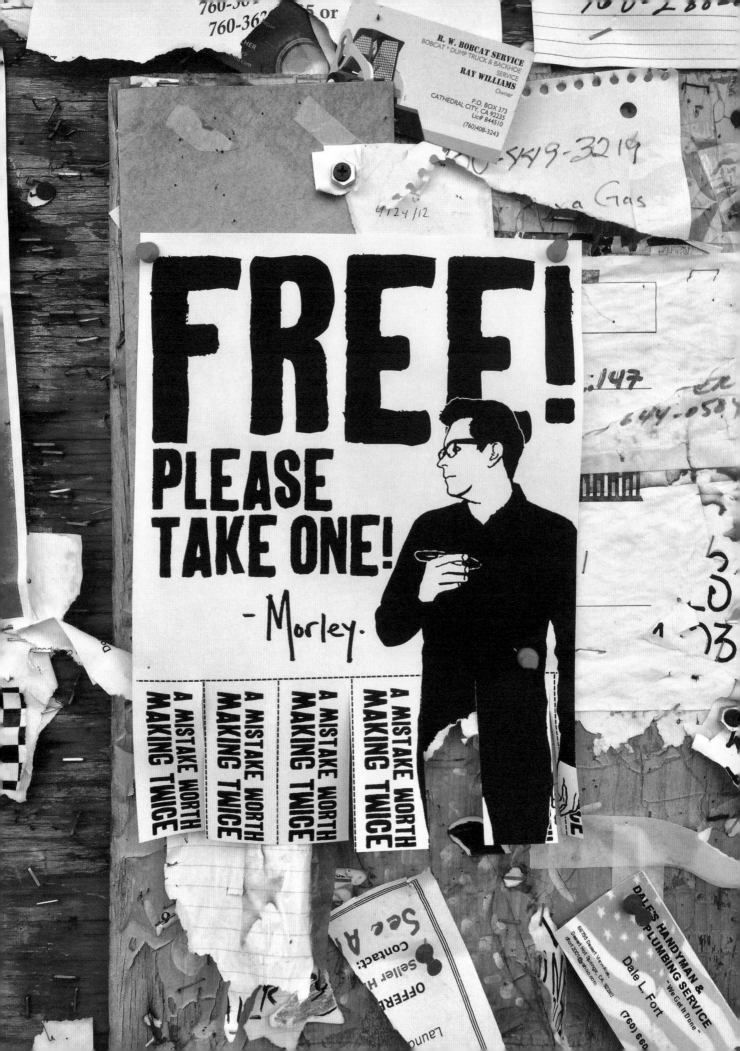

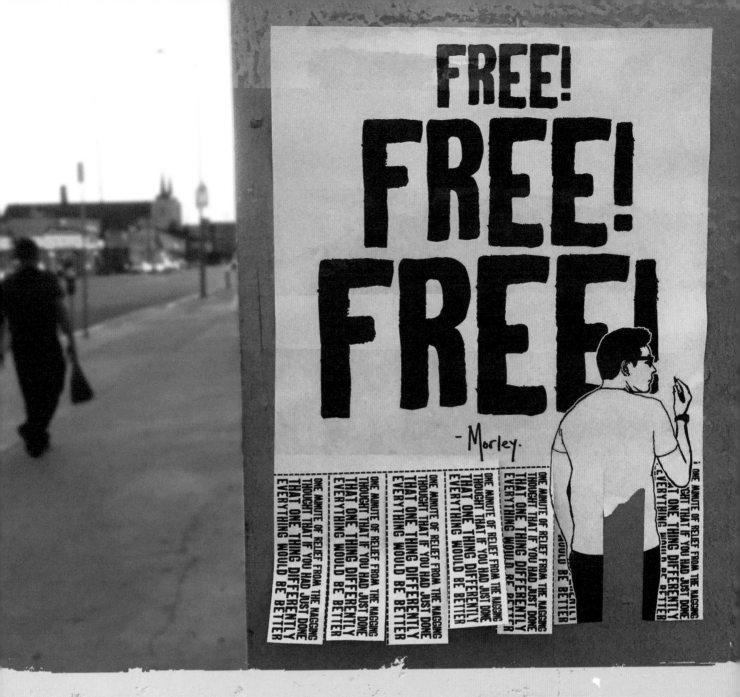

YOU ARE HERE

I once read a study that said that people generally define their personal sense of success based on a comparison with how successful their friends are. This rang true to me, as when I was in my early twenties and had just graduated college, my friends and I were all broke. There was no shame in having empty pockets. We'd bond over tales of struggles to pay rent or buy groceries.

It wasn't until a few of them started reaching new levels of financial success that I started to question my own lack of it. It felt like a kind of betrayal that they had managed to climb above the snapping jaws of the crocodile pit that is early adulthood. No longer was an unfair world to blame for my deflated bank account when the success of my friends proved to expose my own failures as the culprit. But if we only ever define our personal sense of accomplishment by comparing ourselves to someone else, we'll always have a skewed perception of reality. The truth is, the closer you come to being king of that small hill, the more it becomes clear that you're standing next to a mountain.

There is a whole world full of people that are much better off than you and a whole lot more that are much worse. If we try to measure our success within parameters that aren't defined by the idea of someone else's life, we might actually notice the dot on the map that says YOU ARE HERE, and maybe then we can start heading in the direction we want to go.

TO THINE OWN SELFIE BE TRUE

In our day-to-day life, in any given moment, we are usually one of two people. Either the person we present to the world, or the person that we are when no one is watching. The person we present to the world is usually some approximation of the person we aspire to be. The clothes and makeup worn, the demeanor exhibited, and the flaws that are carefully concealed are all examples of the various methods we employ to convince our peers that the role we play is genuine. Of course, while some people manage to create elaborate and strikingly different creations than what they allow the world to scrutinize, others may feel comfortable with a slightly photoshopped version of their personality. For all intents and purposes, they are sincere but maybe they soften their more abrasive quirks or vulnerable pressure points until they feel they can trust someone to reveal them.

While it's tempting to say that social media is to blame for our duplicity, it's a behavior that must span the breadth of time. It is, however, a lot easier to observe through sites like Facebook and Instagram. The idea of crafting a persona for the world to see that may fly in the face of the one that actually exists is much more profound and obvious when you dictate which digital images represent you. We carefully curate the image of our lives to paint ourselves in very specific colors. Maybe you want to be an exciting jet-setter or the life of the party. You could show off a gallery of famous friends or be the modern matriarch of an idyllic family. You could want the world to see your life as one big Anthropologie catalog, and you as someone with impeccable taste.

These may be benign deceptions, but deceptions nonetheless. We all do it. Which is what makes it all the more ironic when we fall for it with others. We convince ourselves that everyone else is living some impeccable life, free of self-conscious need for approval. What is clear is the importance of the people in our lives with whom we trust enough to be our real, unfiltered, uncurated, unglamorous selves. We need people that remind us that we aren't loved only on condition of being exciting and attractive. In truth, while we may think we're trying to convince other people of how great our lives are, we're really only trying to convince ourselves of this fact. My advice? Find that person who loves you no matter what and thank them for being the real proof that your life is actually pretty great. Even if it wouldn't impress an ex-boyfriend.

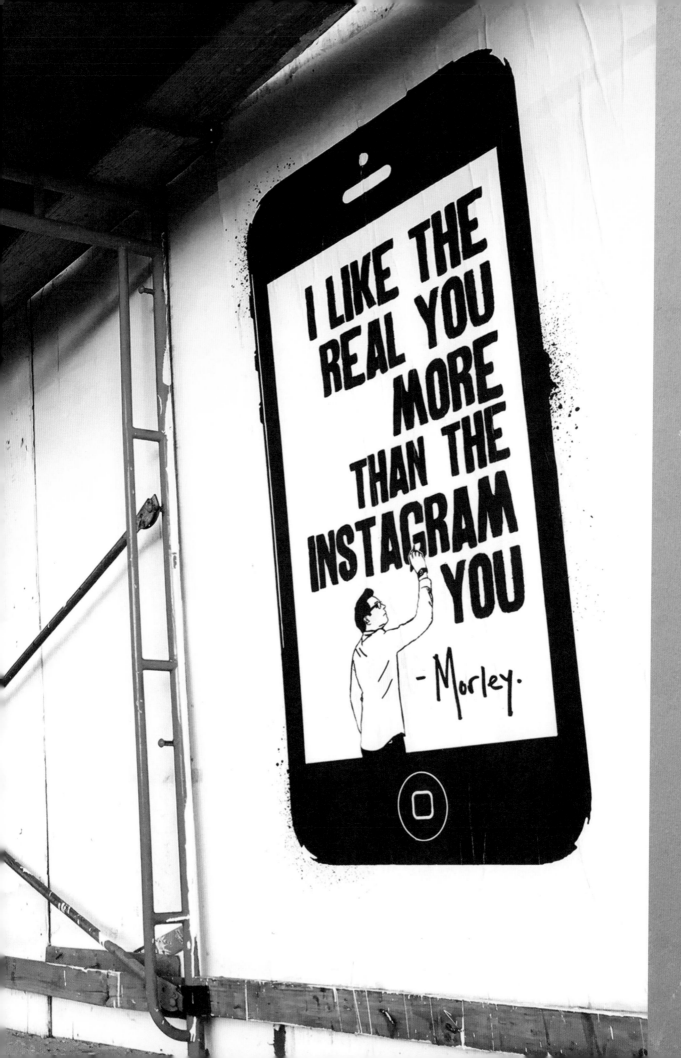

WHEN I GROW UP

The first thing I ever wanted to be in my life was a Goonie. Preferably Data because he had all those cool inventions, but I would have accepted any of them. Well, except for Sloth... because of all the severe mental and physical disabilities and y'know, being chained up in the basement by his family for most of his life.

When I got a little older I briefly played with the idea of being a veterinarian or a radio DJ, and eventually settled on wanting to write and direct movies. If I couldn't be one of the Goonies, at least I could make a movie like it. I still aspire to filmmaking, but fate seems to have had other plans for me. I've accepted that my life may look different than the one I fantasized about since childhood, but it's taken time.

Accepting the dreams that may never come true takes effort but not necessarily disappointment and frustration. Sometimes it just means honing one's skills at embracing the unexpected. Or maybe that's life's great trick—that even an achieved dream generally has unexpected results. That there is no master plan that can be followed to its predetermined conclusion. Our lives may not look like the blue prints we spent years drawing up. They may not even look like the stick figures, but we've always got more crayons, so let's start drawing.

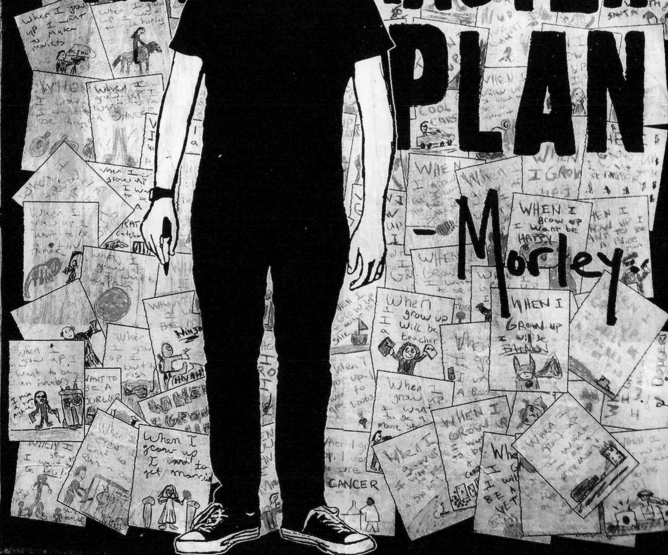

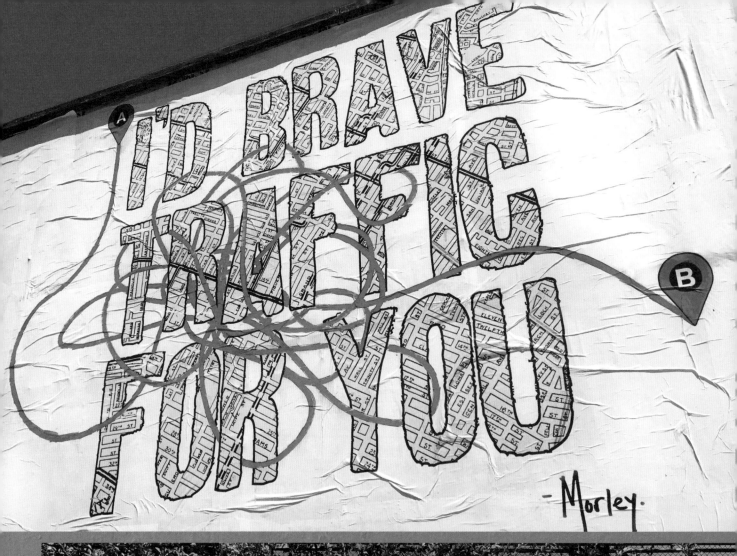

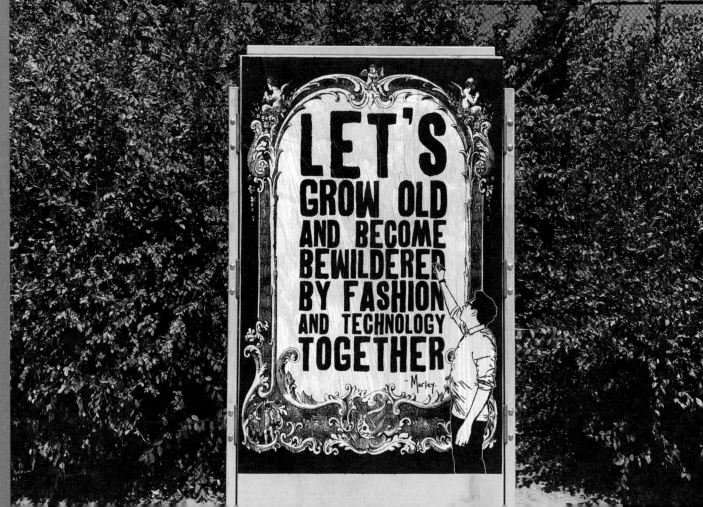

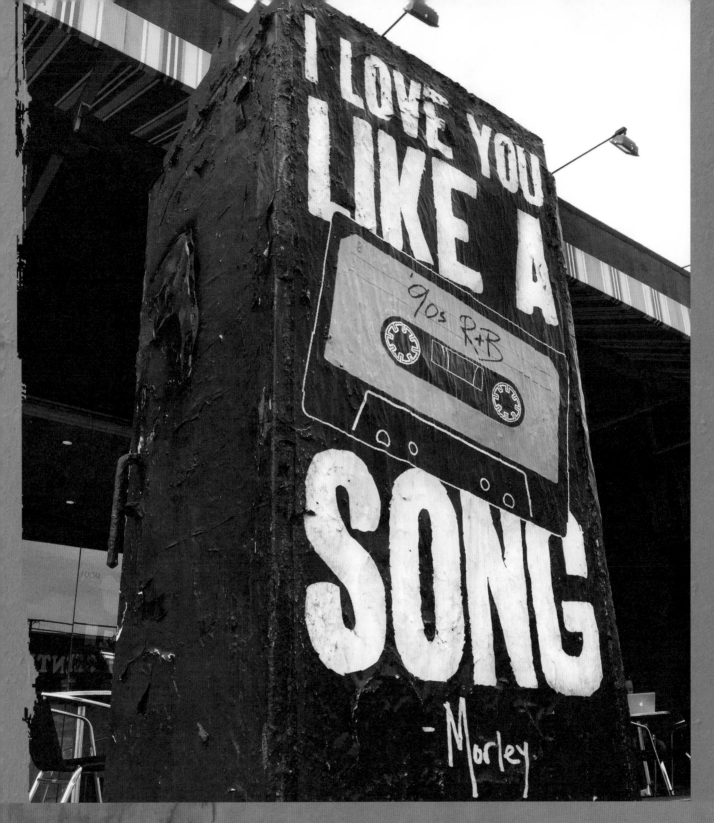

I LOVE YOU LIKE A SONG

'90s R+B

- Morley

YOU GOT ME FEENIN'

I was in seventh grade the first time I ever kissed a girl. The details are vivid and easy to recall. We were at a dance. The girl, Tabitha, was a year older and held a power over me that I couldn't quite explain. I was so unfamiliar with a girl finding me attractive enough to even fleetingly call her boyfriend that I felt unbalanced and precarious. I was like a tourist in Paris trying to pass off their high school French as native while constantly checking a guidebook to understand the meaning of the customs. She was cool, confident, pretty, and probably shouldn't have been wasting her time

with me. A point that her friends certainly seemed to agree with. At the risk of exposing my ignorance in the field, I had, up to that point, demurred an attempt to kiss her, and as we swayed awkwardly to the music, I heard a cackle from Tabitha's hair-sprayed friend who danced nearby with an acne bespeckled boy of her own. "What's wrong?" she taunted. "You don't kiss girls?!" Tabitha did her best to shrug off the words on my behalf but her sympathy couldn't have felt more unintentionally emasculating. The harmonized warble of "I Swear" by the group All-4-One hung like a smoky haze across the dance floor and after inhaling a deep lungful of it, I nervously took a charge at my first pair of lips. Since then, I've learned that you should never underestimate the power of a good '90s R&B jam.

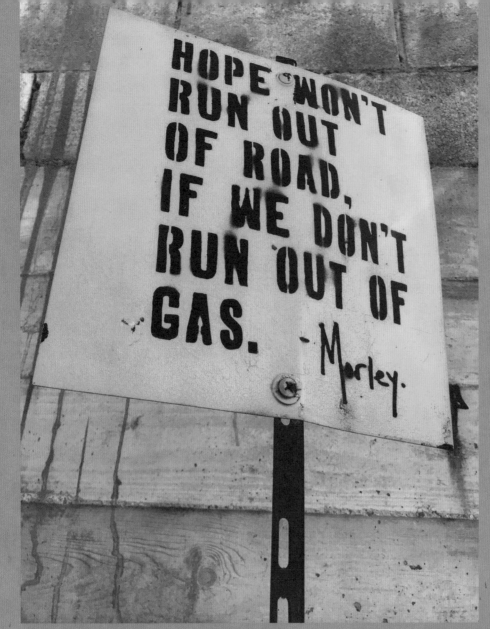

HOPE WON'T RUN OUT OF ROAD, IF WE DON'T RUN OUT OF GAS. — Morley.

I decided some discarded road signs I found at a construction site could still have some use, with a few slight alterations.

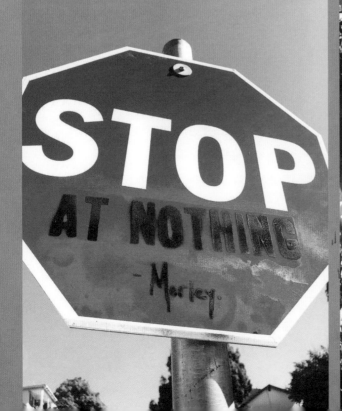

STOP AT NOTHING — Morley.

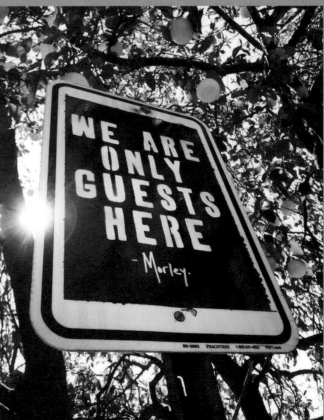

WE ARE ONLY GUESTS HERE — Morley.

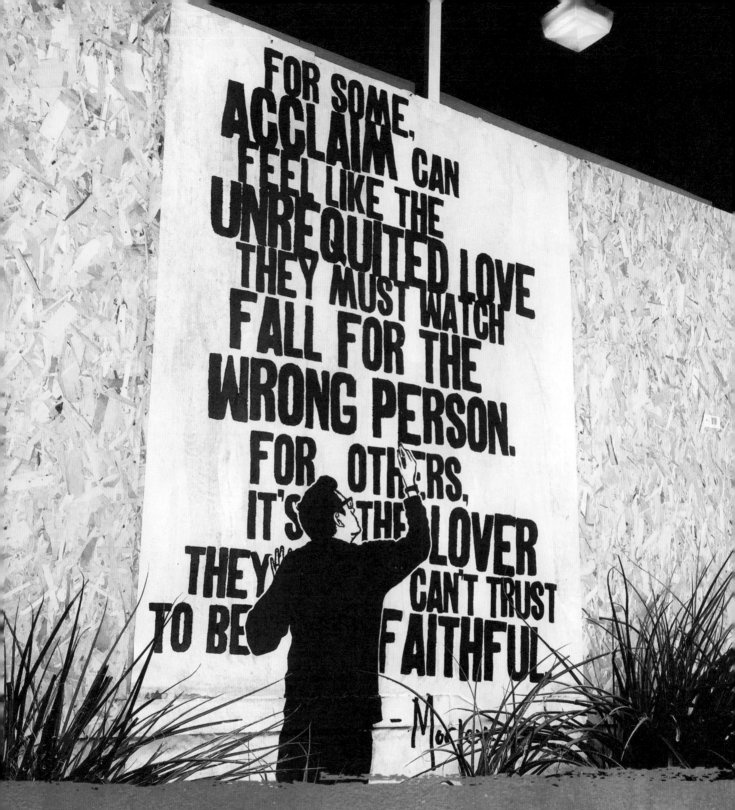

BE ALL END ALL

The things we chase can't complete us. No matter how much money we acquire, how much praise we receive, how high up we get in our professions—even if we find a beautiful person to love us, there will always be that moment or feeling that something must be missing. For the millions of people that could tell us we're worthy of being loved, there is always some contingent calling us frauds, and we will often find ourselves among them. Contrary to what Jerry Maguire says, no one else completes us. Not one person, not throngs of fans. The trappings of success and love are great, but it's inside our hearts that we fit the pieces together, and only we can be responsible for putting them all in place.

Other people and things can't do it for us, no matter how much we wish they could. Really, it's not fair to place the burden of that expectation on someone else. All the king's horses and all the king's men can't put us back together, but with a little help from God or the universe or whatever you believe in, we can do it ourselves.

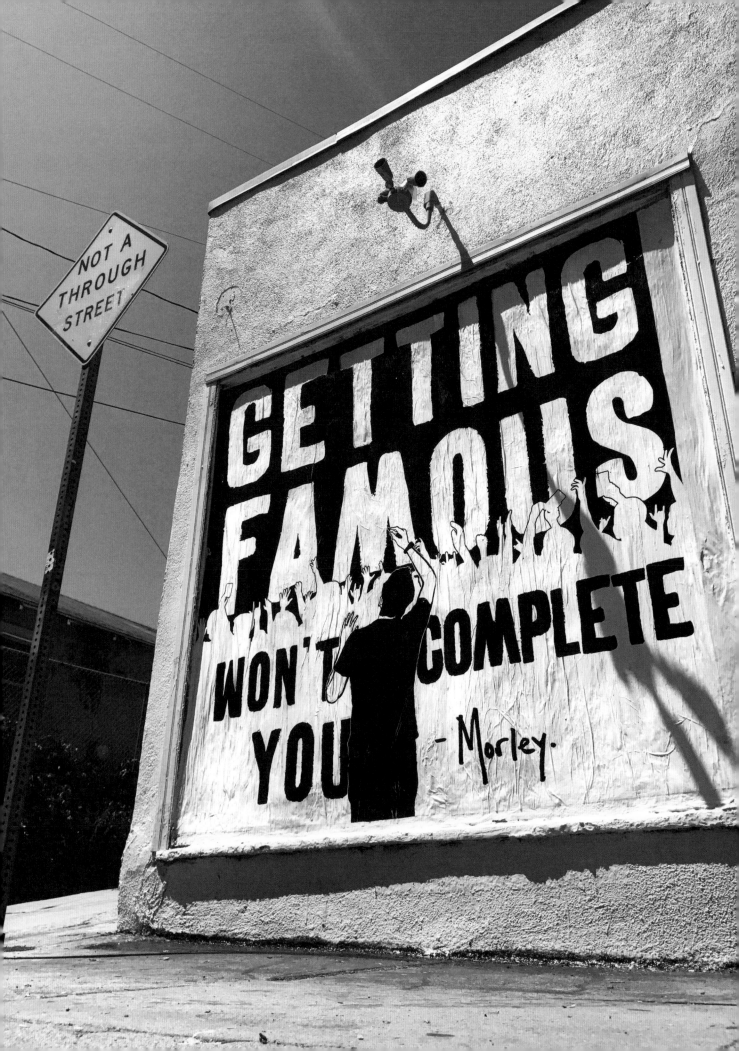

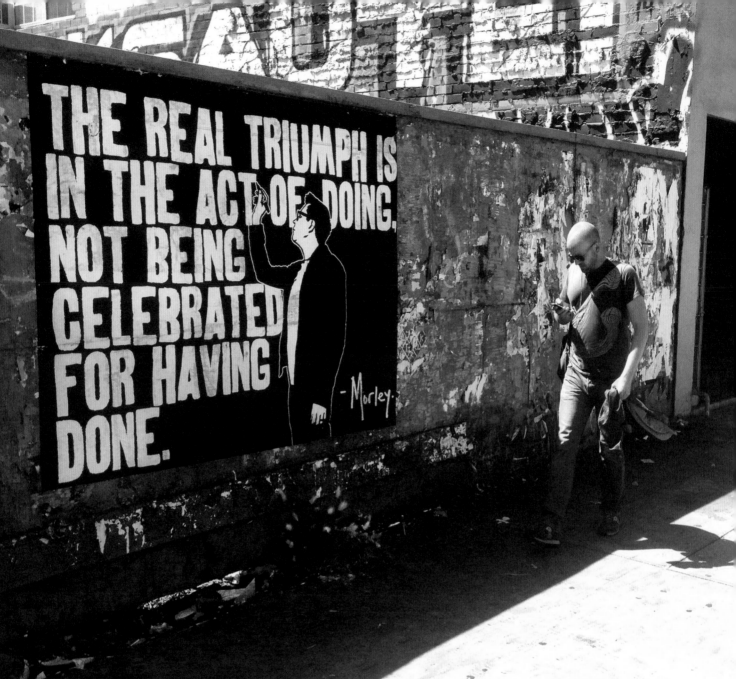

THE REAL TRIUMPH IS IN THE ACT OF DOING, NOT BEING CELEBRATED FOR HAVING DONE.

—Morley.

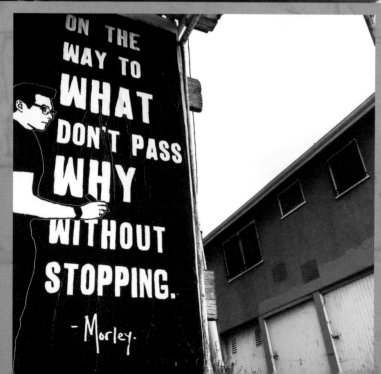

ON THE WAY TO WHAT DON'T PASS WHY WITHOUT STOPPING.

—Morley.

"YOU WERE NOT BORN TO IMPRESS THE WORLD, BUT TO IMPRESS THE UNIVERSE."

—MATSHONA DHLIWAYO

MAY YOU GET
WHAT YOU
WANT
AND THEN
WANT
WHAT YOU
GET

- Morley.

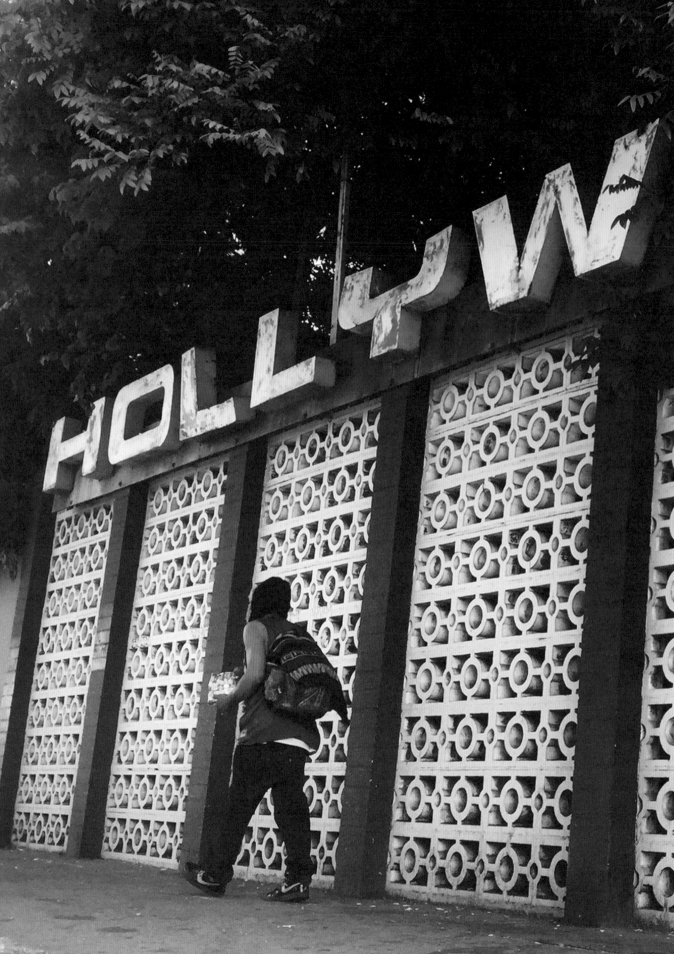

THE PURSUIT OF DREAMS CAN OFTEN FEEL LIKE HAULING SOMEONE'S COUCH UP AN ENDLESS FLIGHT OF STAIRS.

- Morley.

DESTINY'S ILLEGITIMATE CHILD

I put this poster up the day before my thirty-second birthday. Here in Los Angeles, many of us spend our birthdays in a slump. Depressed over how little we've accomplished, embarrassed to have to conceal another slash on the wall of time, and desperate to convince ourselves that we're not too old to be considered relevant. This is then followed with an assessment of the pros and cons of giving up whatever dream we're chasing. You begin considering the other options, forming escape plans and longingly ruminating on your cousin with the steady job, family, and regular biannual dental appointments. You question why you're still out here, what you're doing, if you're just wasting your time, and if it's too late to still have an actual life.

We can intellectually comprehend the notion that not every aspiring artist is going to be successful and that just because you want something—even something you are willing to endlessly chase—doesn't mean you'll get it. This notion used to be devastating for me. It just didn't seem fair, and it ran in the face of what we're told as kids that "if you set your mind to it, you can accomplish anything!" What they never bothered to consider was "if millions of kids are all setting their mind to the same dream, won't it be up to a series of arbitrary gatekeepers to lord their hollow power over the dreamers and keep them from achieving anything?" Maybe the problem is that we just can't seem to diversify our dreams.

Maybe if we didn't all want to do the same thing, we'd have a better chance at reaching some ground where the population is a little less dense. The trick is discovering that maybe there isn't just one thing that could make you happy. That maybe there is something else that you're good at—maybe even better at, that you might excel at in ways you couldn't have dreamed.

Over the years, I've put up hundreds of posters that are meant to encourage dreamers to keep dreaming, to not give up, to persevere. But there are others out there who quietly wish for a different kind of encouragement. People who just want permission to let go without being shamed by a culture that has told them that it's not okay to redefine what you want from life midway through. Happiness isn't just for the people who didn't give themselves any other options. There's no reward for burning every bridge to the future except for the one in which you become a movie star. Or a rock star. Or a patient in a time-travel experiment. Believe me, I've scoured Craigslist for years and no one is looking for someone to Quantum Leap into different adventures—and if they have, someone else got the gig. It's unfair but I've made peace with it. The point is, I promise that there is more than one way to be happy. There is more than one destiny in which you can make a positive contribution. There is more than one way to give your gift to the world, so keep your heart and mind open to discovering it.

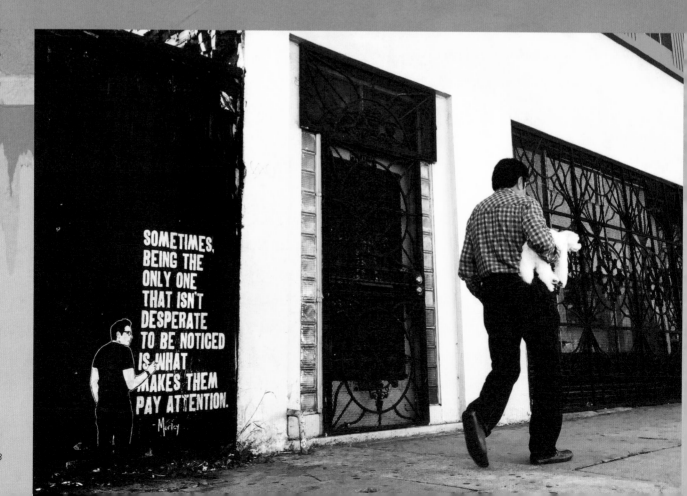

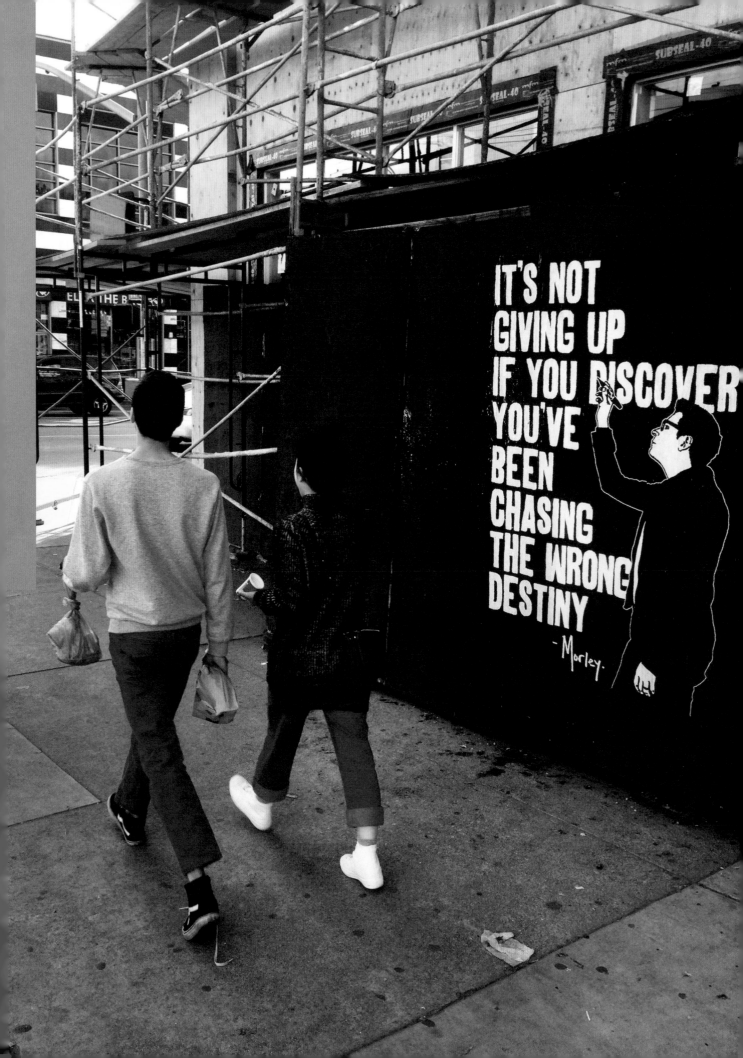

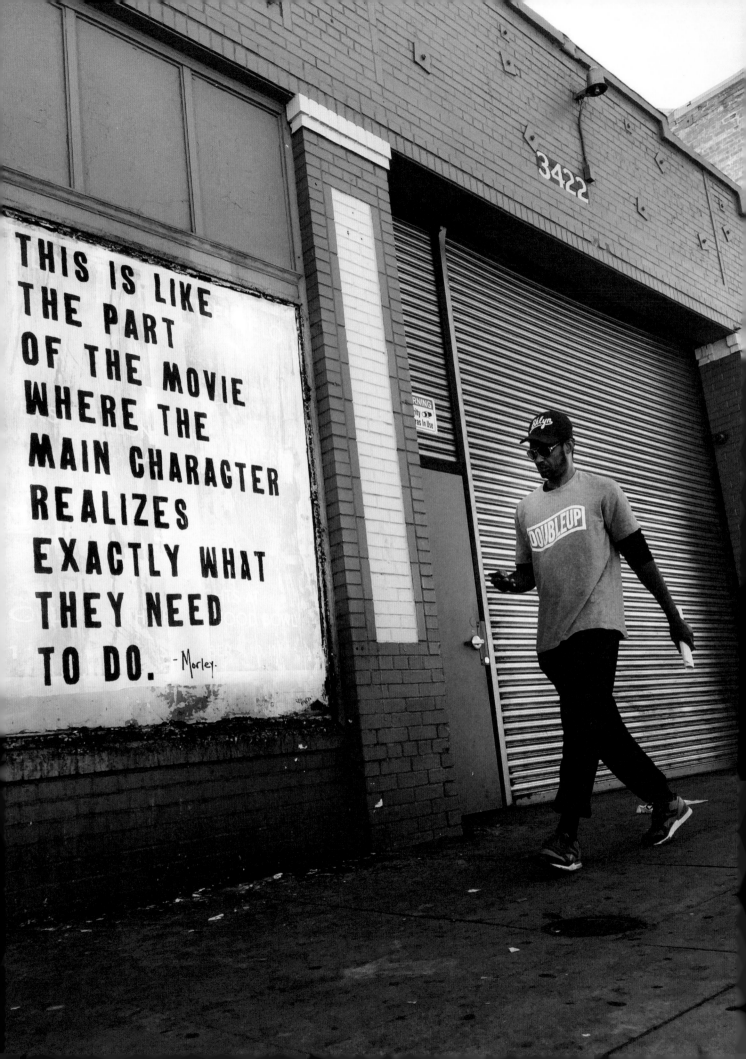

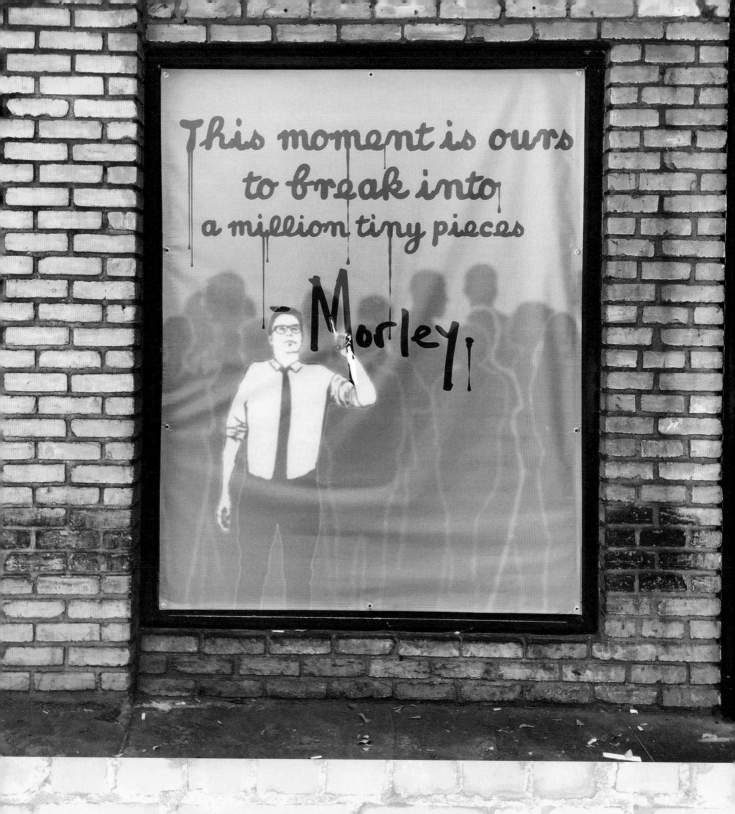

One aspect that has changed a bit since I started doing what I do is that from time to time, building owners who have seen my art over the years will offer me wall space to utilize. While the majority of my work is still posted illegally, it's nice from time to time to put something up without having to look over my shoulder, and if it's for a good cause, even better.

Context is always an important factor when I come up with ideas. So when I was asked to make some art for a series of boarded up window frames, I wanted to play with the space in an interesting way. I thought it might be cool to emphasize the window aspect and make it appear as though Morley was writing in the fogged-up glass.

As an artist that trades in ephemeral messages, I felt the visual reference was apropos.

CREATIVE CONTRIBUTIONS

When I was approached by Children's Hospital Los Angeles to visit the patients and run an art lab alongside their art therapists, I didn't think twice. It was an honor to be thought of as someone who the kids might want to spend time with, and I hoped that in offering some small measure of inspiration for them, I would find it returned to me tenfold. I wanted to offer these kids the same kind of freedom I felt communicating with the world around me, so I brought in a stack of magnet sheets and permanent markers and promised that whatever the kids wanted to say to the world, I would stick them up and send back photos. I met a lot of truly brave kids that day, who despite their circumstances remained refreshingly free of cynicism.

When CHLA asked me a couple weeks later to create a mural for them, it didn't take long to land on a message that illustrated my experience. Though varying degrees of illness may be present within the walls of this hospital, the hope I encountered was one of a kind. The visual of a prepubescent Morley on a crumpled piece of paper was intended to show that beyond our weathered, tattered spirits, hope can still flourish, and the kids at CHLA and the families, friends, and staff that stand by them are all the proof I need.

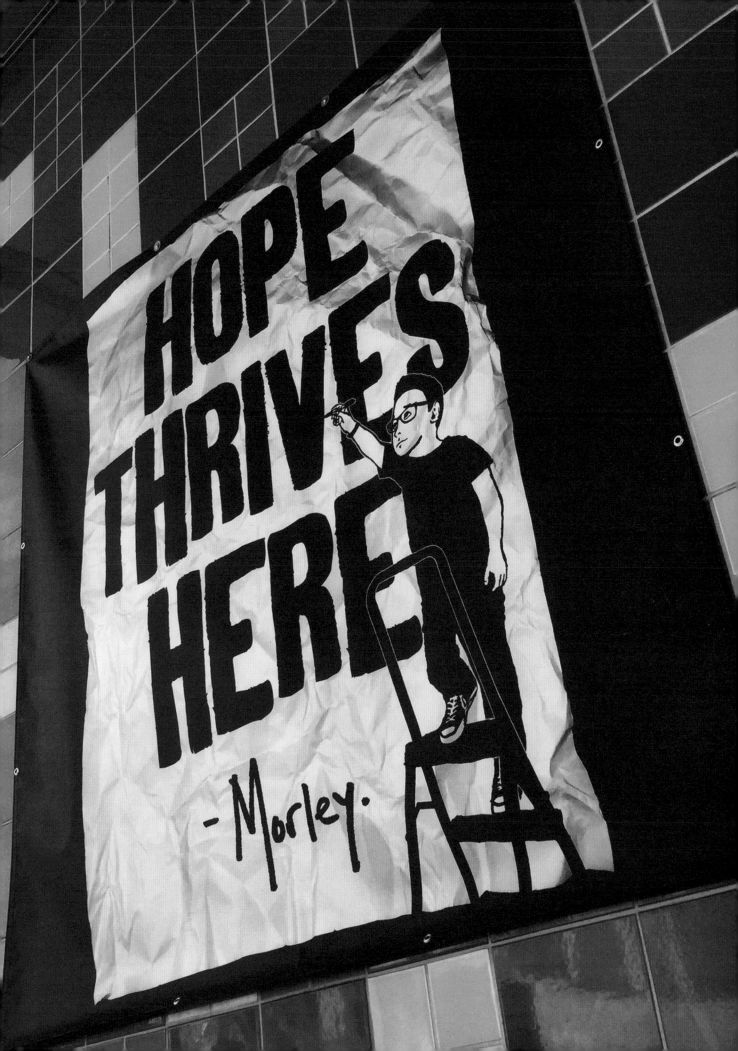

NEVER APPROVE YOUR DETERMINATION'S REQUEST FOR TIME OFF

- Morley.

I was asked to create a piece for the Salvation Army's "Way In" building in Hollywood. The Way In is a place where homeless teens find refuge from the Hollywood street life. It helps provide food, shelter, counseling, and independent living programs. The intention of this piece was to act as a reminder that, as the old saying says, the winner of a fight is someone who gets knocked down seven times and gets up eight. The inhabitants of the Way In have every reason to give up, but as long as they don't give their determination the day off, they're still in the fight.

Time Off Request Form

Employee Name _____Determination_____ Supervisor _____Head_____

 Supervisor _____Heart_____

Time Off Start Date _____Now_____ Return To Work Date ___?___

Reason for Leave ___Disappointed / Frustrated / weary / Hopeless___

___Determination___
Employee Signature

Approvals: ☐ Request Approved ☒ Request Denied

Reason for Denying Request ___Because I refuse to___
___give up on myself.___

___Head + Heart___
Supervisor Signature ___From Now on.___
 Date

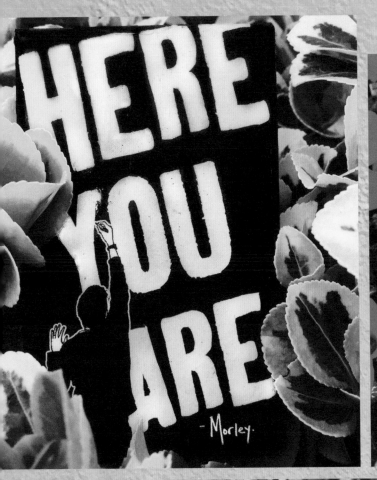

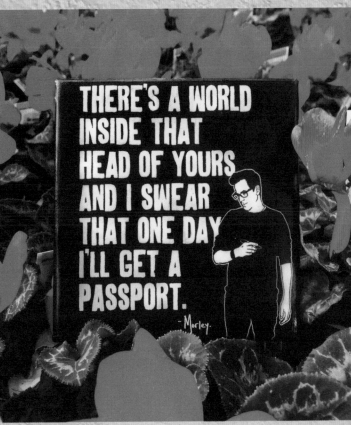

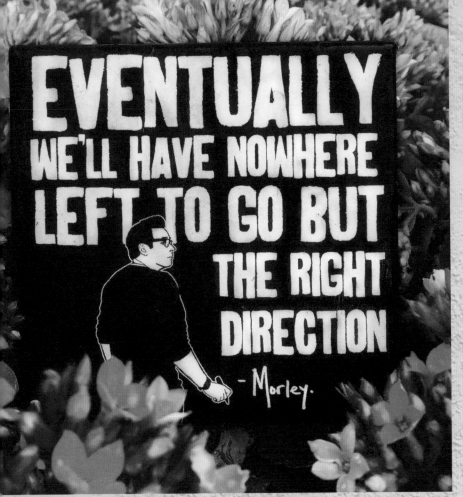

FLOWER POWER

Sometimes I get bored with the gritty urban setting that most of my posters inhabit. With that in mind, I created a series of mini-signs using light switch covers with nails glued to the base and stuck them in flower beds. It took a bit more time to find suitable homes than I had expected, due to the intense drought that California was experiencing. Luckily, I managed to find a few bits of vegetation among the brown lawns.

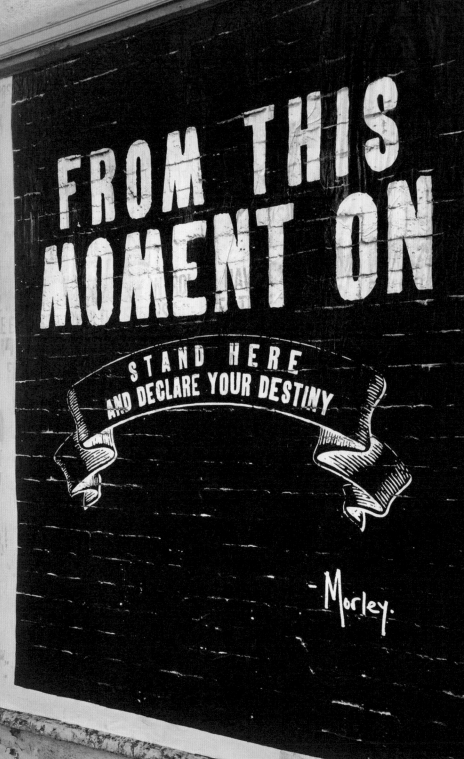

Sometimes a photo op offers more than just the opportunity for a photo. You could, for example, take the opportunity to forever alter the course of your destiny. Just sayin'.

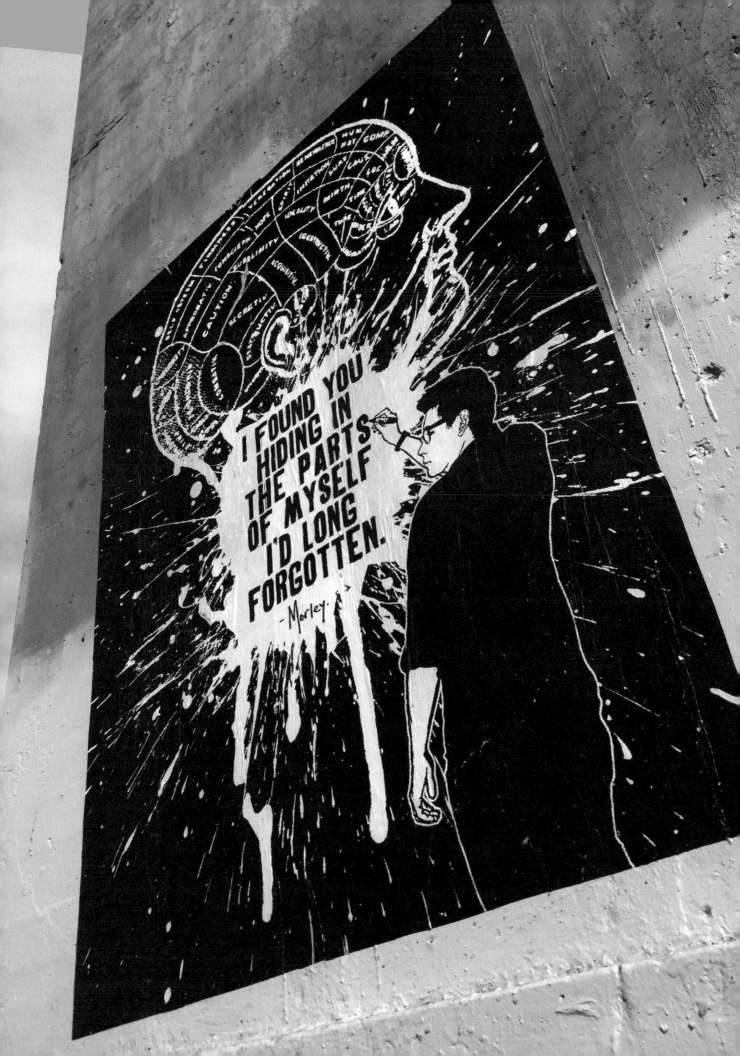

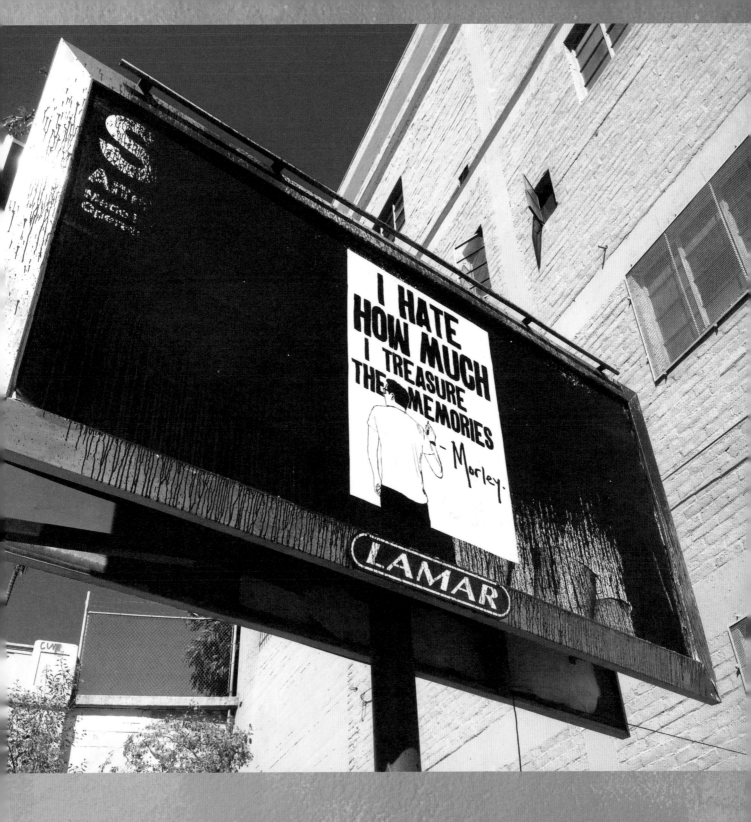

"LOVE IS SO SHORT, FORGETTING IS SO LONG."

—PABLO NERUDA

WALKING CONTRADICTION

I 've been confronted at various times with the fact that some of my posters contradict each other. I have to admit that I never see the problem. I guess I'd always assumed that everyone's mind was as paradoxical as mine. Has everyone else been single-minded this whole time? Is it just me that can feel any number of conflicting emotions toward the struggles of life? Even if that were true, the tone of every person's situation can vary wildly. For one person, the piece of advice they need is to WAIT until things get better, to accept that their battle may take time and that simply surviving it may be the truest victory. For another, they might need to be encouraged NOT to wait but to take the leap, make the change and trust their instincts. My posters are fashioned as the words of a friend, and sometimes I need a friend who knows how hard it is and can share in lamenting life's difficulty. Other times, I need someone to give me a pep talk. I need someone to promise me that things will work out in the end. Often times, these will come from the same friend and even in the same conversation. I can't know who exactly will walk past something I've put up, but I have faith that the right people in the right moment of their lives will see it, and maybe I'll get everyone else pegged with the next one.

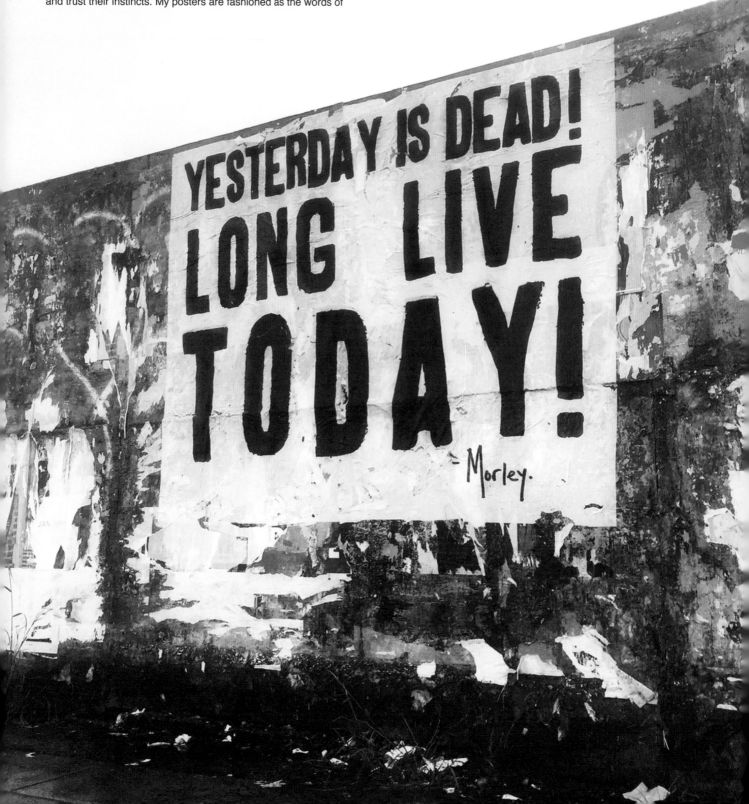

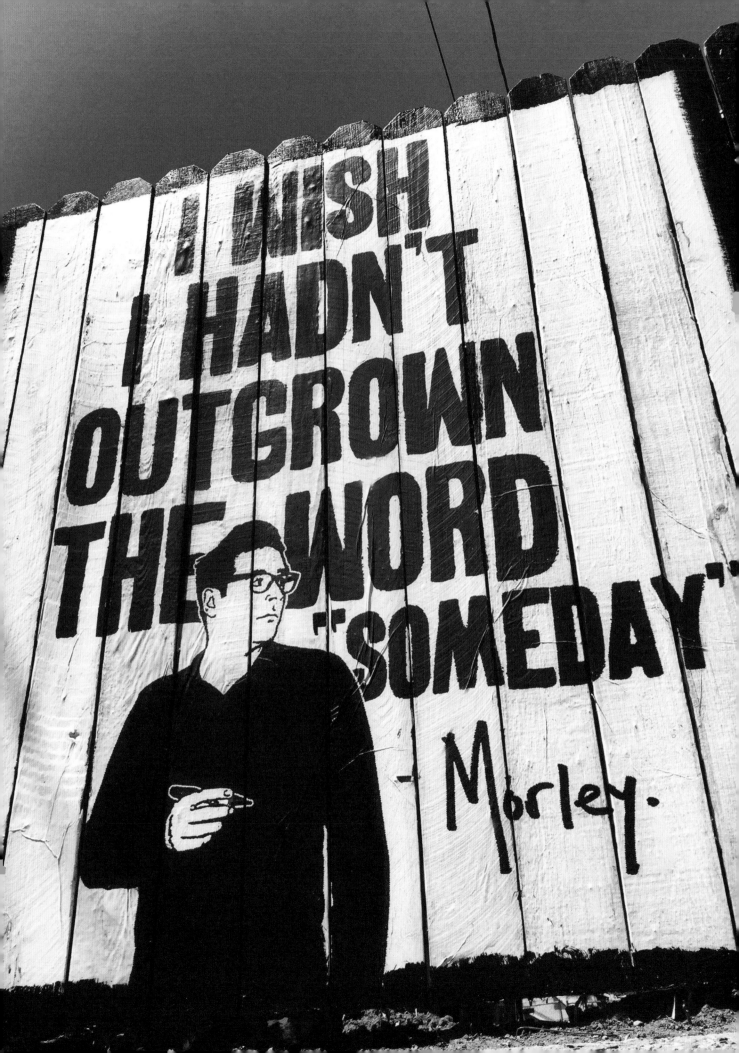

IN CASE OF
EMERGENCY

THIRTY SECONDS

WHERE NOTHING
CAN HURT YOU
- Morley.

BREAK

GLASS

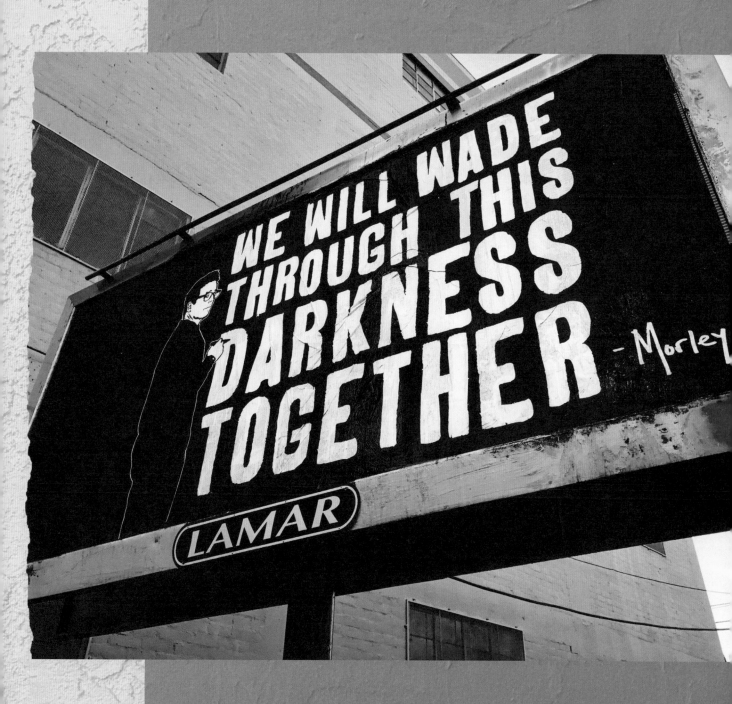

"I WOULD RATHER WALK WITH A FRIEND IN
THE DARK, THAN ALONE IN THE LIGHT."

—HELEN KELLER

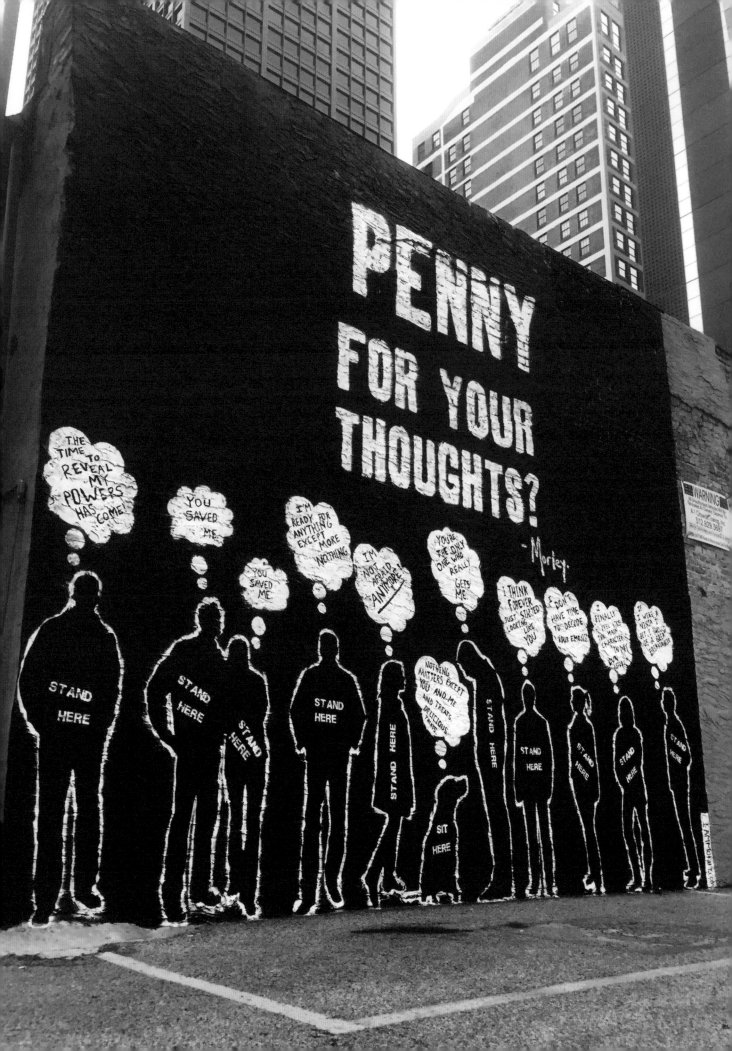

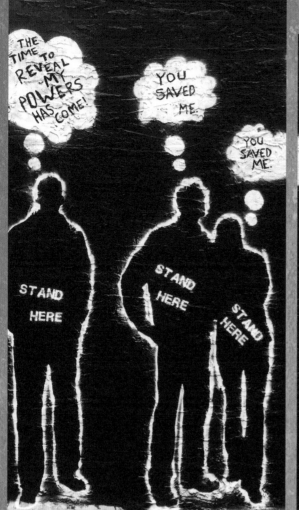

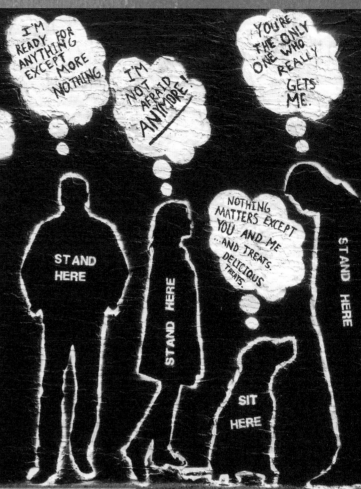

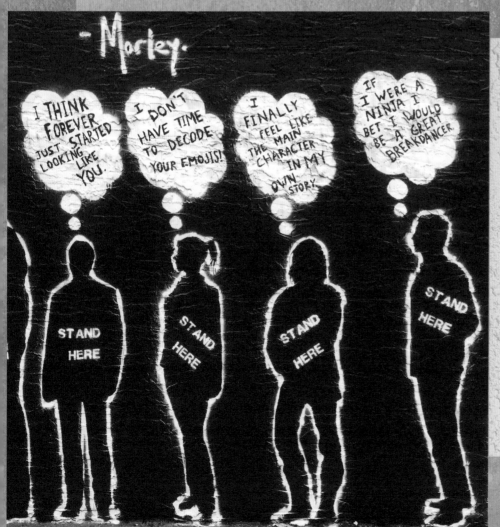

PENNY ANTE

As a kid, I was always annoyed by museums. I hated the velvet rope that kept you at a distance from the art, as though the painting was a club that you weren't allowed into. I wanted to touch everything. I wanted to feel the texture of the paint strokes, I wanted a tactile connection with the artist who painted it and to feel what they felt. For me, creating art that you can interact with is part of the fun.

Sometimes I have an idea that allows people to interact with a piece and literally be part of it. In the case of this wall in Chicago, I wanted to offer people a series of thoughts and the opportunity to take a photo in front of whichever one they related to the most. Some are meant to be silly, some romantic, some empowering, and some a bit heartbreaking. In my eyes, this piece isn't fully realized without someone interacting with it. It's kind of the exact opposite of a velvet rope.

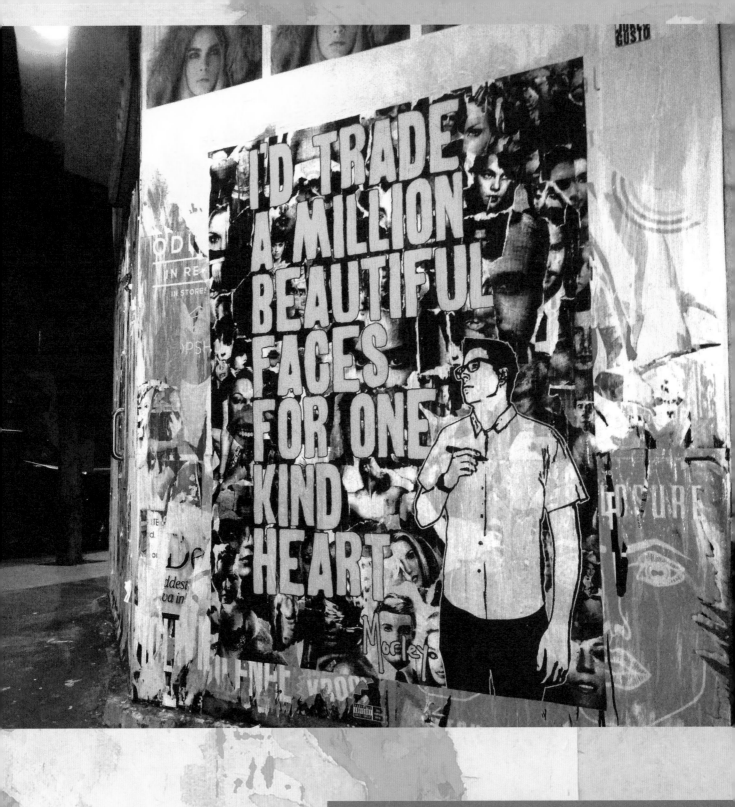

The beauty that comes into focus when you observe kindness is a beauty that doesn't fade or evaporate with time. It isn't a trick or a facade created by makeup and Photoshop. Conversely, the ugliness you'll discover in cruelty can sour even the most stunning of us with a decay that is impossible to overlook.

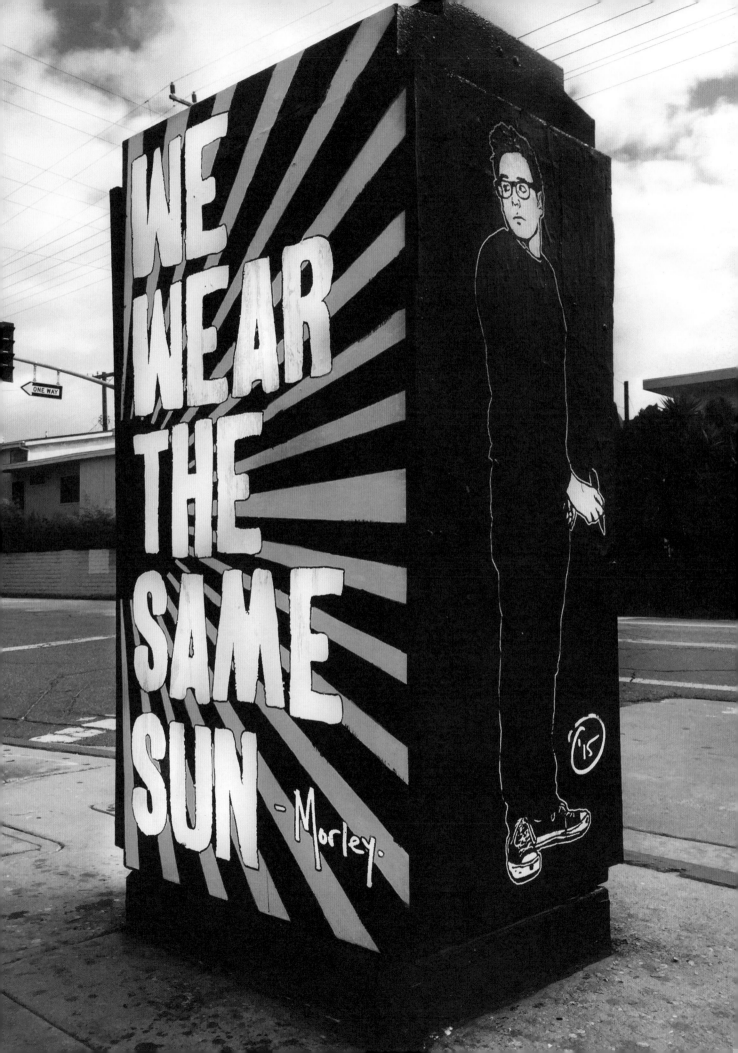

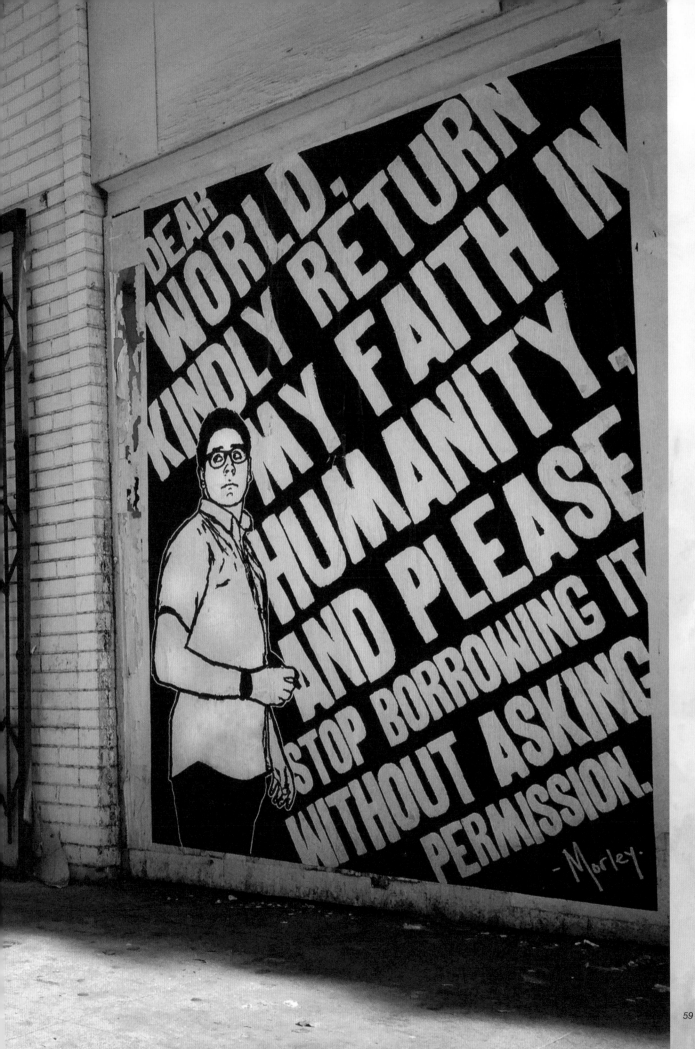

On the other side of grief we meet the person that it crafted.

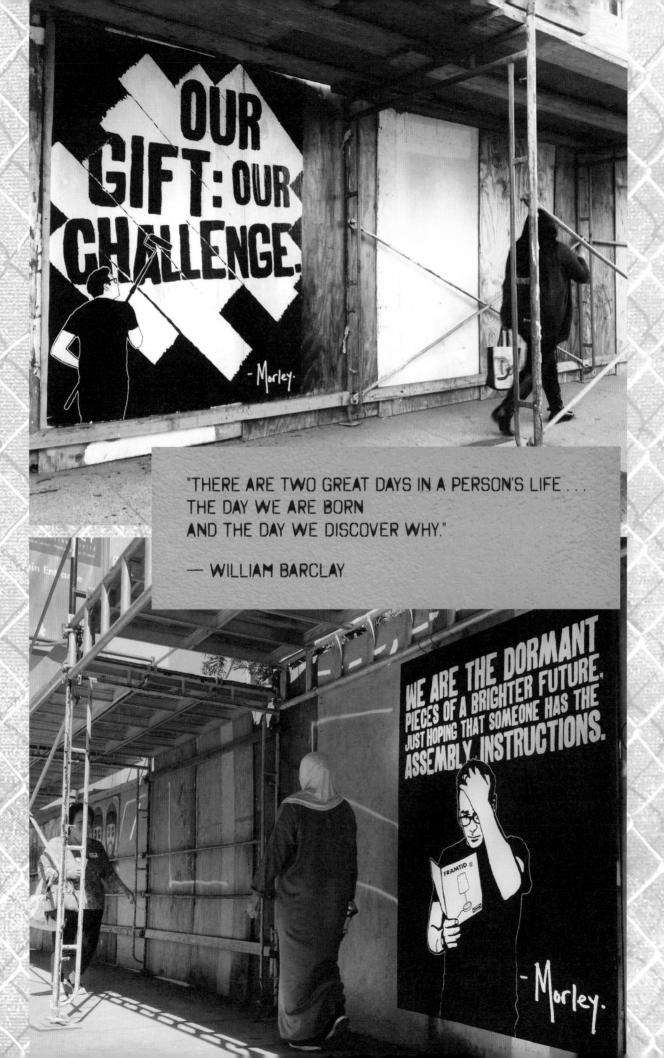

"THERE ARE TWO GREAT DAYS IN A PERSON'S LIFE . . .
THE DAY WE ARE BORN
AND THE DAY WE DISCOVER WHY."

— WILLIAM BARCLAY

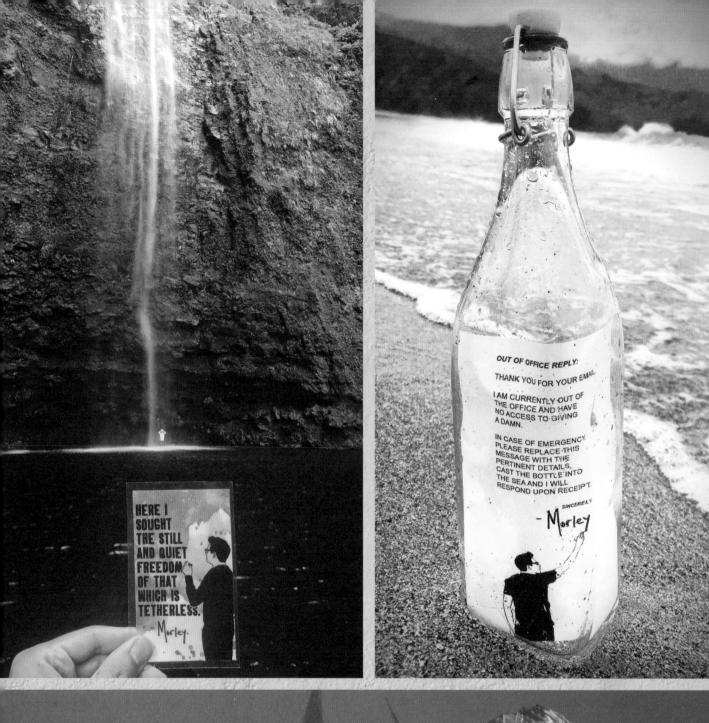

HERE I SOUGHT THE STILL AND QUIET FREEDOM OF THAT WHICH IS TETHERLESS. — Morley.

OUT OF OFFICE REPLY:

THANK YOU FOR YOUR EMAIL.

I AM CURRENTLY OUT OF THE OFFICE AND HAVE NO ACCESS TO GIVING A DAMN.

IN CASE OF EMERGENCY, PLEASE REPLACE THIS MESSAGE WITH THE PERTINENT DETAILS, CAST THE BOTTLE INTO THE SEA AND I WILL RESPOND UPON RECEIPT.

SINCERELY,
— Morley

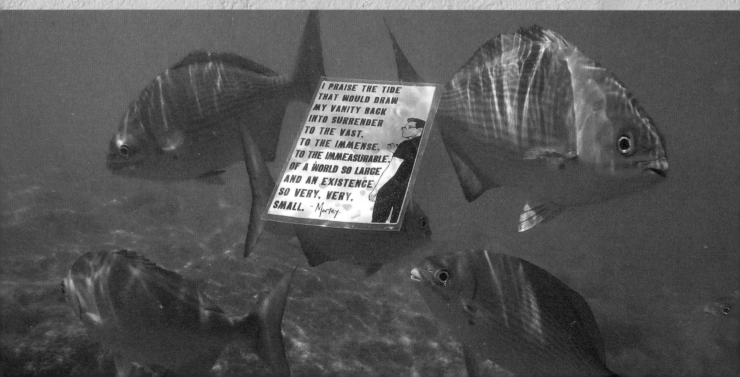

I PRAISE THE TIDE THAT WOULD DRAW MY VANITY BACK INTO SURRENDER TO THE VAST. TO THE IMMENSE. TO THE IMMEASURABLE. OF A WORLD SO LARGE. AND AN EXISTENCE SO VERY, VERY, SMALL. — Morley.

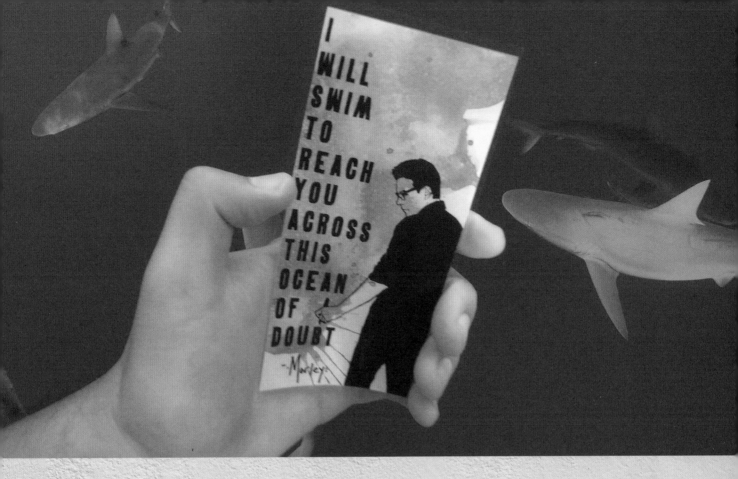

WATERWORKS

Traveling to new places always gives me a new environment and new context to put my messages. On a vacation to Hawaii I discovered that apparently there are spots in the ocean where crabbing fishermen leave traps for crabs and when they pull them up the sharks swarm the boats. My wife and I went into a shark cage to take a look. I brought a GoPro and stuck my hand through the bars just long enough to grab a shot of some art I had laminated.

This message, in the context of the company it was keeping, was meant to speak to the doubts that seem insurmountable. Like an endless ocean filled with ravenous creatures looking only to consume one's confidence in the mission, some things are worth the journey, no matter how perilous it proves to be. As for my experiences snorkeling my art among the ocean dwellers, it seems these critters share the same indifference most humans have as they pass me working, but I made sure to take these pieces home with me.

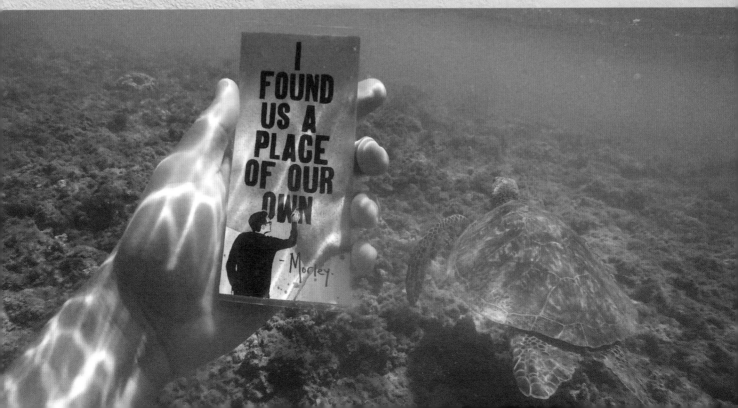

WE TOOK THE LONG WAY TO YOUR PARENTS' HOUSE THAT NIGHT.
THE CHILL IN THE AIR EXPOSED OUR FRAGILE BREATH AS IT FLED OUR LUNGS
AND EVAPORATED LIKE THE DETAILS OF A DREAM INFECTED WITH DAYLIGHT.
AND AS THE SNOW GRACEFULLY FELL UPON US, I OFFERED YOU MY SCARF.
YOU REPLIED THAT YOU WEREN'T COLD, THOUGH THE TREMBLING FINGERS
LACED WITHIN MINE REVEALED YOUR DECEPTION, AND FORCED ME TO INSIST.
WE KEPT A HESITANT PACE AS WE NEARED YOUR HOME,
HOPING THAT OUR STEPS MIRRORED EVERY CLOCK IN THE WORLD
AND LENGTHENED EACH MOMENT TO ITS NEGOTIABLE BREAKING POINT.
WE SPOKE OF DISTANT DREAMS, AND MADE PREDICTIONS
OF THE NUMEROUS FUTURES THAT COULD AWAIT US.
WE WERE ROCK STARS AND ASTRONAUTS,
AND NOBEL PRIZE WINNERS.
WE HAD DOZENS OF CHILDREN AND ROBOT PETS,
AND CARS THAT DROVE THEMSELVES.
WE JOKED AND CURSED AND SWORE TO SECRECY
OUR PREDICTIONS OF THE FRIENDS
WE SUSPECTED WOULD AMOUNT TO NOTHING.
WE REVELED IN THE
INTOXICATING POTENTIAL
WE CARRIED WITHIN OUR YOUTH;
AND FOR THE LENGTH
OF THAT CRUELY SHORT WALK,
WE LIVED LIKE A MOVIE SCRIPT
FOR A FILM IN WHICH I FOUND
A FLEETING PEACE INSIDE MY SKIN,
AN EASE INSIDE MY MIND
AND A MEMORY I'D HOPE
TO ONE DAY RECALL
AS I SAT, RECLINED WITH MY ROBOT PET,
IN MY CAR THAT DROVE ITSELF.

I NEVER DID GET THAT SCARF BACK.

— Morley

THE LONG WAY HOME

I made this poster in the height of nostalgic reverie for my youth in the Midwest. The winters can be brutal, but every now and then, there are moments of such beauty. These are the days before the mud-colored icy sludge lines every gutter and divot in the sidewalk. Before the mid-March thawing of plowed snow piles promises a not-too-distant future of shedded boot and glove. I don't visit Iowa very often. The last time was an interesting experience. It had been more than half a decade and returning to the place felt a bit like seeing an ex-girlfriend at a party after you've both moved on.

While you can rationally understand why you are no longer with the person and wouldn't want to be with them now, some dormant memories are hard to shake. There's also the sense that the person you once knew and loved doesn't exist anymore. There are hints; she cut her hair, she dresses differently, but what's off-putting is the knowledge that the world doesn't stop turning when you close your eyes. People (and places) grow and evolve even when you're not there and have stopped thinking about them. To them, the change is imperceptible.

For those who have witnessed one's gradual evolution through a spanning of time, the changes may not seem so startling, but stark years between those who were once as intimate as I was with Iowa, leave me struck by a strange feeling of betrayal. How could she have moved on so easily? Had Iowa missed me at all? Had I ever mattered to Iowa in the first place? I like to think so, though I suppose we only run ourselves down worrying so much about things we knowingly left behind. In its own way, Iowa is a magical place and I'm happy I got to revisit it, and perhaps like the ex-girlfriend at the party, I'm glad I went over and talked to her, found out she's happy with her new job, her new boyfriend. And yet I could tell that there was some small part of her that missed me, that also accessed those memories of youthful and adventurous nights all those years ago, when I would walk with her, my heart so full of hope and expectation for an exciting future. Then as the party winds down, we each go our separate ways. But our eyes linger for a moment in the other's as we say goodbye and wonder just what could have been.

But only for a moment . . . and then it's gone.

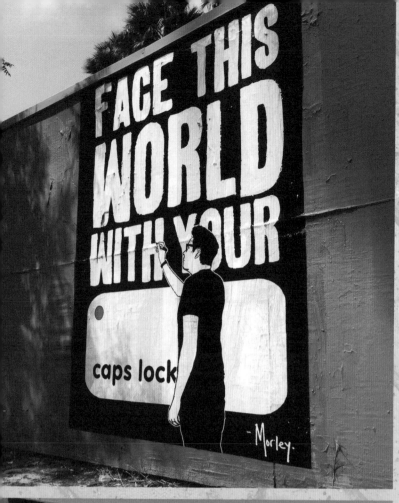

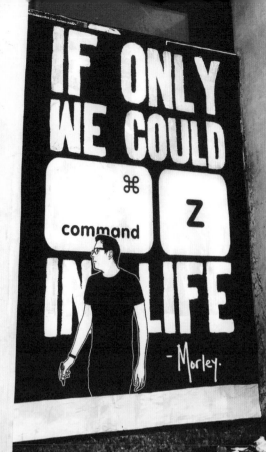

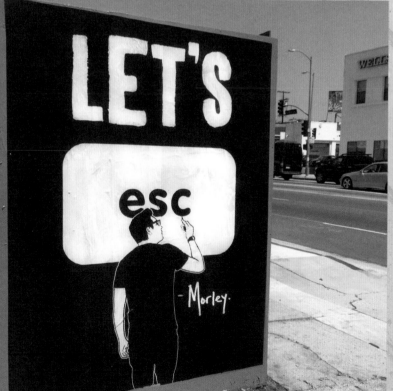

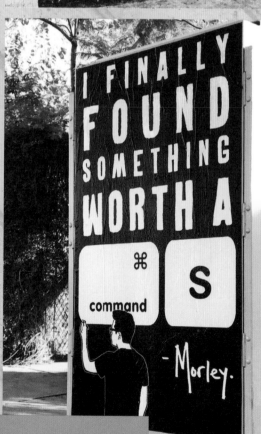

SHORTCUTS

This little series of posters that use the theme of computer keyboard commands might be proof that I spend more time than I should on my laptop, but I can't imagine I'm alone. These commands are shortcuts for your computer, and my hope was that they might also be shortcuts to the ideas they represent.

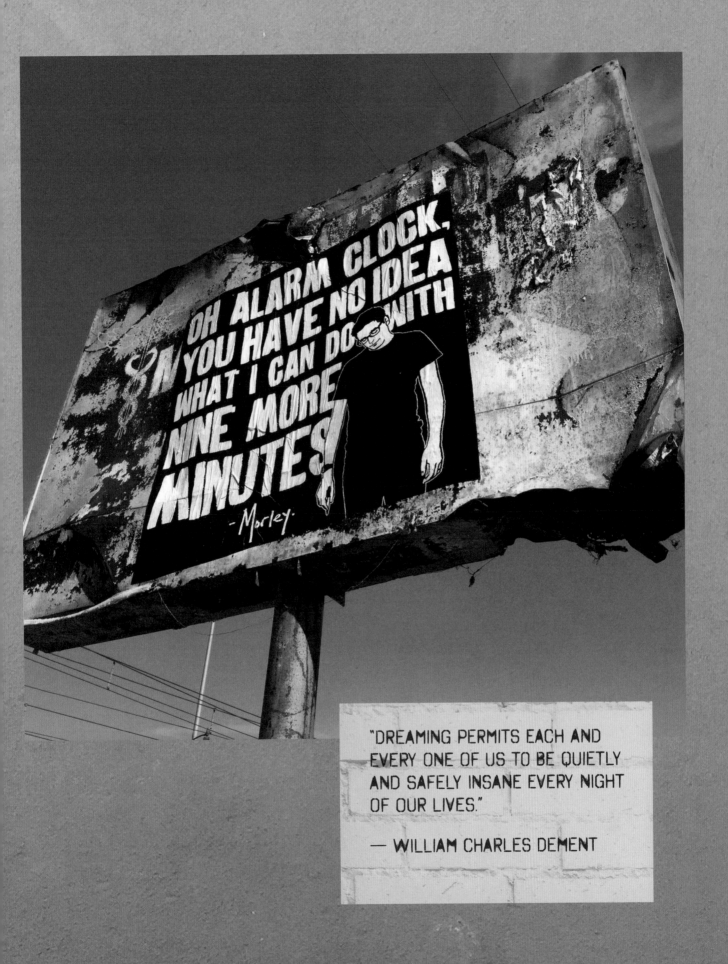

"OH ALARM CLOCK, YOU HAVE NO IDEA WHAT I CAN DO WITH NINE MORE MINUTES"

—Morley.

"DREAMING PERMITS EACH AND EVERY ONE OF US TO BE QUIETLY AND SAFELY INSANE EVERY NIGHT OF OUR LIVES."

— WILLIAM CHARLES DEMENT

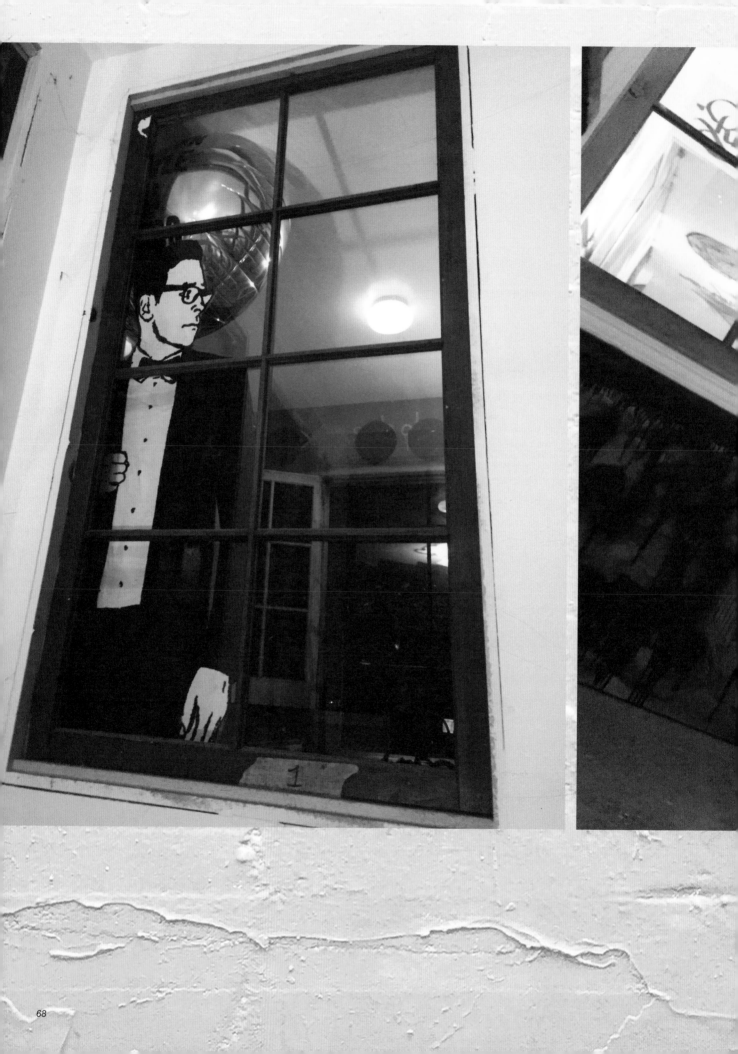

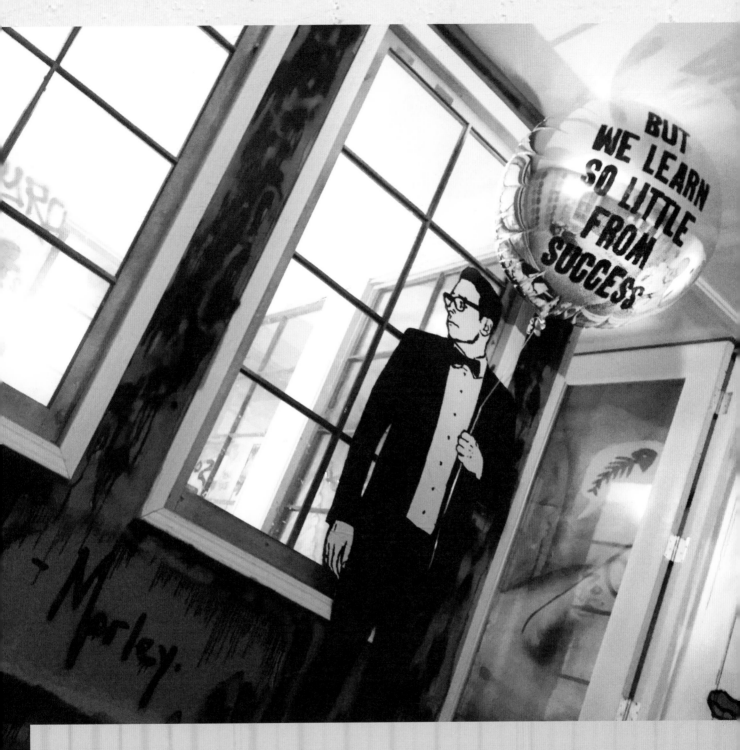

SURPLUS CANDY

In October of 2015, New York–based street artist Hanksy visited Los Angeles to throw an event called "Surplus Candy." He rented an old, dilapidated mansion and invited artists from all over California to decorate every square inch of it. For a single night, he opened the space up to anyone who wanted to observe the finished spectacle. When most artists are asked to show their work in a gallery, the first question they have is, "Where do you want me to hang my work?" For most street artists though, the question is, "What's off limits?" because everything else is fair game.

I loved the visual canvas of a decrepit LA mansion, so I decided to dress Morley in a vintage tuxedo, and since the space seemed to give a new dimension to a traditional art show, I wanted to make my pieces a bit more 3-D. I used life-sized cardboard cutouts holding floating balloons that bore my messages. I looked for spaces that the other artists might not have noticed—including a somewhat hidden bathroom where I splattered the walls with multicolored paints. The event was a massive success and I was happy to have been involved in it.

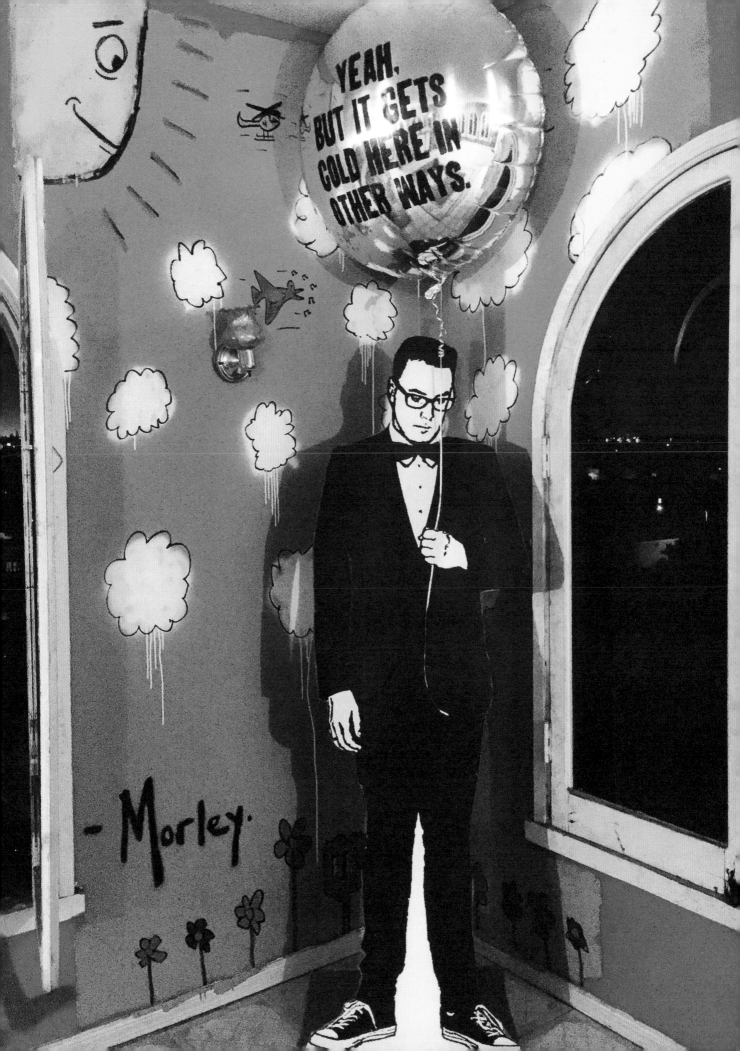

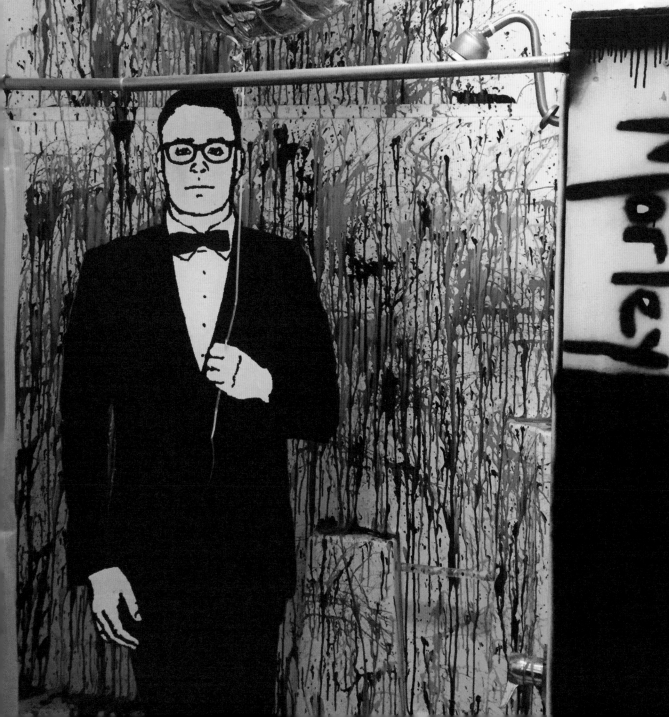

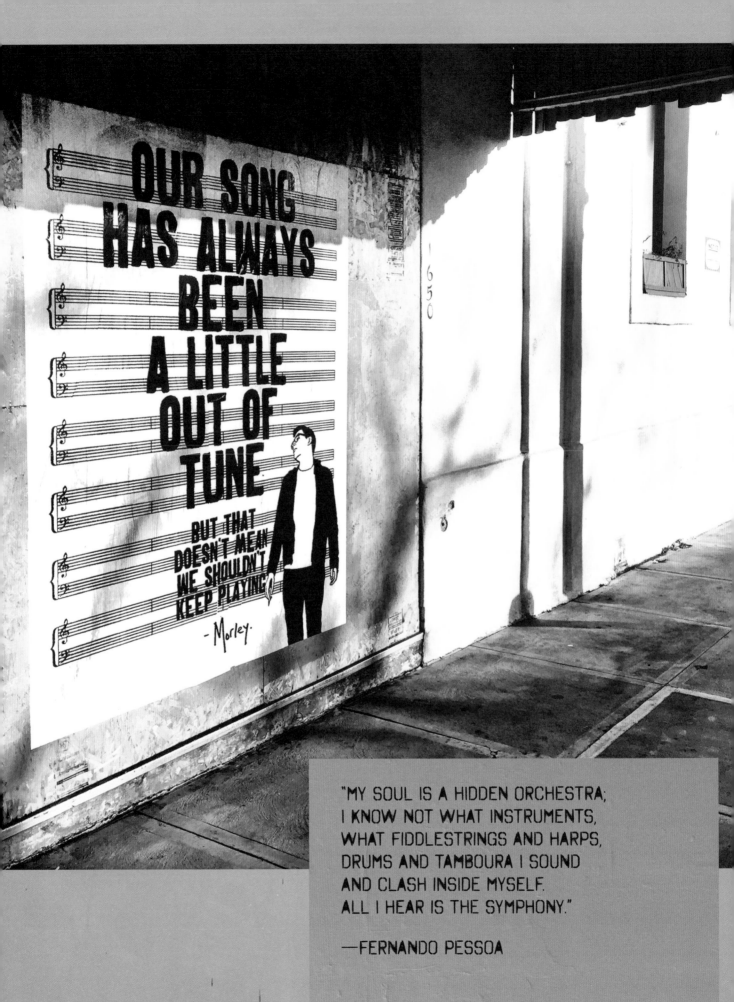

"MY SOUL IS A HIDDEN ORCHESTRA;
I KNOW NOT WHAT INSTRUMENTS,
WHAT FIDDLESTRINGS AND HARPS,
DRUMS AND TAMBOURA I SOUND
AND CLASH INSIDE MYSELF.
ALL I HEAR IS THE SYMPHONY."

—FERNANDO PESSOA

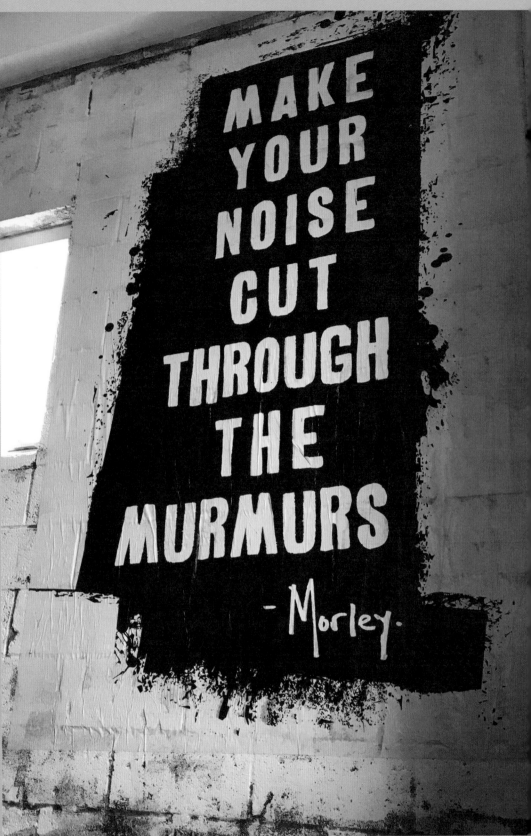

MAKE YOUR NOISE CUT THROUGH THE MURMURS

— Morley.

SOMETIMES LIFE CAN SEEM LIKE ONE LONG VERSE AND THEN ALL OF A SUDDEN YOU REACH THE CHORUS

-Morley.

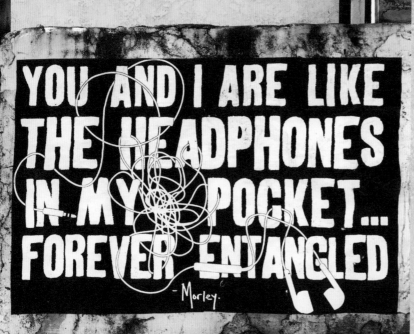

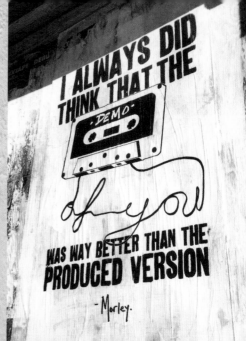

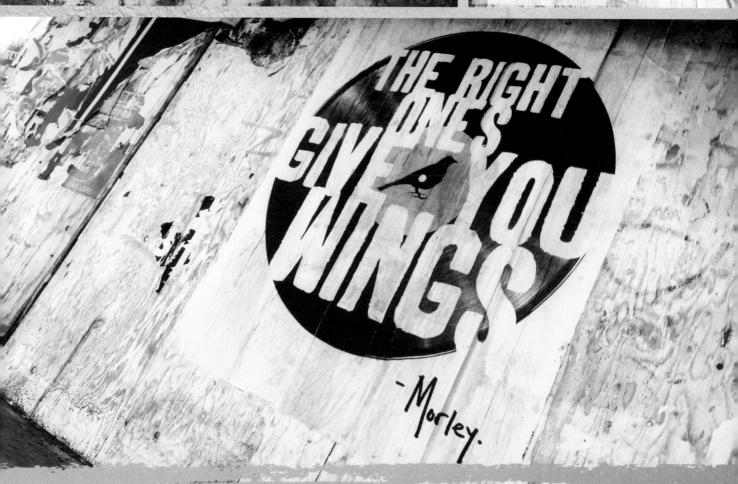

ONLY IN DREAMS

I remember being twelve years old. I was lying on my bedroom floor and listening to "Only In Dreams" by the band Weezer. It was that season in life where you start to really discover the power of a great song. Music changes everything. It can take you to places so far outside the world in front of you. Places where there are finally words for those whispers in your heart and even the tiniest of lives can feel infinite. Music can define and redefine how we see the world and how we want the world to see us. It acts as a soundtrack to our moments of triumph and tragedy—our first love and our first heartbreak. Music is the glue to the bricks that are memories, and together they form the structure of who we are. There have been other musicians that have shaped me into who I am today. The Beatles, Archers of Loaf, Everclear, Beulah, Death Cab for Cutie, Tom Waits, the list goes on and on. But when I was twelve and lying on my bedroom floor listening to "Only in Dreams," that was where it all began, because that is where I really started to become the person I am today. There are few things in this life that can top the transformative power of the right song at the right time.

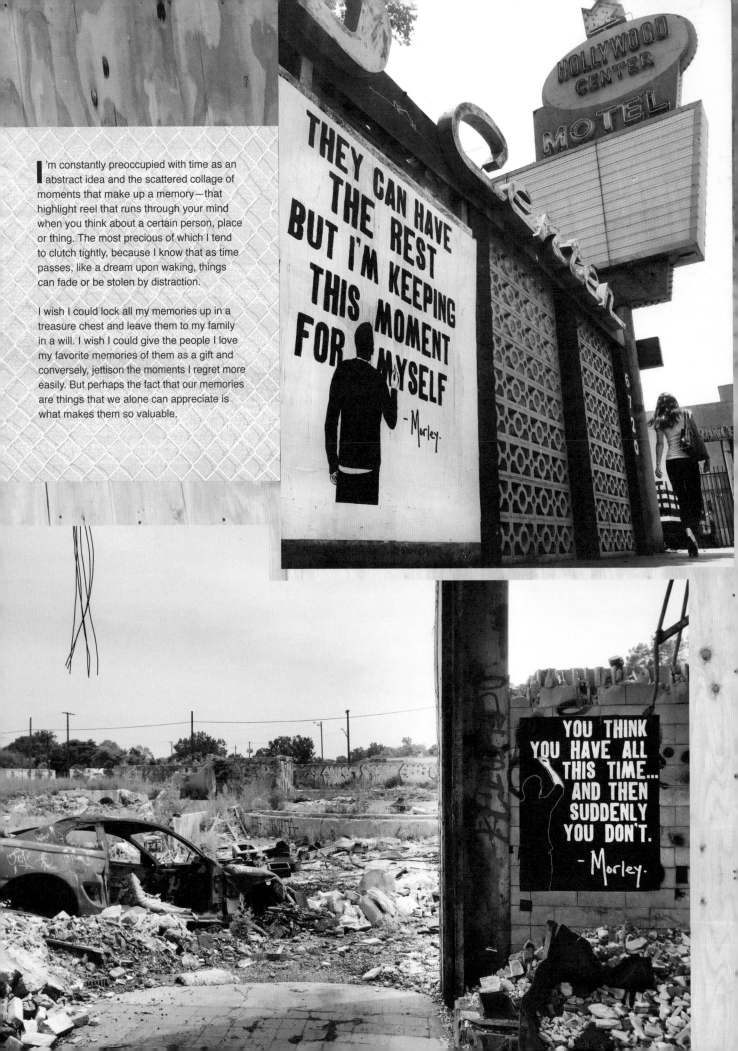

I'm constantly preoccupied with time as an abstract idea and the scattered collage of moments that make up a memory—that highlight reel that runs through your mind when you think about a certain person, place or thing. The most precious of which I tend to clutch tightly, because I know that as time passes, like a dream upon waking, things can fade or be stolen by distraction.

I wish I could lock all my memories up in a treasure chest and leave them to my family in a will. I wish I could give the people I love my favorite memories of them as a gift and conversely, jettison the moments I regret more easily. But perhaps the fact that our memories are things that we alone can appreciate is what makes them so valuable.

THEY CAN HAVE THE REST BUT I'M KEEPING THIS MOMENT FOR MYSELF

—Morley.

YOU THINK YOU HAVE ALL THIS TIME... AND THEN SUDDENLY YOU DON'T.

—Morley.

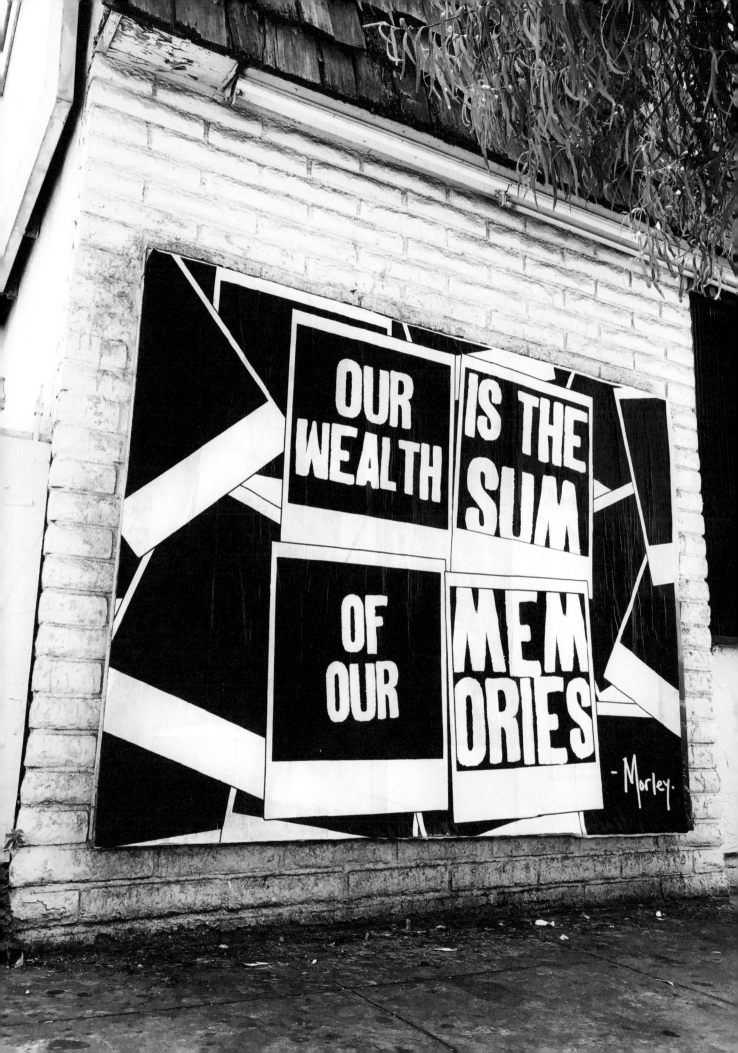

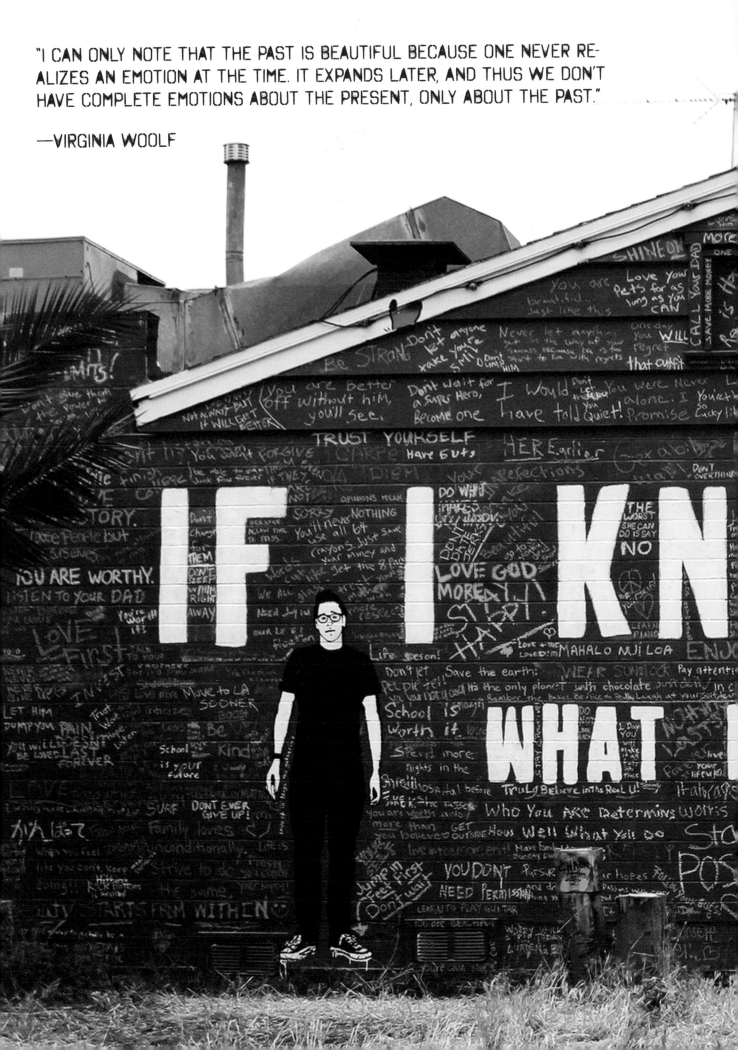

"I CAN ONLY NOTE THAT THE PAST IS BEAUTIFUL BECAUSE ONE NEVER RE-ALIZES AN EMOTION AT THE TIME. IT EXPANDS LATER, AND THUS WE DON'T HAVE COMPLETE EMOTIONS ABOUT THE PRESENT, ONLY ABOUT THE PAST."

—VIRGINIA WOOLF

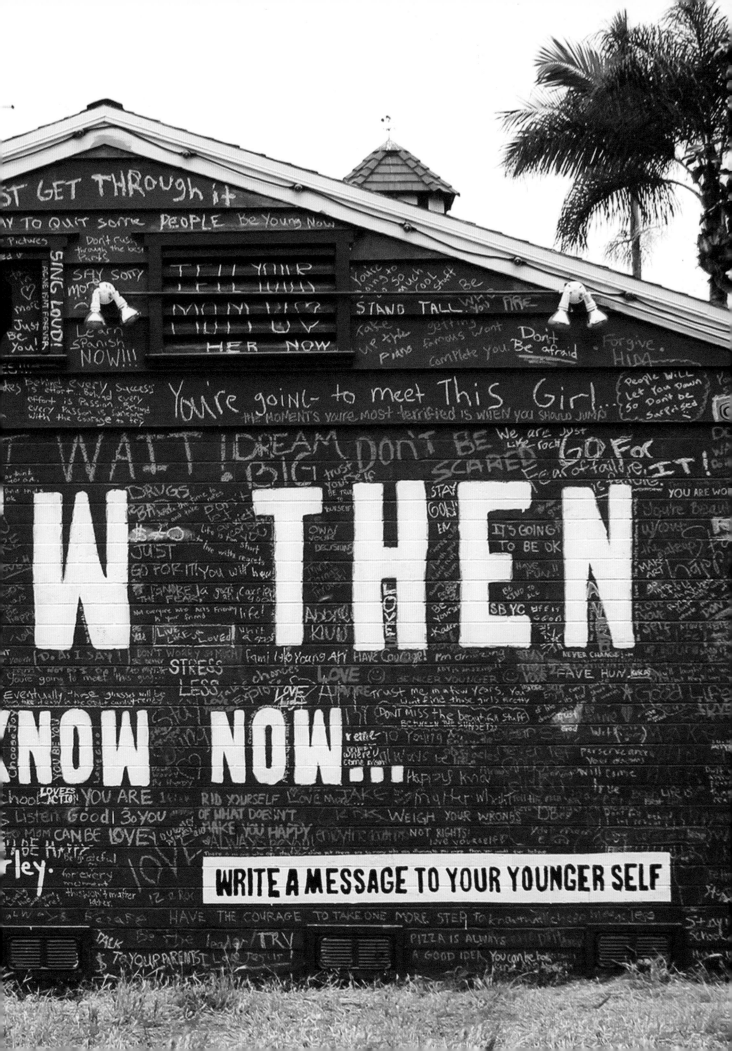

CHALK IT UP

In April of 2015, I was called by Bryan Snyder, an artist from Carlsbad, California. He had been given permission to create a mural on the wall of Senior Grubby's, a Mexican restaurant in the heart of Carlsbad. Being a generous guy, he decided to invite a different artist each month to paint a rotating series of murals. He asked me if I wanted to do one. I said "sure" and then asked whom else he'd made the offer to. He gave me a substantial list of highly skilled and creative artists, and I immediately started imagining finishing the piece and overhearing someone say, "Compared to last month's mural, this one's pretty 'meh.'" I've always tried to be pragmatic about my strengths and weaknesses and what I feel I may lack in technical skill or visual flare, I make up for in ideas. I wanted to make something that was interactive and pushed people to think and contribute to the art—to see a piece of themselves on the wall.

I once had a dream in which I could write letters and somehow send those letters through the time stream to reach my younger self. In my dream, I couldn't change the course of history, but I could offer advice and solace from someone who truly knew how it felt. I could encourage myself with the knowledge that I'd make it through the storm, I'd warn myself to prepare for the struggles that lay ahead, and I would promise things to look forward to. I took this idea and decided to implement it into my mural. I started by painting the whole wall in green chalkboard paint, and then I painted the concept over that in white so that for the next four weeks people could stop by and add to it. I also asked anyone who couldn't make it down to send me their messages and I'd add them as well.

The response was overwhelming. There were so many messages that by the end of the first day, it was jam-packed. Some sentiments were hopeful, some heartbreaking. ***"Spend more nights at the hospital before she passes away"; "You'll never use all sixty-four crayons, so save your money and just get the eight pack"; "Take it easy on the credit cards."*** The wall got so crammed with messages that every week the Senior Grubby's staff would wipe the wall clean to give more people a chance to contribute a message. I may not have gotten the chance to send the messages that I contributed to the wall through the space-time continuum, but I still like to think that if the young version of me could see how much joy this mural gave a lot of people, he'd be pretty proud.

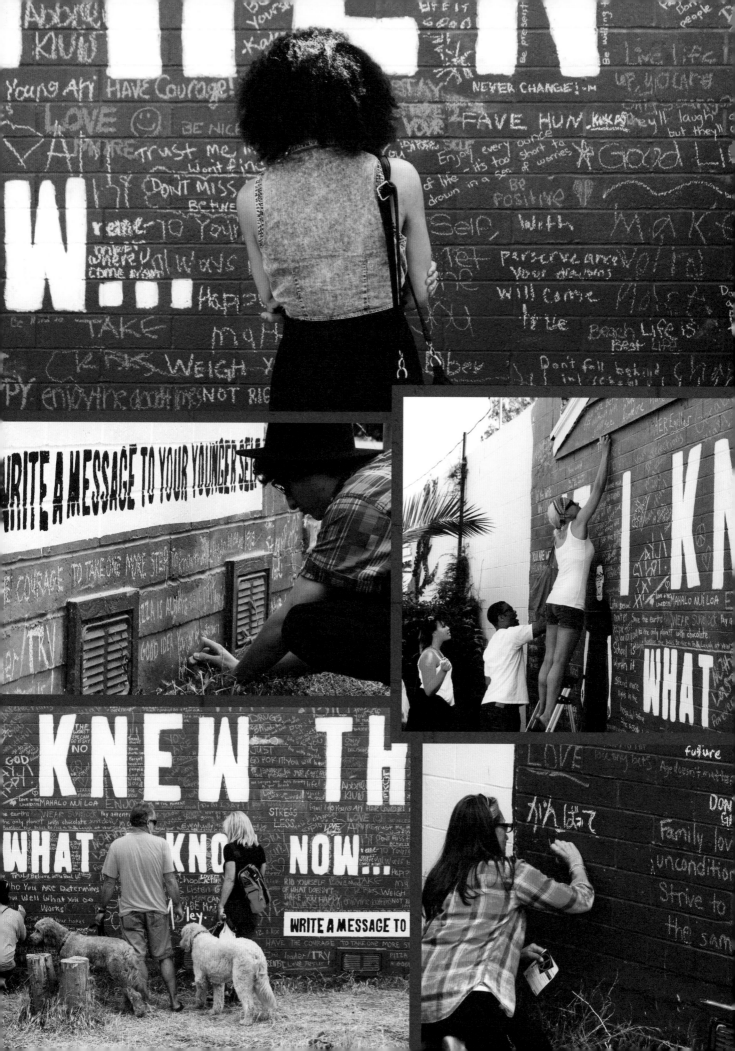

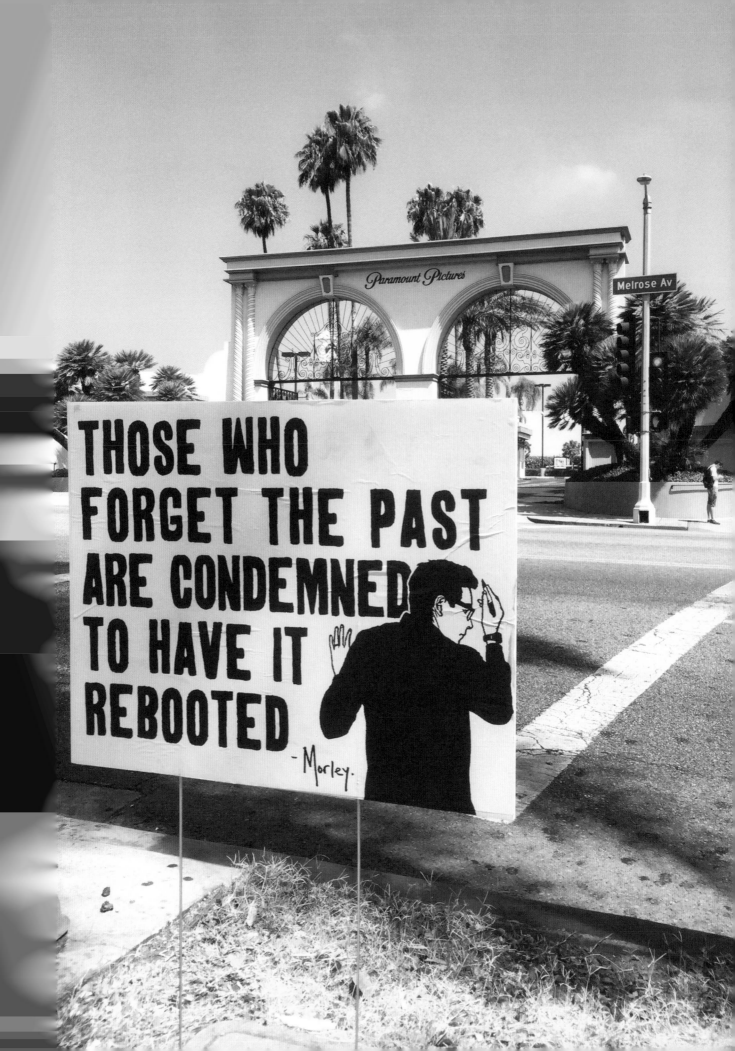

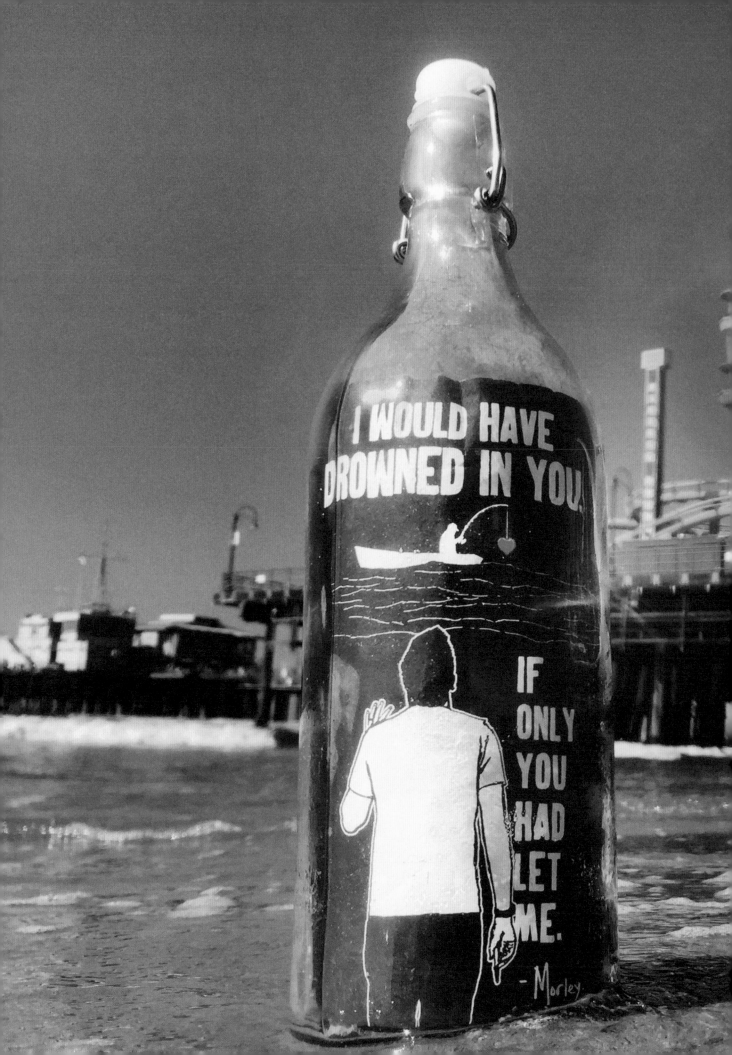

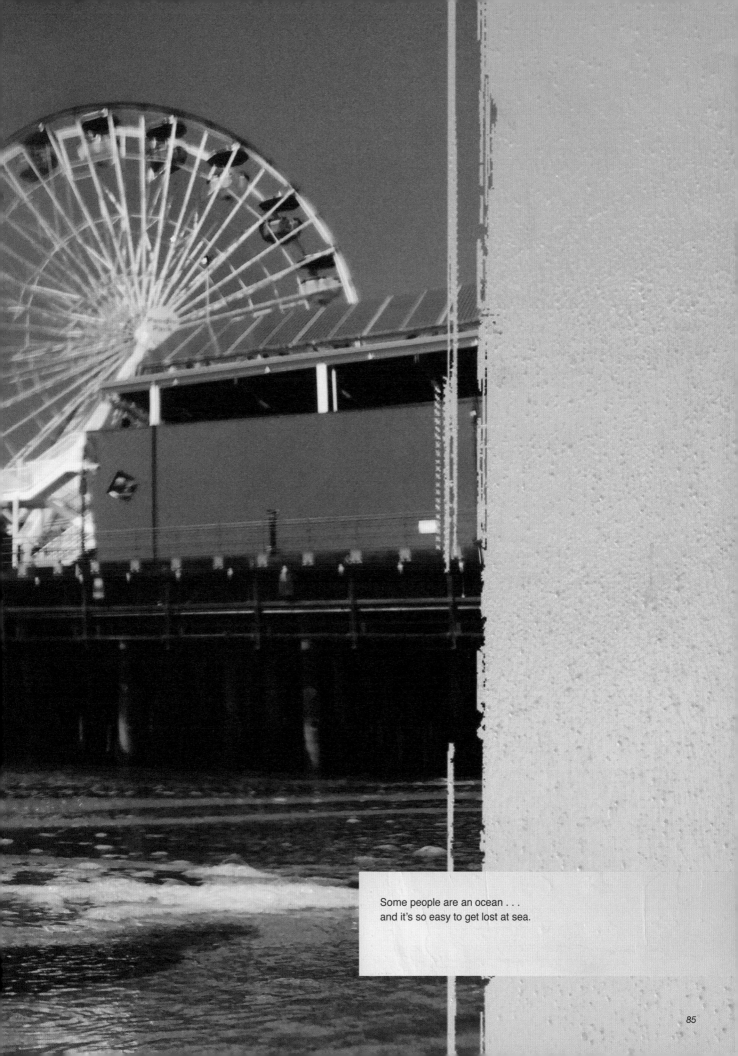

Some people are an ocean . . .
and it's so easy to get lost at sea.

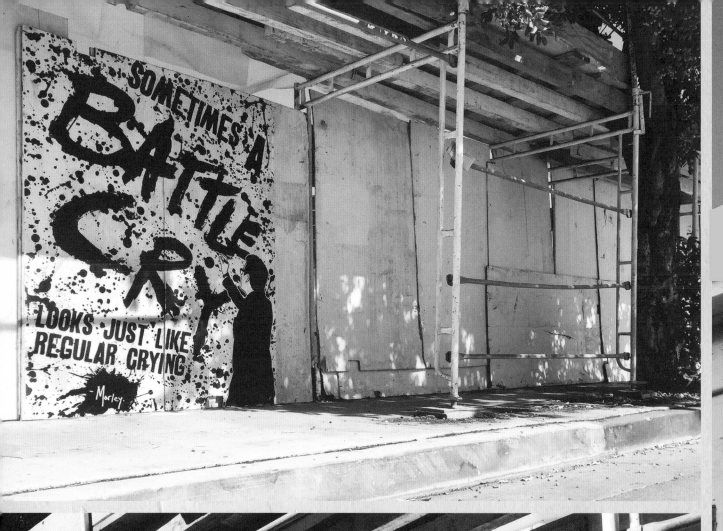

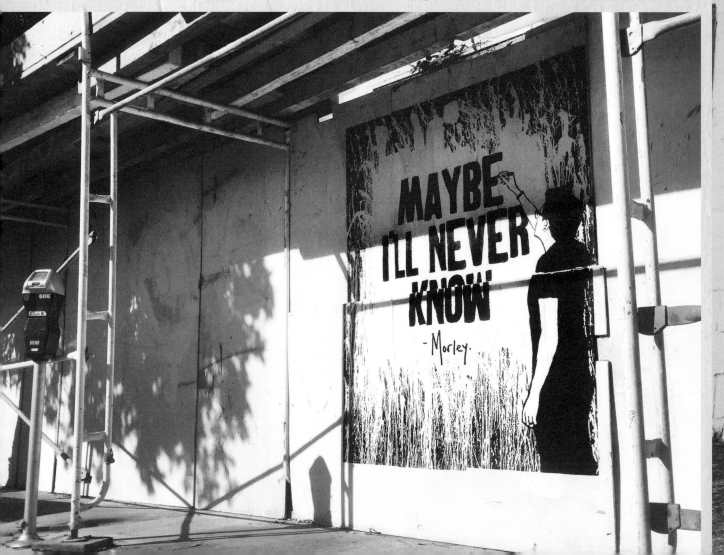

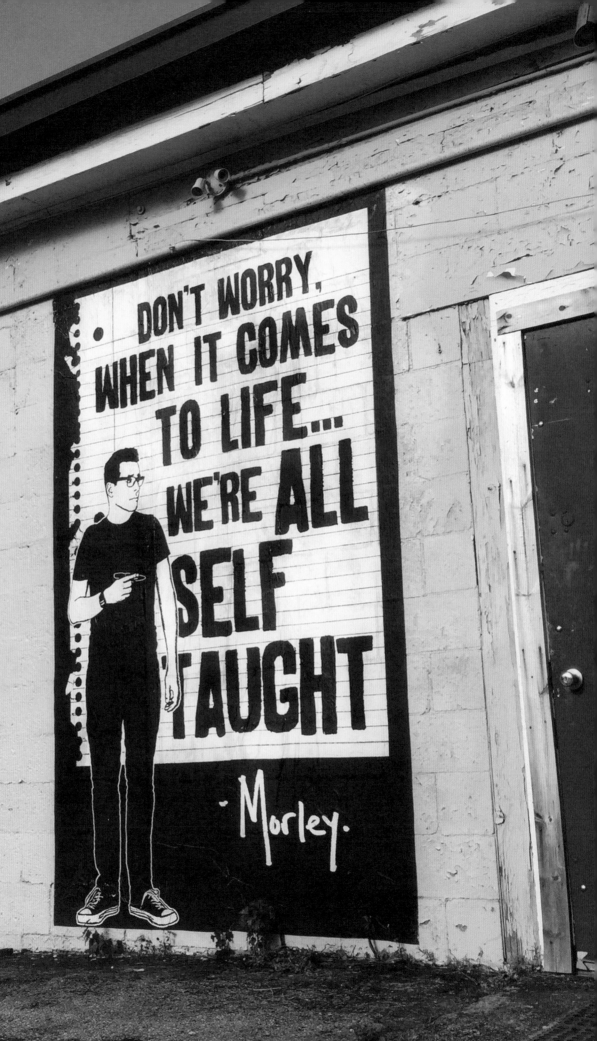

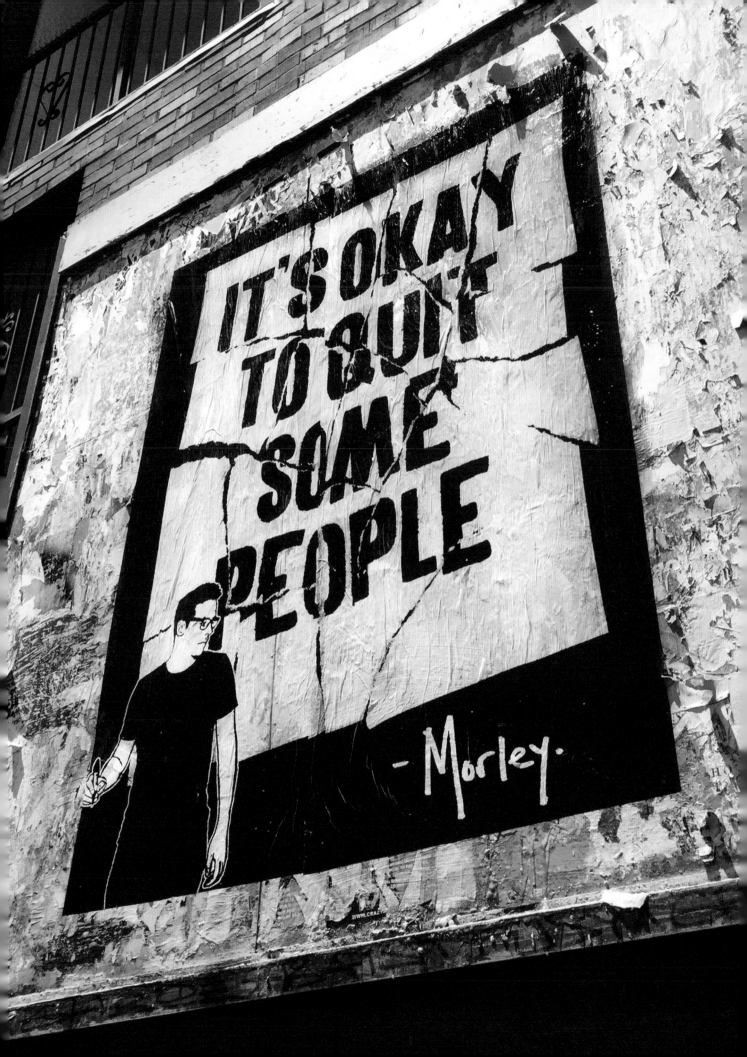

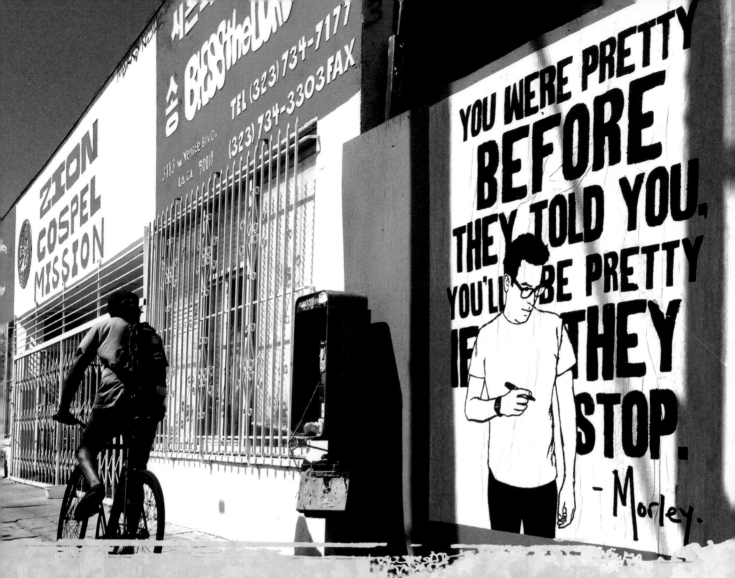

REFLECTIONS

People far too often neglect the freedom of subjectivity. They shrug it off and allow others to define the appraisal of things for them, as though it were empirical fact. As though one person's opinion held greater value than another's. Los Angeles is filled with people desperate to find someone who will co-sign their beauty and their talent. To promise the world that they found someone worth looking at, and in the process, these talented, beautiful people forget that those qualities won't go away if everyone turns to someone else. The more time I spend in the art world, the more I can see how flawed this thinking is. One person spends millions of dollars on a painting that someone else wouldn't pay ten bucks for. Which person is the fool? The only fool is the one who can definitively tell you.

There are relationships that are worth fighting for—friendships that stumble over a conflict and require hugs and apologies, romantic relationships that require compromise or counseling. Many of these problems require us to work in order to repair what's broken. But sometimes, it's best to just move on. It's hard to know the difference between something toxic or abusive and something worth saving. I think some people almost need permission to let go. Loyalty is a wonderful thing, as is a resolution that can create a closer bond between people, but sometimes it's better to mend what you can and walk away.

Of course, this is tricky—I'm not saying you should just dump the friends and loved ones that aren't meeting your standards—I'm talking about the relationships that make you feel small, that serve only to bring you down or hurt you. We hold on to these because of a history or simply because no one told us we were allowed to stop trying—and often this is long after the other person has given up doing any work of their own—we just keep patching over our own feelings and watching as the relationship limps along. Sometimes you just need to let go. This can be done without massive drama; sometimes it's nothing more than just saying, "I refuse to let this person be a negative influence in my life," and just phase out the elements of the relationship that you're allowing to affect you. Other times, it's more of a clean break. The important thing to do is to forgive them for the flawed relationship and forgive yourself for not being able to make those flaws go away.

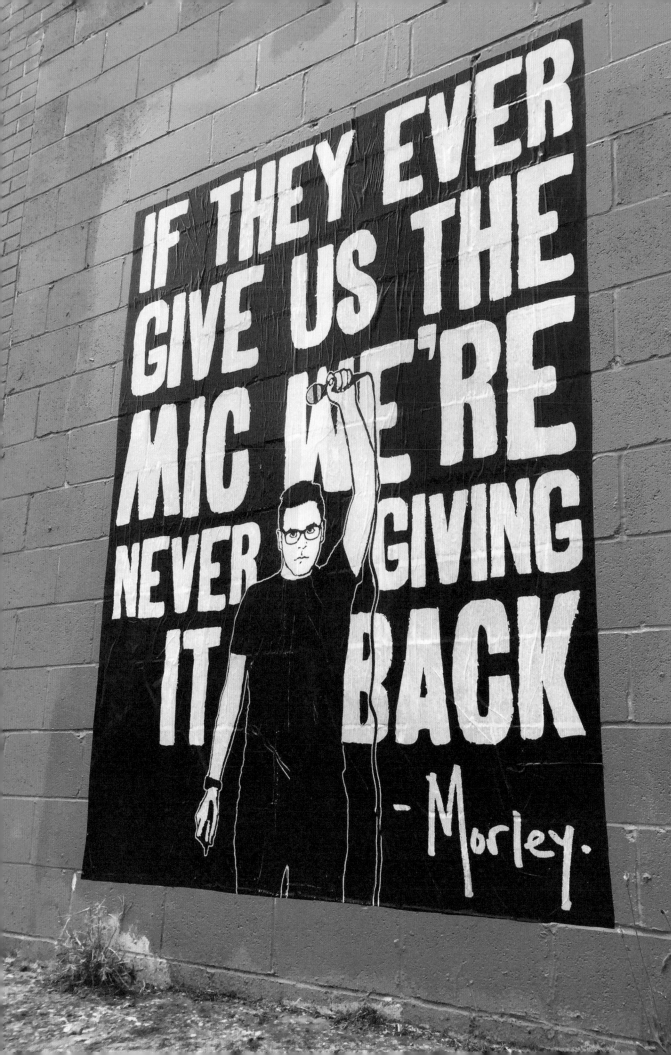

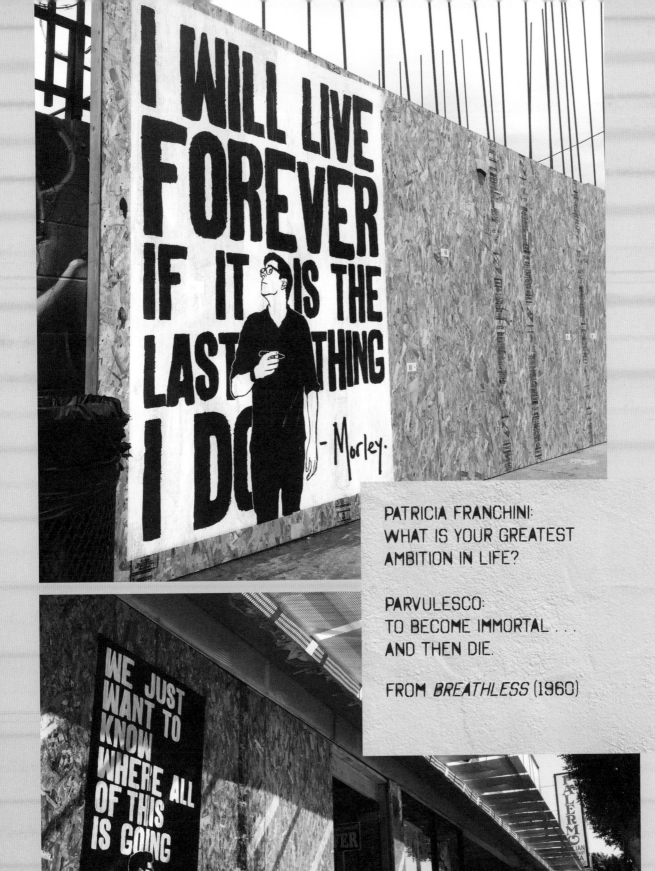

PATRICIA FRANCHINI:
WHAT IS YOUR GREATEST
AMBITION IN LIFE?

PARVULESCO:
TO BECOME IMMORTAL . . .
AND THEN DIE.

FROM *BREATHLESS* (1960)

GIVE YOUR VOICE A PURPOSE NOT JUST A USERNAME

- Morley.

PURPOSE & PERMISSION

In this world of comment board debates, Internet trolls, and innumerable pieces of floating disinformation, I believe it's important to live out your beliefs in real life with real people. One of the reasons for this is that it gives back some humanity to the way we converse. It's far too rare to look someone in the eye and respectfully disagree. To be challenged to articulate the way you feel without resorting to using smug name-calling and ALL CAPS expletives to get your point across. Respecting someone's right to have a differing opinion is the only way you will ever convince someone to actually listen to you and perhaps even see your side. The Internet has given us the ability to communicate with each other in a way that removes the obligation of social courtesy thanks to its gift of anonymity and distance, but it has taken the soul out of these communications. I'm not saying we should throw our laptops in the ocean, I'm just saying that if your only tool to live out your beliefs is one that is so often toxic, and you're not trying to make practical changes because they lack the payoff of a retweet, then you're falling short of your potential . . . and so are your ideas.

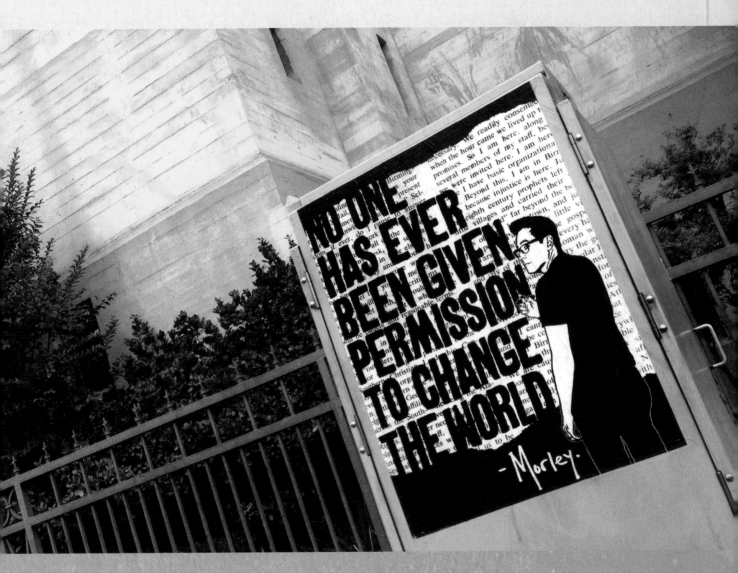

In the background of this poster is a piece of a letter written by Martin Luther King Jr. from his jail cell after he was arrested in Birmingham, Alabama, in 1963. In it, he defends his belief in nonviolent protest as well as one's moral responsibility to break unjust laws. This is not to say that I feel street art comes anywhere close to being as vital a rebellion as the Civil Rights Movement, but rather just as an illustration of something bigger. There will always be resistance to reshaping the world. If you want to make a difference, you can only do so by pushing through those who will try to dissuade you, be it with indifference, mockery, or aggression. In this day and age, it is important to look back at history and see what kind of difference a positive, nonviolent yet unwavering quest for change can create. There are people out there who aren't interested in anyone altering the status quo. This is true in broad cultural issues as well as many individual ones. If you want to change our world or even just your little part of it, don't wait for someone to give you permission.

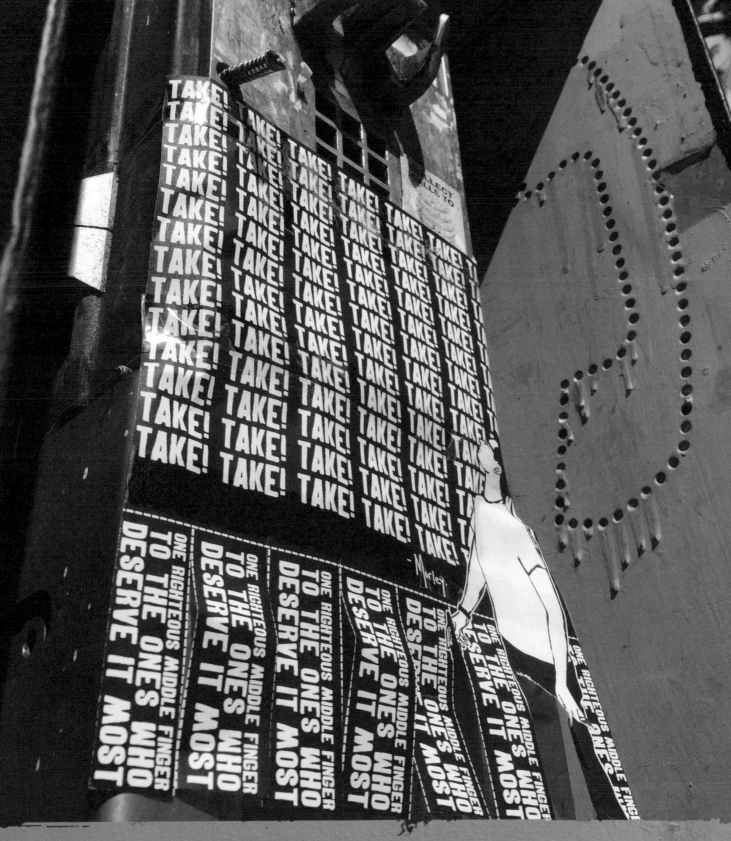

SNIFF SNIFF

It took some time, but I have given up trying to please everyone with who I am and what I do. If you make or do anything that is creative, you will always bother someone and often that person will feel obligated to punish you in some convoluted, petty, self-satisfying way. I'm not even talking about criticism, which seems like an outdated concept these days. People don't critique, they simply label something the BEST or the WORST and for some reason attach a personal offense to it. It's not enough to dislike something when you can decide it's the source of what's wrong with the world today. Generally this line of thinking can be traced to envy or personal frustration that actually has nothing to do with you or your work. In some ways I pity these people because so often it's born of an impotence to create something themselves that motivates their animosity.

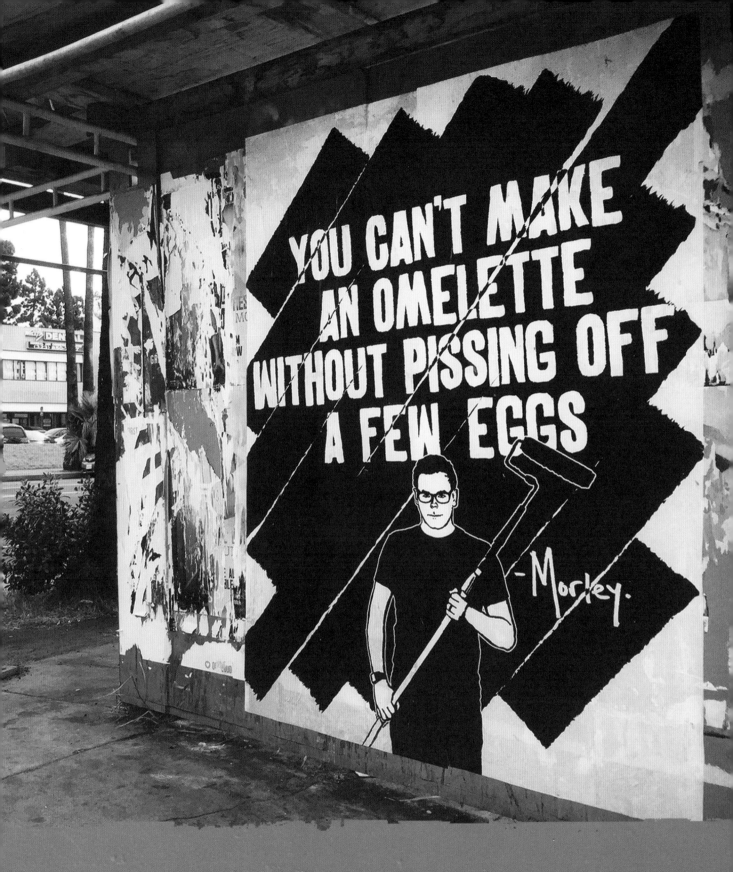

The best way to defeat this mentality is to continue on without heed. No one has ever made an impact if the only thing they contribute is a narrow definition of what they deem satisfactory. The only people worth listening to are the ones who speak with the wisdom of knowing that we don't all have to fit the same mold, like the same stuff, create with the same voice, and have the same ideas. Forgive my crudeness, but a wise man once said, "Opinions are like assholes. Everyone's got one and everyone thinks everyone else's stinks." I'd just as soon not spend my day sniffing butts.

"THE OPPOSITE OF LOVE
IS NOT HATE,

IT'S INDIFFERENCE.

THE OPPOSITE OF ART
IS NOT UGLINESS,

IT'S INDIFFERENCE.

THE OPPOSITE OF FAITH
IS NOT HERESY,

IT'S INDIFFERENCE.

AND THE OPPOSITE OF LIFE
IS NOT DEATH,

IT'S INDIFFERENCE."

—ELIE WIESEL

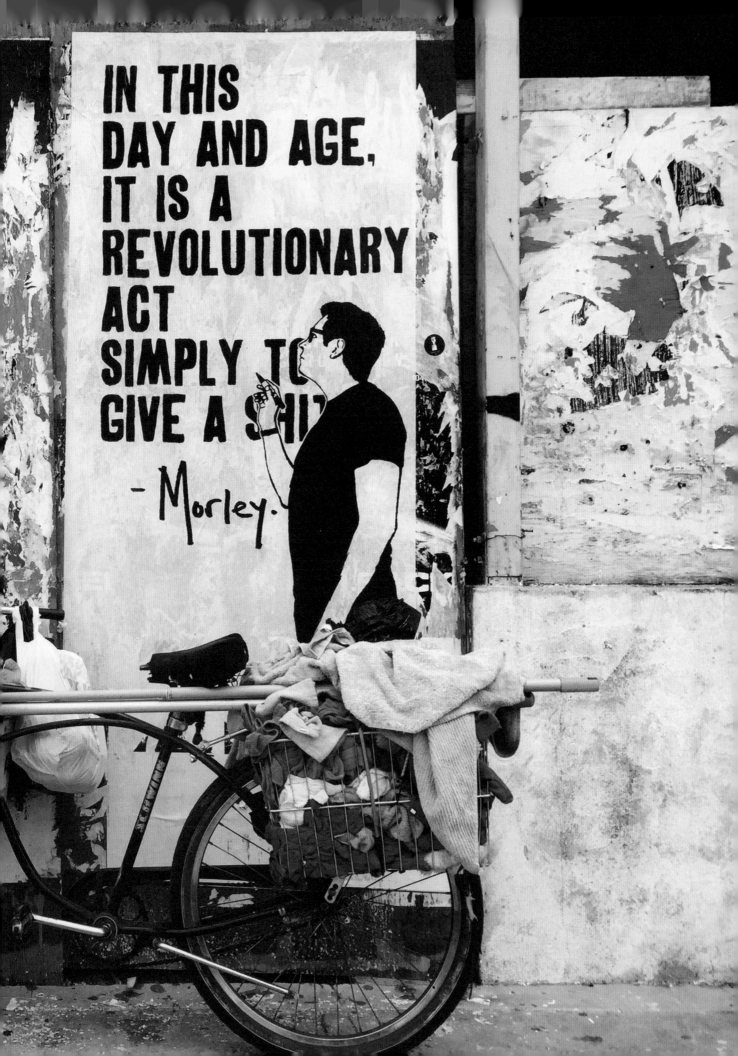

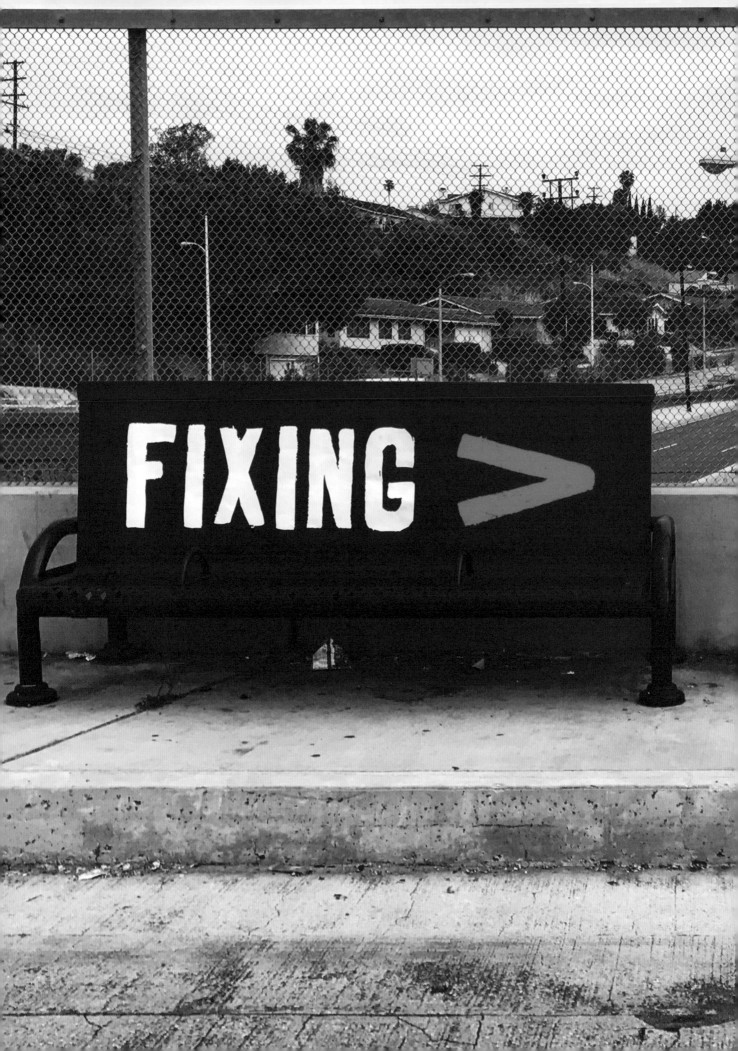

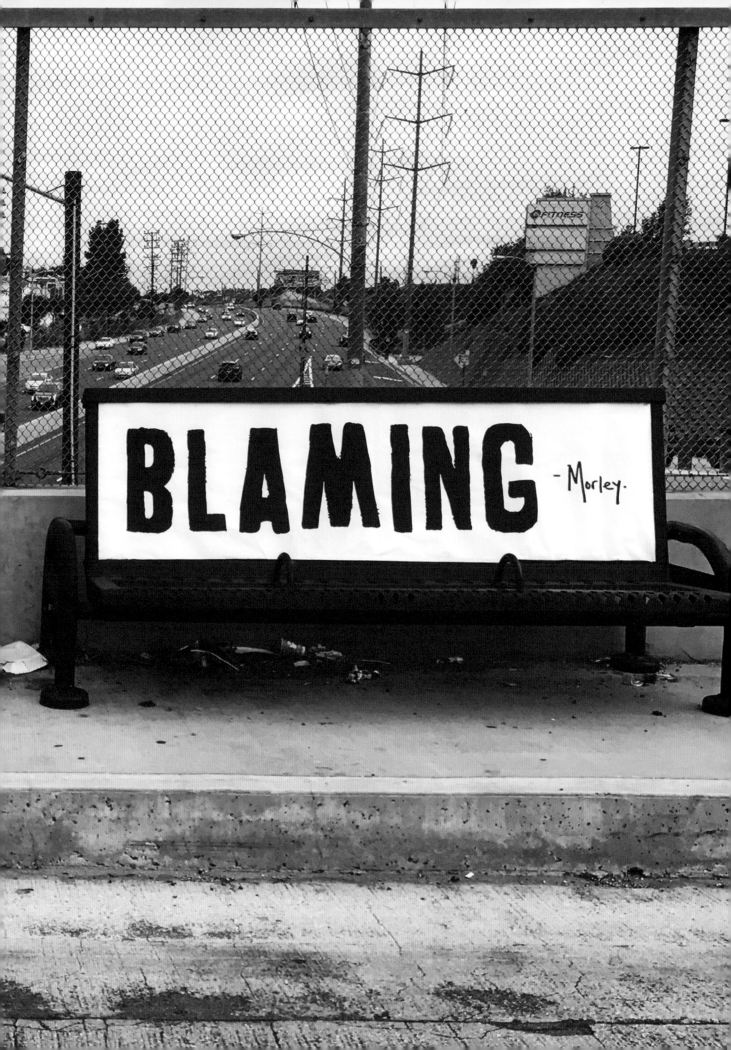

California
General
Election

323

Dean C. Logan
Los Angeles County
Registrar-Recorder/County Clerk

OFFICIAL

Official Sample Ballot
General Election
November 8, 2016

Polls open at 7 am and close at 8 pm

I ONLY REGRET
THE DECISIONS
I WASN'T
STRONG
ENOUGH
TO MAKE

— Morley.

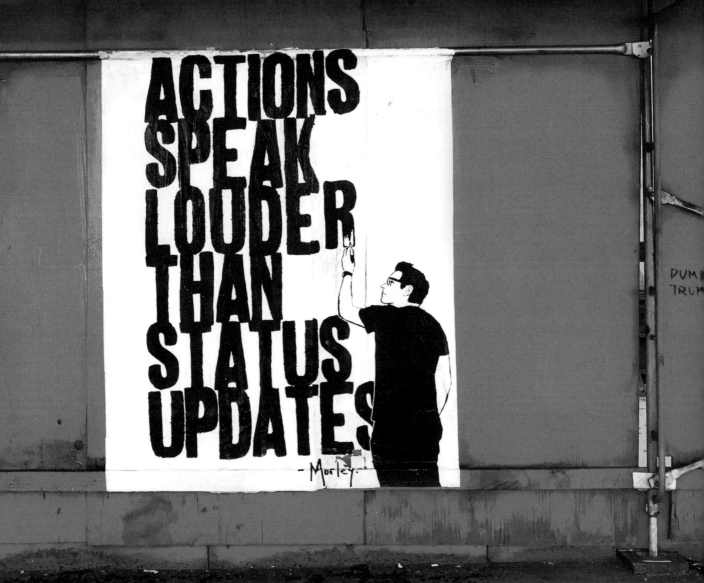

STREET POLITICS

It has been a soft rule for me to avoid overtly political messages in my work. There are a few reasons for this. Primarily because there are so many other street artists who tackle the subject matter, and, while some do it well, the jokes about those whose messages lack any intellectual nuance are innumerable, and who needs one more "bumper sticker" political statement? Secondly, as my creative focus has always steered toward the human emotional experience, I've rarely felt convicted to create art that added to the ever-widening political divide. I'm a big believer in the importance of voting in both national and local elections, and I'm passionate about progressive politics, but I generally keep my preferences separate from the art that I'm pasting into some stranger's life.

Then the 2016 presidential election happened and for me, the emotional and the political became more difficult to untangle. It became important for me to look back and know that I wasn't simply passive. In the weeks and months that followed, I must have made a dozen signs to carry at protests and tried to align myself with organizations that could combat a regressive agenda. To many, I'm sure these statements were more of the "bumper sticker" variety, but being able to look back and find proof that I spoke out, even in small ways, seems worth a few eye rolls.

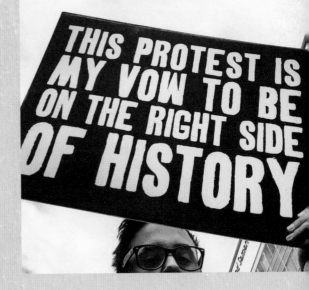

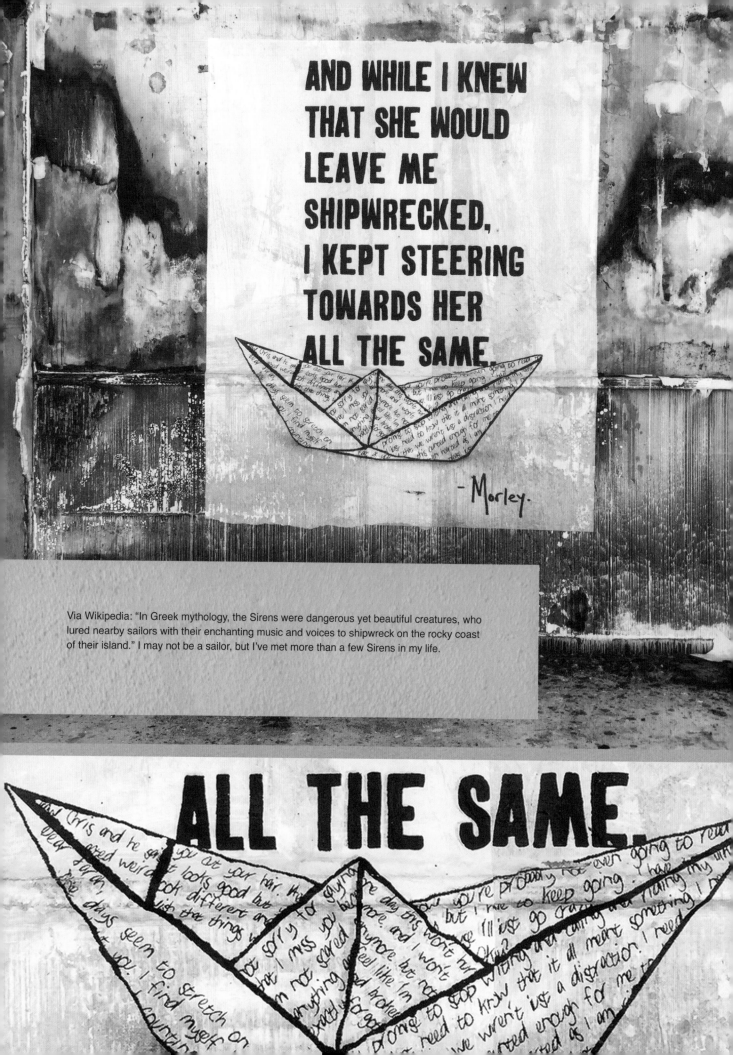

AND WHILE I KNEW THAT SHE WOULD LEAVE ME SHIPWRECKED, I KEPT STEERING TOWARDS HER ALL THE SAME.

— Morley.

Via Wikipedia: "In Greek mythology, the Sirens were dangerous yet beautiful creatures, who lured nearby sailors with their enchanting music and voices to shipwreck on the rocky coast of their island." I may not be a sailor, but I've met more than a few Sirens in my life.

ALL THE SAME.

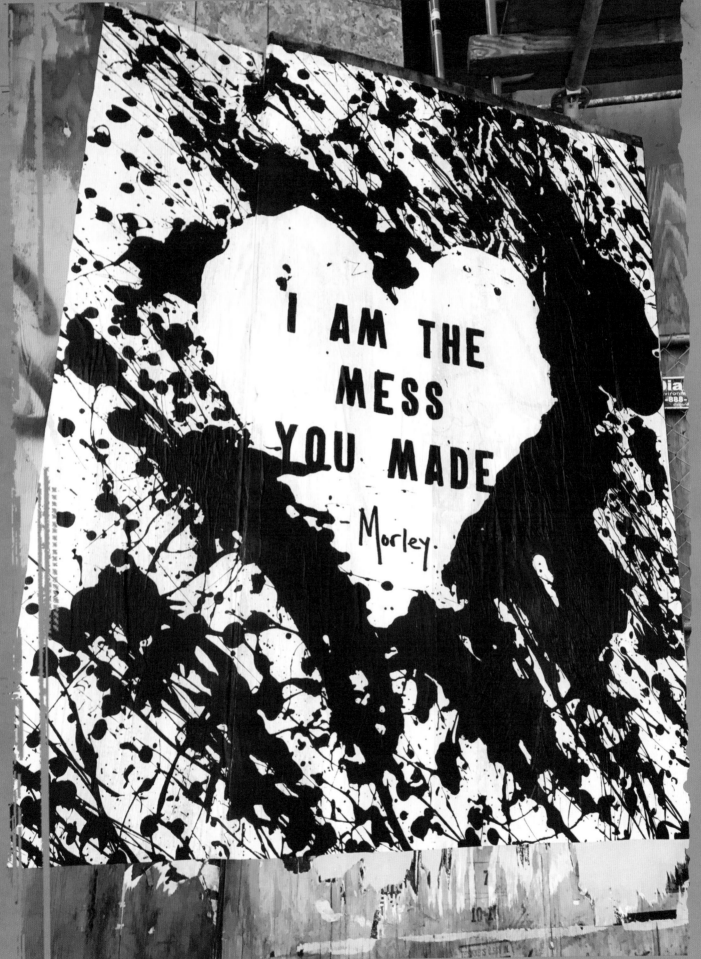

EPHEMERA

It's a challenge to continually expand the way people experience my art. If you become too familiar with a voice, it can start to fade into the background noise. With that in mind, I try to come up with different methods of injecting a message into the world.

I printed up some 4-x-2-inch cards and visited shops around LA, quietly sticking them into the stores' stacks of business cards. Discovery among a crowd is what this slogan is all about, so it seemed fitting.

I made temporary tattoos and left little stacks at tattoo parlors around the city, next to the ever-present flyers for concerts and head shops.

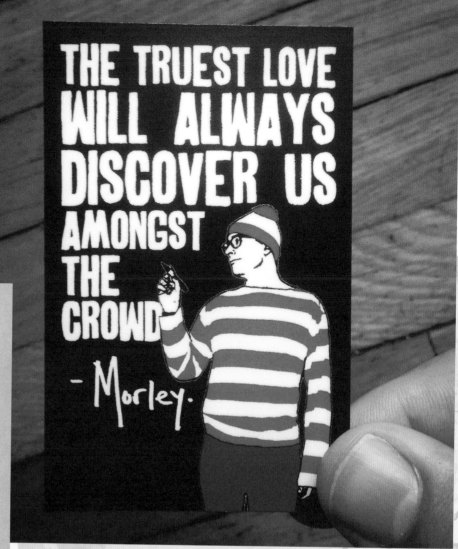

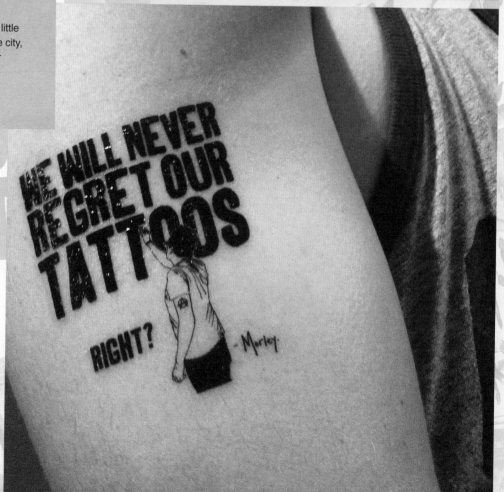

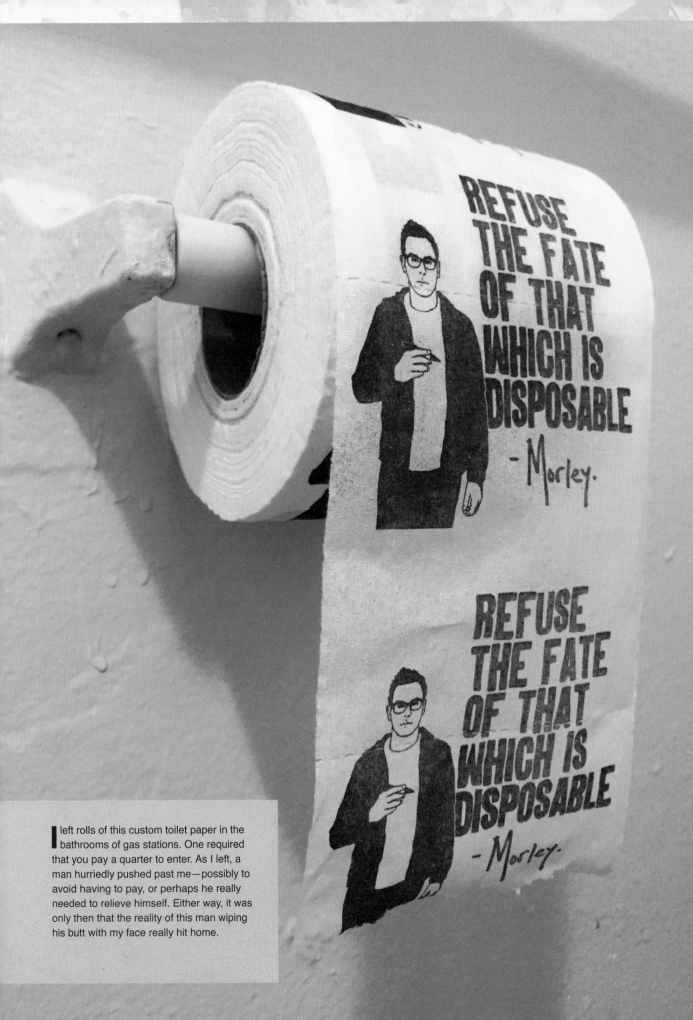

I left rolls of this custom toilet paper in the bathrooms of gas stations. One required that you pay a quarter to enter. As I left, a man hurriedly pushed past me—possibly to avoid having to pay, or perhaps he really needed to relieve himself. Either way, it was only then that the reality of this man wiping his butt with my face really hit home.

PAPER PLANES

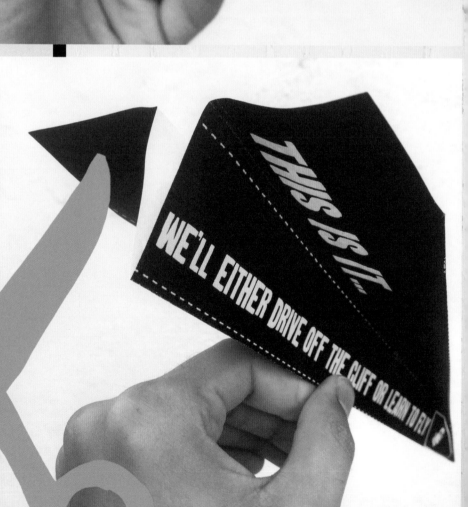

...DRIVE OFF THE CLIFF OR LEARN TO FLY

THIS IS IT...

WE'LL EITHER DRIVE OFF THE CLIFF OR LEARN TO FLY

FOLD 1

FOLD 2

FOLD 6

FOLD 7

FOLD 5

Morley.

WE'LL EITHER DRIVE OFF THE CLIFF OR LEARN TO FLY

WE'LL EITHER DRIVE OFF THE CLIFF OR LEARN TO FLY

WE'LL EITHER DRIVE OFF THE CLIFF OR LEARN TO FLY

WE'LL EITHER DRIVE OFF THE CLIFF OR LEARN TO FLY

FOLD 3

FOLD 4

THIS IS IT...

THIS IS IT...

I was invited to bedeck the windows of the Museum of Broken Relationships in Hollywood. This is a unique museum that is filled with the submitted relics from the wreckage of past relationships. I felt this piece was appropriate not only for a window, but specifically for *this* window.

In life, there are times we discover ourselves the victim of heartbreak. Sometimes we will, knowingly or unknowingly, be the cause of the damage.

And sometimes we are simply called to be the one who helps sweep up.

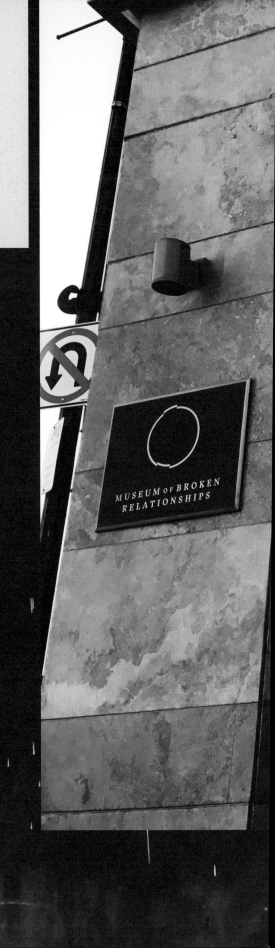

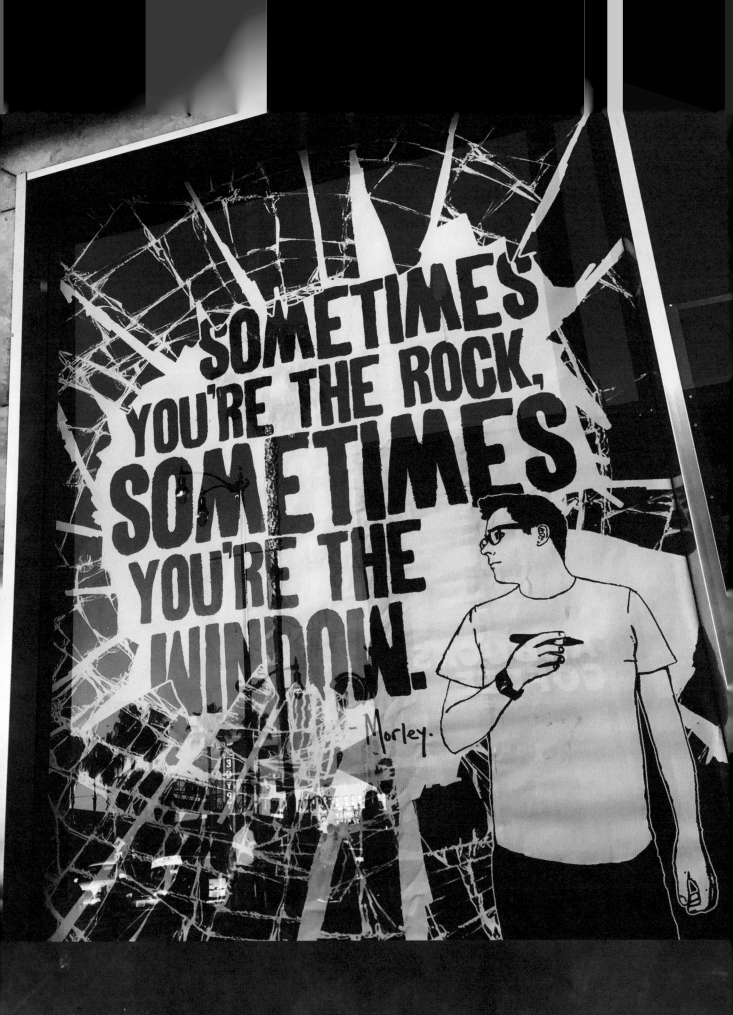

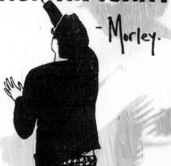

FROM
UP THERE
EVERYTHING
SEEMS SO
INSIGNIFICANT

— Morley.

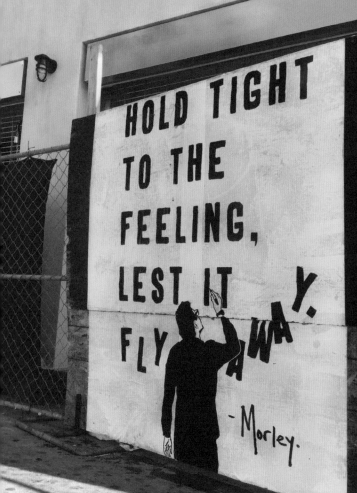

HOLD TIGHT
TO THE
FEELING,
LEST IT
FLY AWAY.

— Morley.

Cynicism creates a ceiling,
a limit to what's possible.
But maybe the meager limits
of someone else's hope is
just the beginning of yours.
Maybe what they call a
ceiling, you call a floor.

MAYBE WHAT THEY
CALL A CEILING
YOU CALL A
FLOOR

— Morley.

THE LIGHTS BLURRED,
THE CHOIR SANG,
TIME DRIPPED
DOWN THE WALL
INTO A PUDDLE
AT MY FEET,
AND I LOOKED UP,
AND THERE YOU WERE.

— Morley.

NO
TRESPASSING
VIOLATORS
WILL BE
PROSECUTED

BUT LITTLE DID HE KNOW THAT A DAY WOULD COME
WHEN HE WOULD UNCOVER A PURIFYING CLARITY.
BURIED SOMEWHERE DEEP WITHIN HIMSELF.
WHEN HE WOULD BE MORE THAN THE SUM
OF APPLAUDED BOWS HE'D ACCUMULATED.
MORE THAN THE SUM OF SECONDS HELD CAPTIVE IN AWKWARD SILENCE.
WHEN HE WOULD DISCOVER A MIND UNABLE TO RESTRAIN THE BEAUTY
OF THOUGHTS UNCOMPLICATED.
AND A STORY UNBURDENED BY THE LIMITS OF BOY. OF MAN.
WHEN HE WOULD REACH FOR THE SUN.
GRASP IT IN HIS PALMS AND CRUSH IT INTO A BILLION STARS
TO DRIFT LAZILY FROM HIS FINGERS WITH THE BREEZE.
WHEN HE WOULD STAND LIKE SOMEONE'S ANCIENT MYTH.
WOVEN AND PASSED DOWN BY CALLOUSED. WRINKLED HANDS.
AND HE WOULD LOWER HIS EYES.
AND HE WOULD CLENCH HIS FISTS.
AND HE WOULD LET HIS LIGHTENING
ILLUMINATE THE SKY.

— Morley.

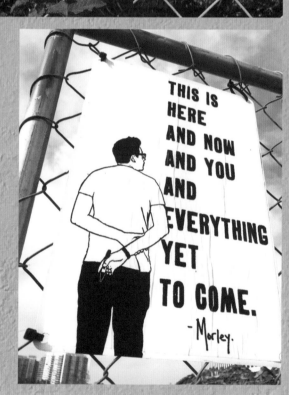

THIS IS
HERE
AND NOW
AND YOU
AND
EVERYTHING
YET
TO COME.

— Morley.

"THE WIDE WORLD
IS ALL ABOUT YOU:
YOU CAN FENCE
YOURSELVES IN,
BUT YOU CANNOT
FOREVER FENCE
IT OUT."

— J. R. R. TOLKIEN

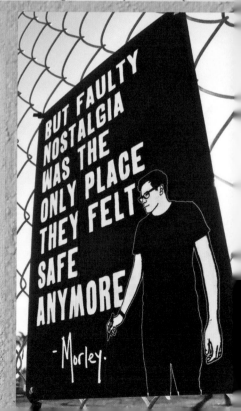

BUT FAULTY
NOSTALGIA
WAS THE
ONLY PLACE
THEY FELT
SAFE
ANYMORE

— Morley.

LET ME KNOW
IF YOU EVER
FIGURE US OUT

— Morley.

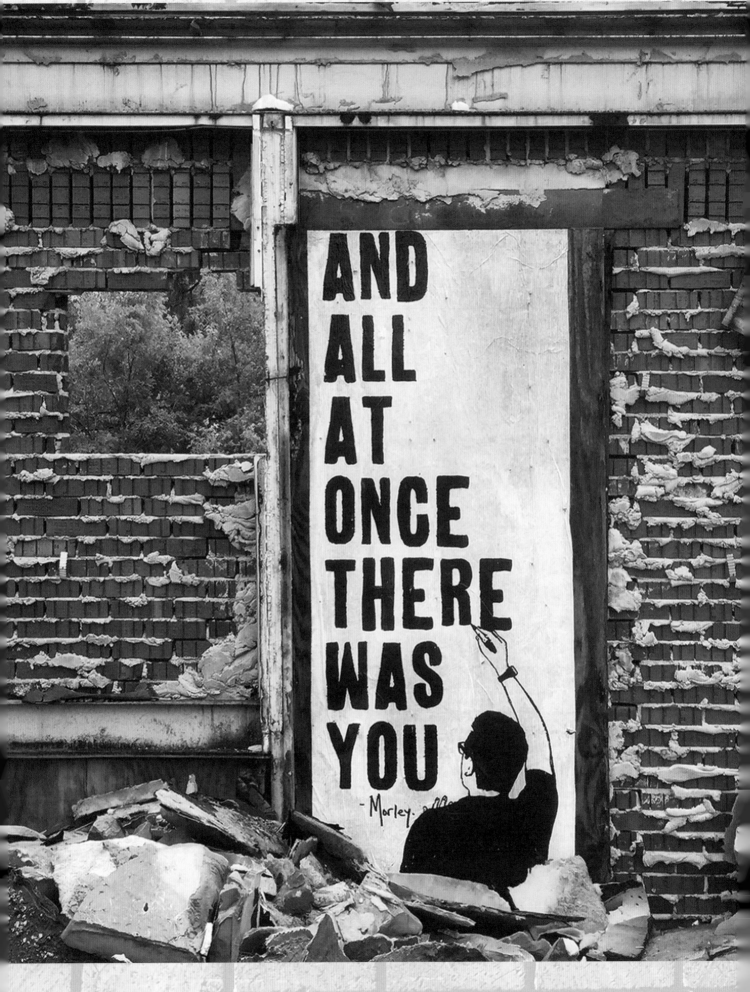

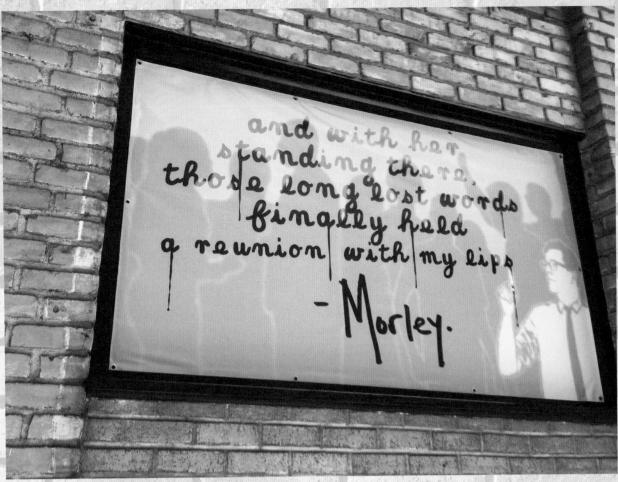

and with her
standing there,
those long lost words
finally held
a reunion with my lips

— Morley.

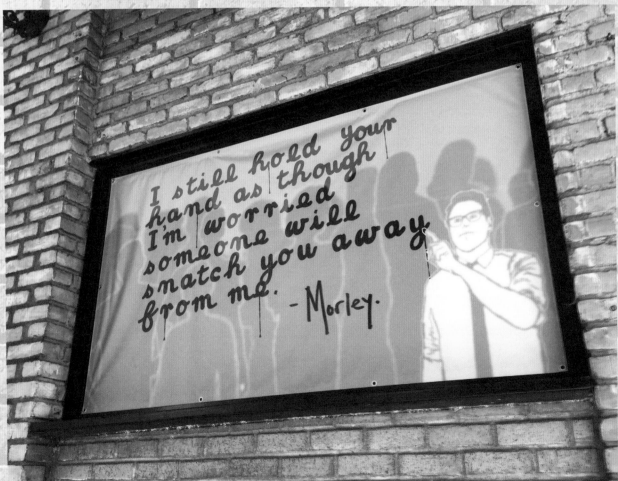

I still hold your
hand as though
I'm worried
someone will
snatch you away
from me.

— Morley.

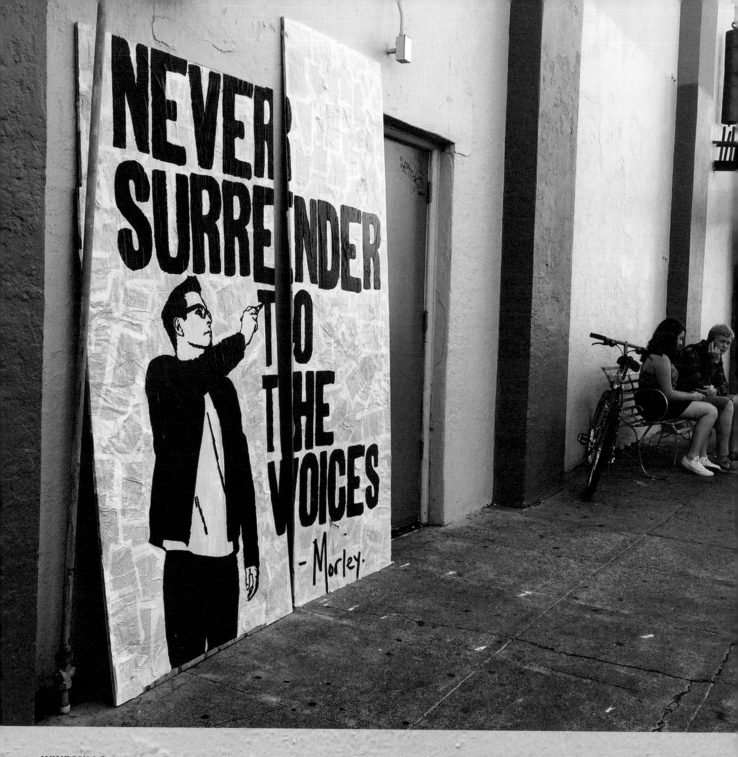

WINDMILLS

One of the first stops on the book tour I went on for the release of my last book was in Petaluma, California. While I was there I had a little event at a local theater where people were encouraged to help me collage pages of Miguel de Cervantes' *Don Quixote* into this piece, which was pasted on some scrap wood.

People of all ages lent a hand, and the young ones were especially happy to get dirty with the paste. It reminded me of a study I read in which researchers visited schools across America. They started with kindergarten classes. They asked the class to raise their hand if they were artists. Nearly the entire class raised their hands. Then they went to the first graders and had nearly the same response,

save a few. Then they went to the second graders where a few less raised their hands. In third grade fewer kids raised their hands, and fewer in forth grade, and so on, until they reached high school where almost none of the kids raised their hands.

As we get older we become more and more susceptible to the follow-the-crowd mind-set, to fit in, to fall in line or be exiled to the far reaches of the cafeteria. My hope is that maybe the kids that took part in this project will take the advice of the piece they helped create. And if they don't listen to me, maybe something they saw on the pages of *Don Quixote* will stick in their minds as well as they made it stick to that wood.

Like an old bike in the garage,
take it out for a spin.

BLOW
THE
DUST
OFF
YOUR
SOUL

- Morley.

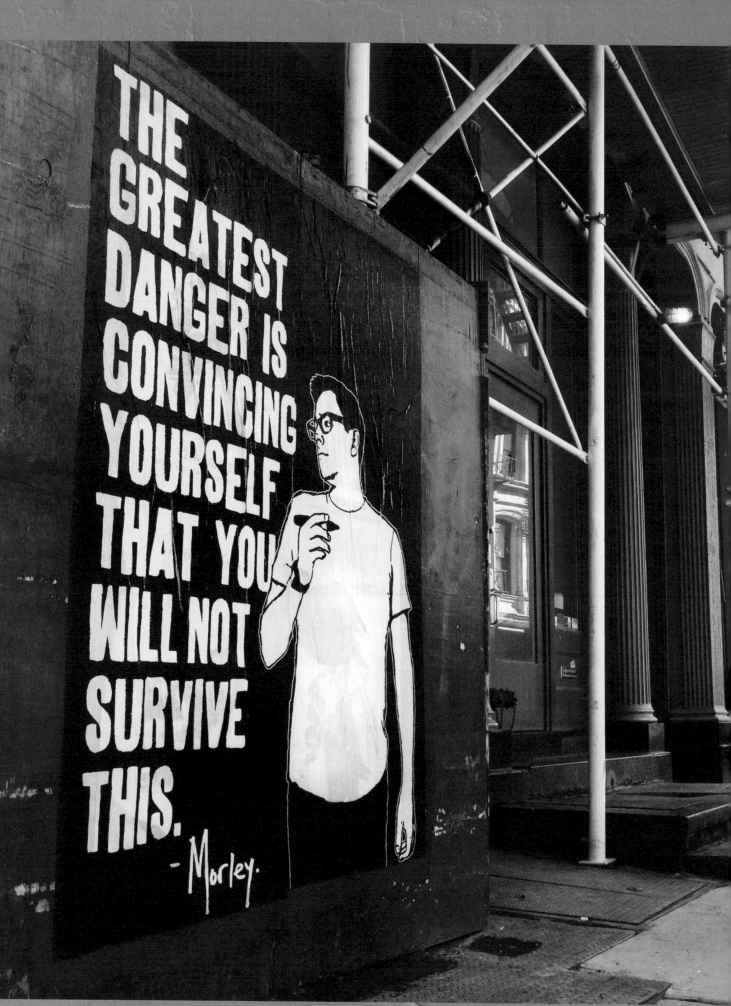

BLOCKBUSTED

The first job I got after I graduated college was as a clerk at Blockbuster Video. This was a taste of the kind of glamorous opportunities an art school degree would afford me. The fact that Blockbuster was even still in business dates this story; it was 2004 and I was twenty-two. The first week of employment was set aside for training. I would shadow a worker who knew the different aspects of the job and try my best to keep up. Most of the jobs were not difficult—stocking, cleaning, taking out the trash, etc.—but there was one task I had trouble with . . . the actual renting of the movies. The problem was the computer.

The systems were these old DOS-style antiques. Every task required a series of numbers and key codes typed in; there wasn't a mouse, just key commands that were in no way self-explanatory. I did okay if someone was standing next to me, guiding me through it—or if I could take ten minutes and use the note pad where I had written down the series of inputs required to access someone's account. Unfortunately, this was back in the day when Blockbuster had lots of customers, many of whom would become angry if they had to wait on the slowed pace of a new hire. They would complain if I took too long or had to start over when I became confused trying to rush through the transaction. Looking back now it seems silly, but at the time, it was pretty stressful for me. I began to psyche myself out. "I'm never going to get this," I thought. "I will NEVER figure out this computer system and I'm gonna get fired when the manager finds out."

But here's the thing. Eventually I did figure it out, and a month later it was me training some new guy how to use the computer. This is obviously a very common occurrence. You think you can't do something and eventually you figure it out. But because the time between worrying about it and figuring it out was so compressed, it gave me the proper perspective to see it more clearly. I could access the anxiety in my memory quite easily and the worry I felt was still vivid. The revelation wasn't so much that "if I could conquer the Blockbuster computer system, I could accomplish ANYTHING," as much as it was realizing that even awkward seasons pass. You get through them; even though you tell yourself "it will be like this forever!" you will eventually discover enough confidence to relax. So when I find myself in new and uncomfortable environments, I tell myself, "It's just the computer at Blockbuster, it's just the computer at Blockbuster."

The trick is to know that there is a conclusion to every problem. For me, this poster is about reminding yourself of the old adage "this too shall pass" and that on the other side of it will be the people who stood with you. The people who walked through the tough seasons alongside you. The friends and family that talked you down and reassured you. And you will be that for someone else at some point. And when you are, just remind them that "it's just the computer at Blockbuster. It's just the computer at Blockbuster."

But don't be surprised if most people respond with "what's a Blockbuster?"

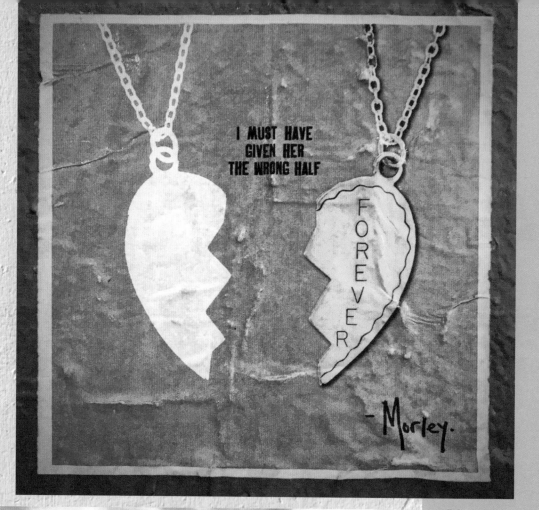

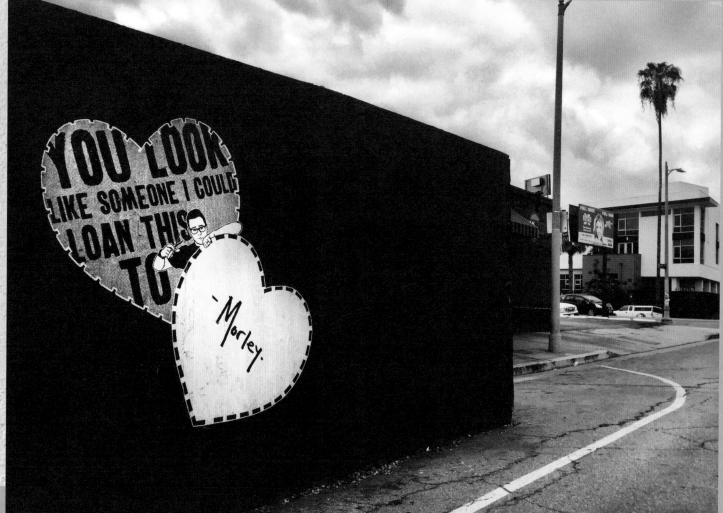

A piece for the Mtl en Arts Festival in Montreal. Translated, it says:
"Let's Fall in Love Like Both Our Parents Aren't Divorced."

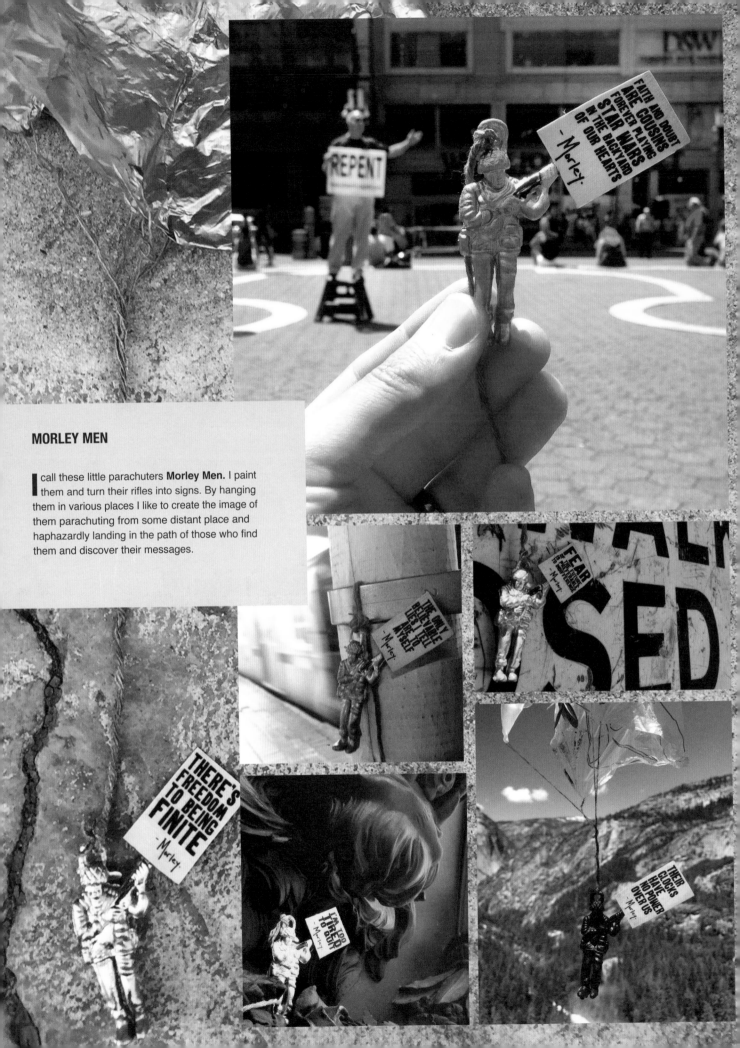

MORLEY MEN

I call these little parachuters **Morley Men.** I paint them and turn their rifles into signs. By hanging them in various places I like to create the image of them parachuting from some distant place and haphazardly landing in the path of those who find them and discover their messages.

FAITH AND DOUBT ARE COUSINS FOREVER PLAYING STAR WARS IN THE BACKYARD OF OUR HEARTS
— Morley

THE ONLY BELIEVABLE LIES I TELL ARE TO MYSELF
— Morley

FEAR
— Morley

THERE'S FREEDOM TO BEING FINITE
— Morley

I'M TOO TIRED TO QUIT
— Morley

THEIR CLOCKS HAVE NO POWER OVER US
— Morley

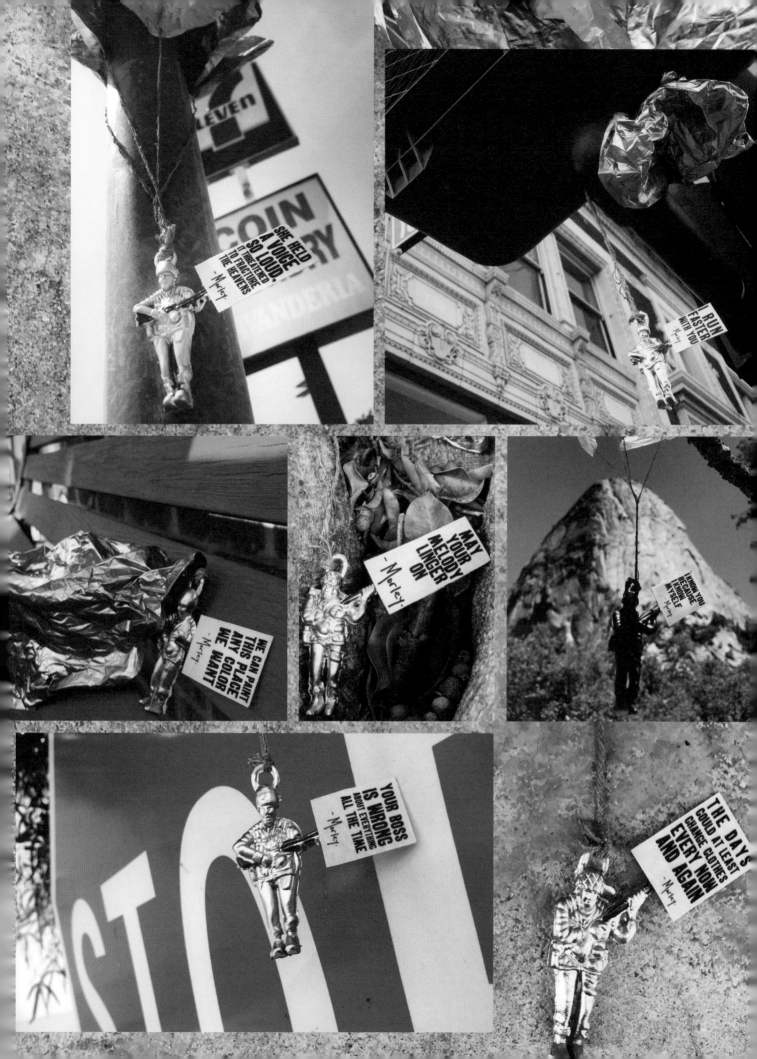

ON THE OTHER SIDE
OF A THOUSAND
MILES OF
MEDIOCRITY
IS THE
DRINKING FOUNTAIN
OF GREATNESS

- Morley

You can love something dearly and still need to scream curse words into a pillow every now and then.

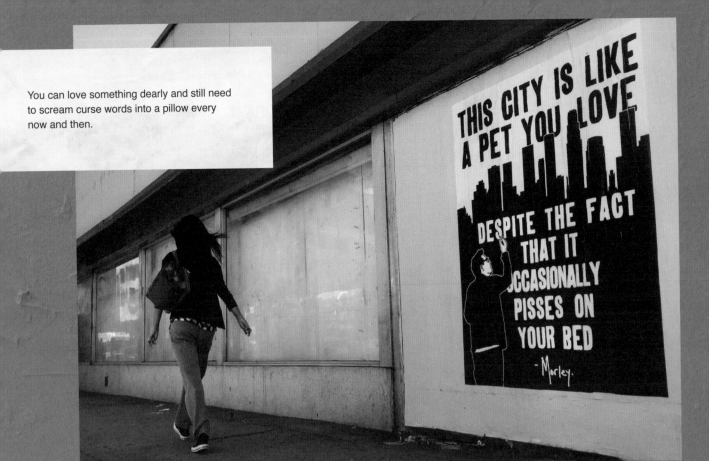

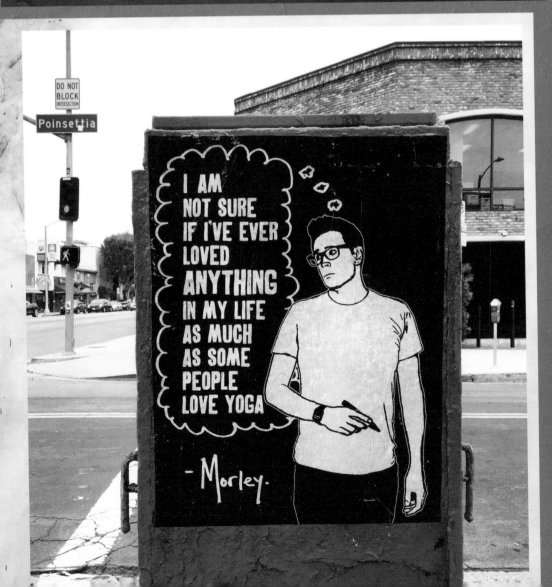

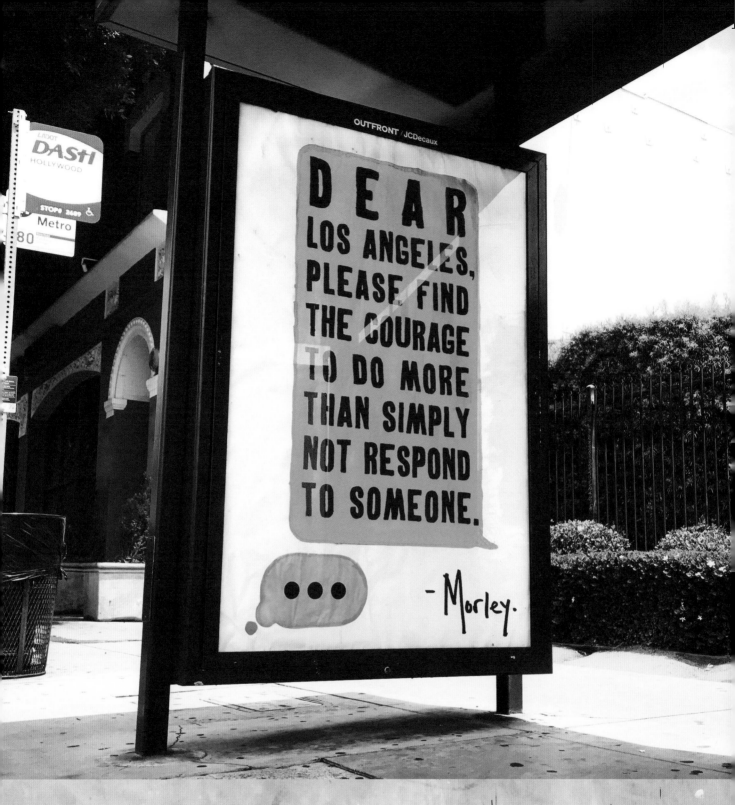

GHOST STORIES

Ghosting is one of the most infuriating social behaviors of my generation. The notion that simply not responding to someone is an acceptable way to communicate "no thanks" is absurd. In Los Angeles it seems to be a particularly malignant problem. Let's respect each other enough to know that we can handle hearing "You seem like a great girl/guy, but I don't really feel a connection" or "Hey, thanks for inviting me, but I won't be able to make it" or "Sorry, we went in another direction" or even "Sorry, I'd help you move but I just really don't feel like it." I feel like we all would rather hear NO than silence. Because silence is just NO without common courtesy. You're not saving anyone the pain of rejection—you're telling them they're not even worthy of your rejection. That you would rather simply forget they even exist—which is much more cruel in my mind.

Let's all be big boys and girls and just be honest with one another and simply say "no thanks."

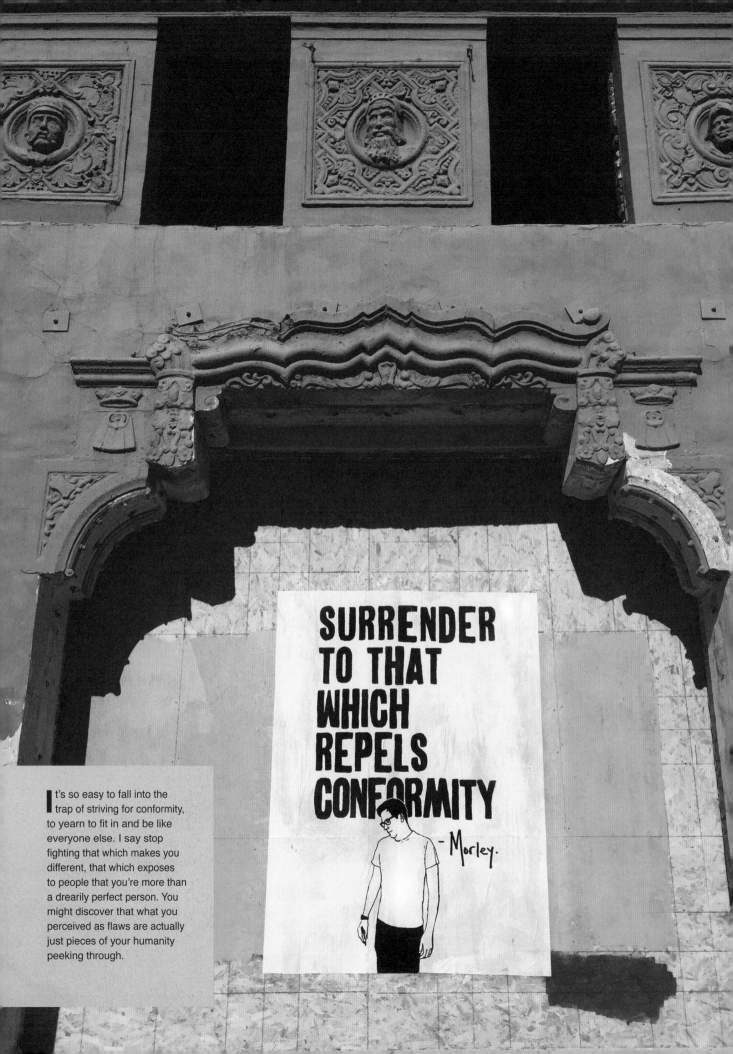

SURRENDER
TO THAT
WHICH
REPELS
CONFORMITY

- Morley.

It's so easy to fall into the trap of striving for conformity, to yearn to fit in and be like everyone else. I say stop fighting that which makes you different, that which exposes to people that you're more than a drearily perfect person. You might discover that what you perceived as flaws are actually just pieces of your humanity peeking through.

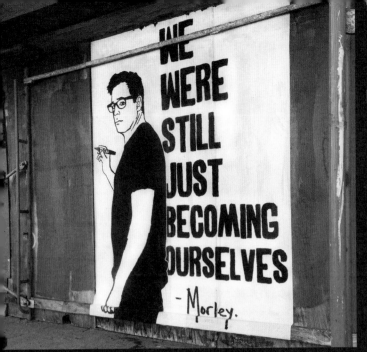

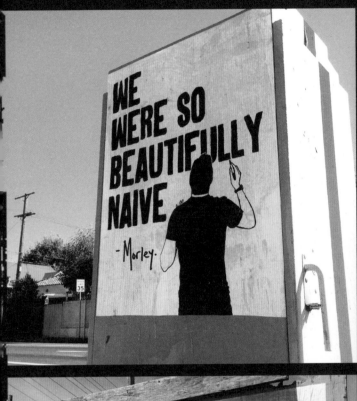

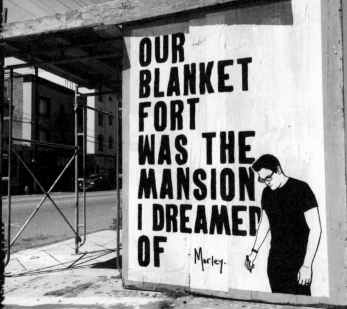

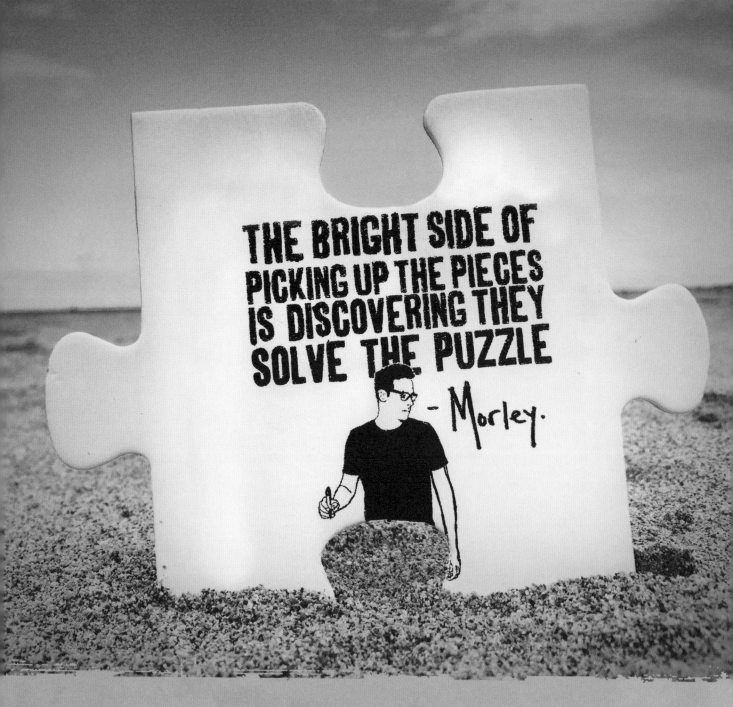

THE BRIGHT SIDE OF PICKING UP THE PIECES IS DISCOVERING THEY SOLVE THE PUZZLE

— Morley.

PIECED TOGETHER

It is possible to discover a lone inkling of solace when sifting through the rubble of a hope dashed or a love lost, and it is the chance to start anew. To face the freedom of infinite possibilities beyond the buildings we'd built to hold our hopes and dreams and say, "Maybe this time I'll build something different." After all, a wrecking ball isn't just the end of one dream, but the destroyer of the dormant and abandoned. A tool to lay waste to the uninhabitable so that something stronger may one day stand in its place.

Though we may find ourselves surveying the damage to our hearts, there's something dormant in the debris.

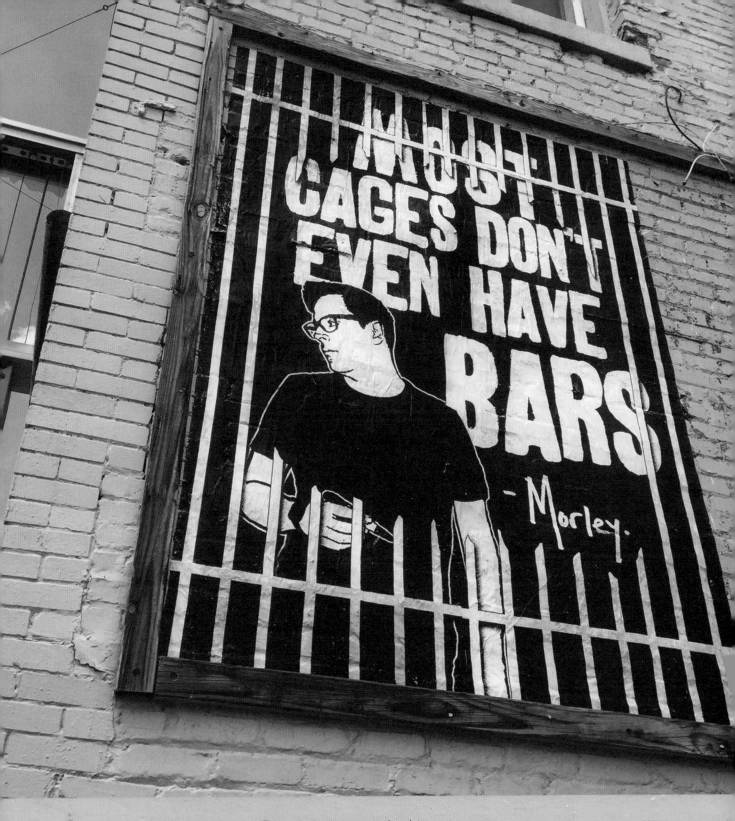

MOST CAGES DON'T EVEN HAVE BARS

— Morley.

Sometimes we turn ourselves into prisoners. We build our cell out of the things we've done, things we refuse to do, a pain we can't let go of, or bad choices we continue to make. But every day you're up for parole and every day you can leave your cage behind.

IN THAT MOMENT I KNEW
THAT MY DAYS WERE YOURS TO
LITTER
ACROSS WHATEVER
STREETS AND HIGHWAYS
YOU DARED
TRAVERSE

- Morley.

You always were a litterbug.

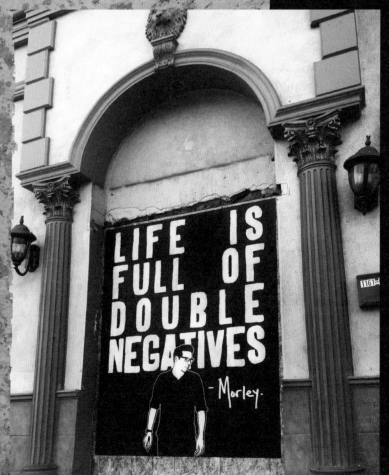
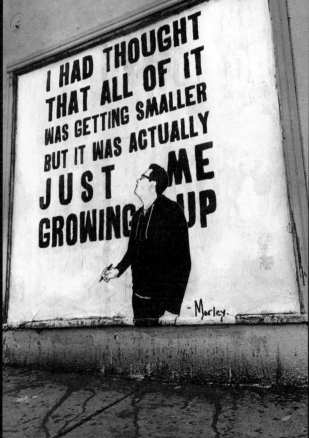

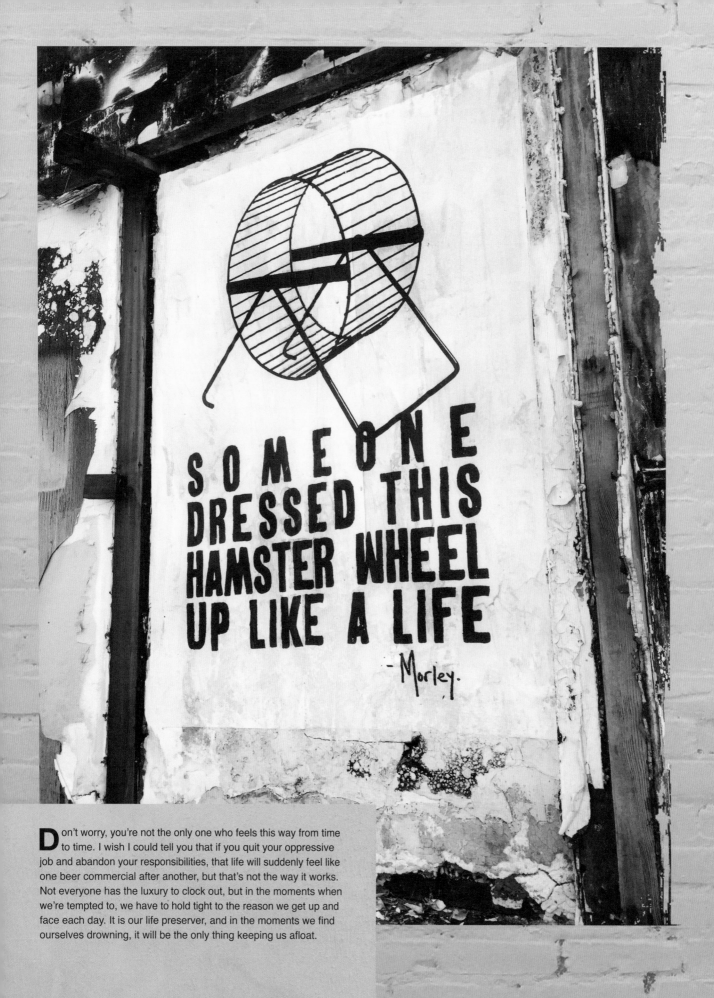

SOMEONE DRESSED THIS HAMSTER WHEEL UP LIKE A LIFE

-Morley.

Don't worry, you're not the only one who feels this way from time to time. I wish I could tell you that if you quit your oppressive job and abandon your responsibilities, that life will suddenly feel like one beer commercial after another, but that's not the way it works. Not everyone has the luxury to clock out, but in the moments when we're tempted to, we have to hold tight to the reason we get up and face each day. It is our life preserver, and in the moments we find ourselves drowning, it will be the only thing keeping us afloat.

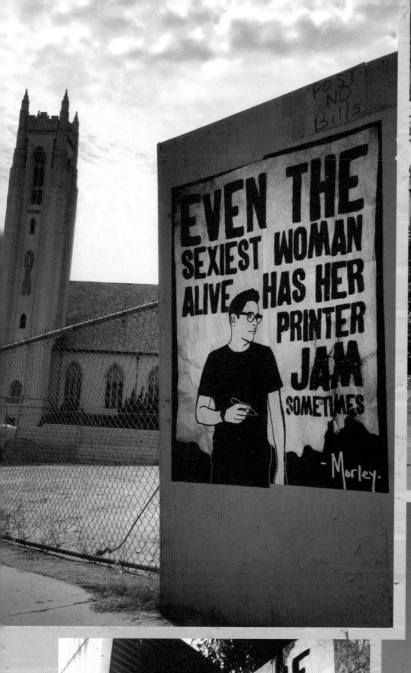

EVEN THE SEXIEST WOMAN ALIVE HAS HER PRINTER JAM SOMETIMES

— Morley.

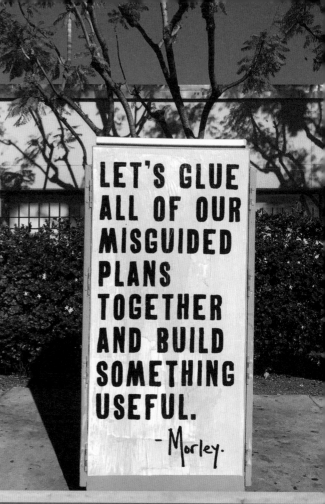

LET'S GLUE ALL OF OUR MISGUIDED PLANS TOGETHER AND BUILD SOMETHING USEFUL.

— Morley.

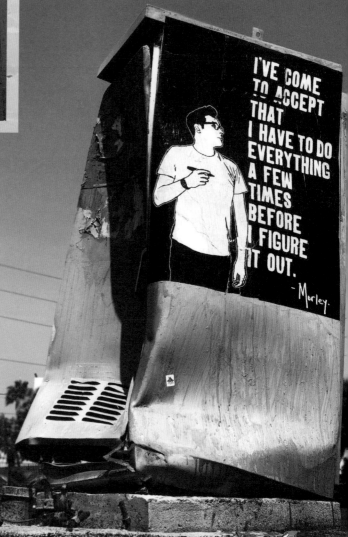

I'VE COME TO ACCEPT THAT I HAVE TO DO EVERYTHING A FEW TIMES BEFORE I FIGURE IT OUT.

— Morley.

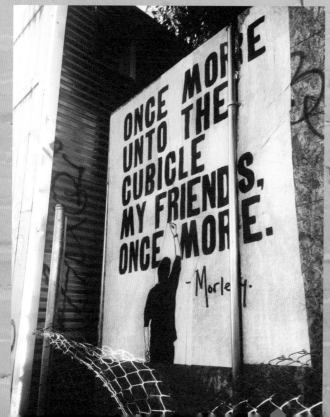

ONCE MORE UNTO THE CUBICLE MY FRIENDS, ONCE MORE.

— Morley.

PLEASE HOLD

This piece included an interactive sound element. I picked up this motion-activated speaker and recorded an automated system telling me to "please remain on the line," and whenever someone walked past the piece, the little voice would sputter forth its mind-numbing promise. As for the meaning of the piece, it's about those seasons in life when you just feel like life is on hold.

When you're waiting for some specific aspect of life to change so it can move forward . . . it can have that same feeling of tedium as when you're waiting to speak to a person on the phone who can fix a problem. Some have mercifully short spans of this. Others may be in the midst of that kind of season right now. I always just remind myself that the most important thing is to always be grateful and live in the present and know that no matter how long it stretches, eventually the awful muzak will end.

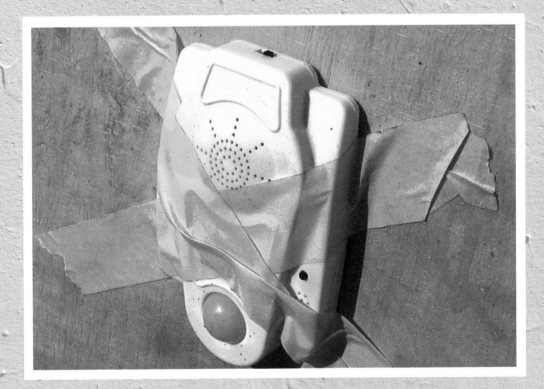

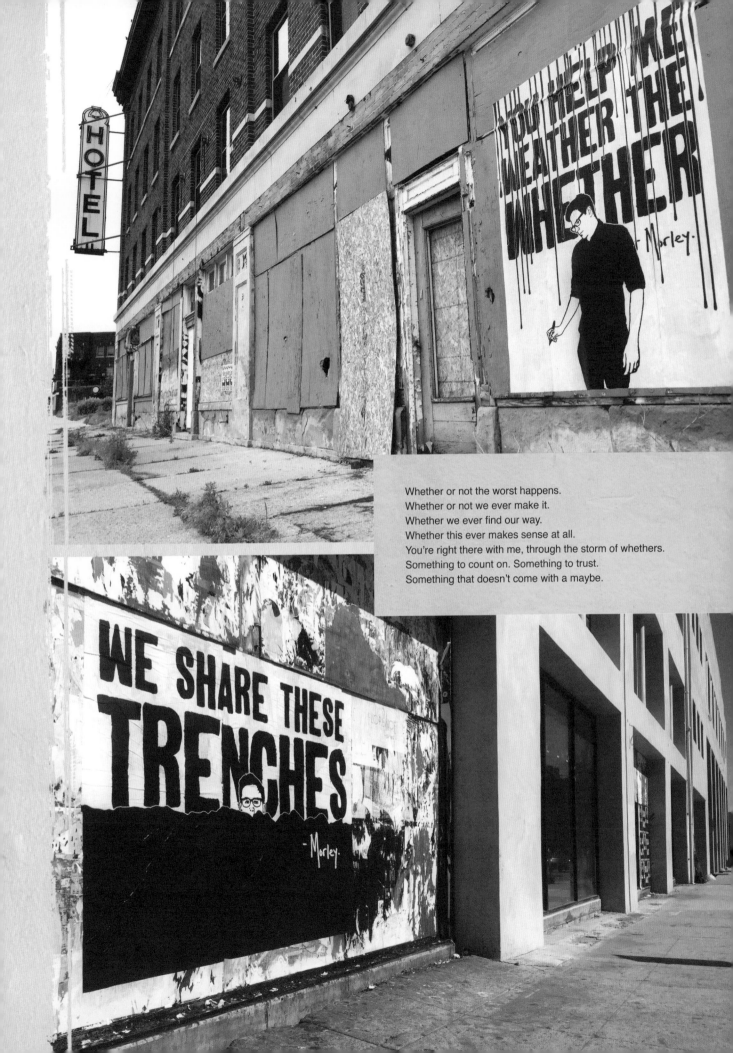

Whether or not the worst happens.
Whether or not we ever make it.
Whether we ever find our way.
Whether this ever makes sense at all.
You're right there with me, through the storm of whethers.
Something to count on. Something to trust.
Something that doesn't come with a maybe.

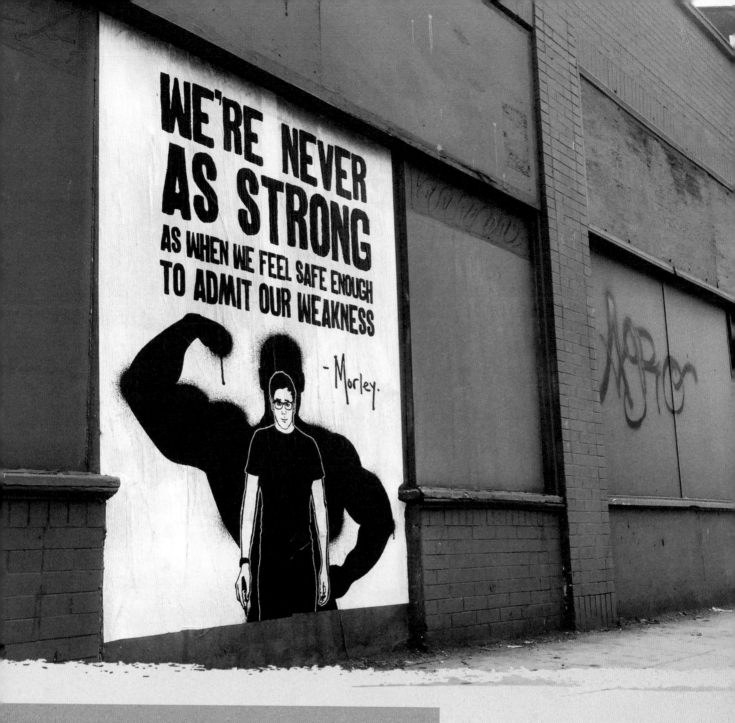

STRENGTH IN NUMBERS

It's a gift when you find the people for whom you don't have to be strong. The people that you can be vulnerable with, that you can be honest about what you struggle with, that you can cry with, that you can mourn with, that you can be angry with. The ones that don't scare easy and run away when they discover who you really are. The ones that you can finally just stop holding a pose for. The ones that pick you up when you've fallen, dust you off, and help you get your stride back. These are the people who make us strong, because we know they still love us despite all of the occasions when we're not.

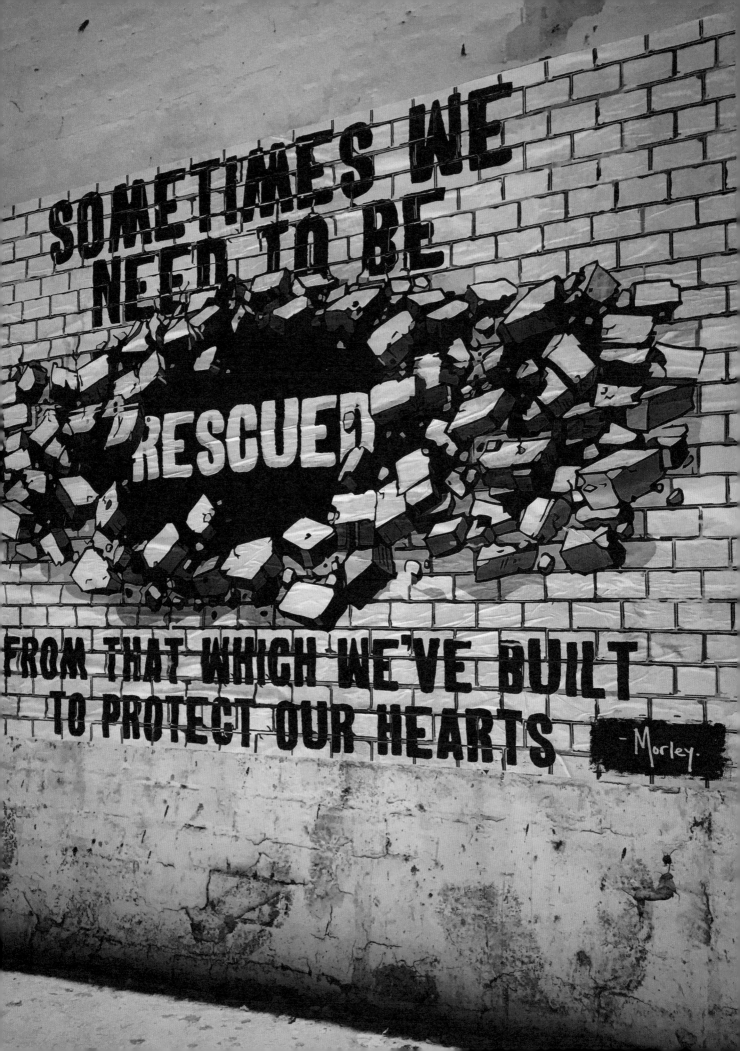

LITTLE DID I KNOW
THAT SHE WOULD BE
MY GREATEST ADVENTURE
-Morley.

LET'S PLAN OUR ESCAPE
FROM THIS MOOD
-Morley.

WHY ARE WE STILL WAITING
FOR OUR LIVES
TO START? -Morley.

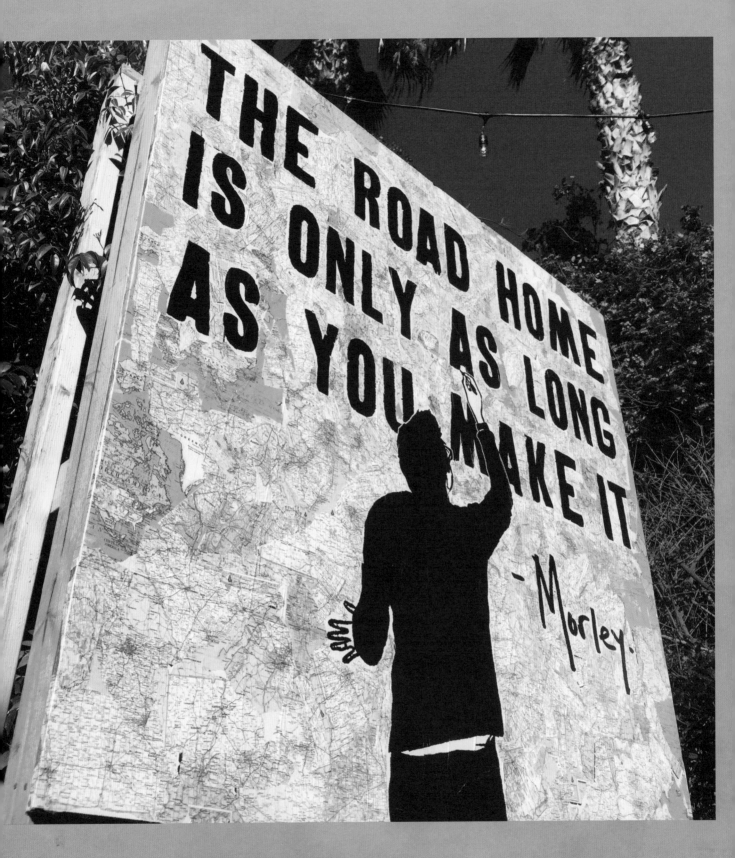

At an event, I invited people to participate in this piece by tearing a map from a stack of atlases I brought; the map was to be of a place that had some personal significance and they could collage it into the piece. The sentiment refers to the idea that any place can be called home, because home is where you make it.

The minute we met I knew you were the one who I wanted to remind me to call my Dad on his birthday

— Morley

YOU LOOK
LIKE THE
RIGHT
KINDA
TROUBLE
— Morley.

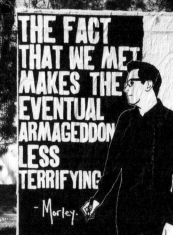

THE FACT
THAT WE MET
MAKES THE
EVENTUAL
ARMAGEDDON
LESS
TERRIFYING
— Morley.

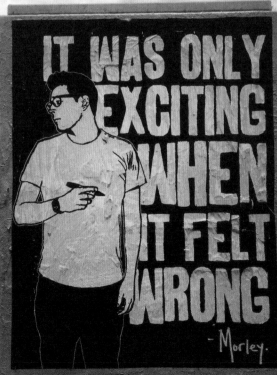

IT WAS ONLY
EXCITING
WHEN
IT FELT
WRONG
— Morley.

AMERICAN

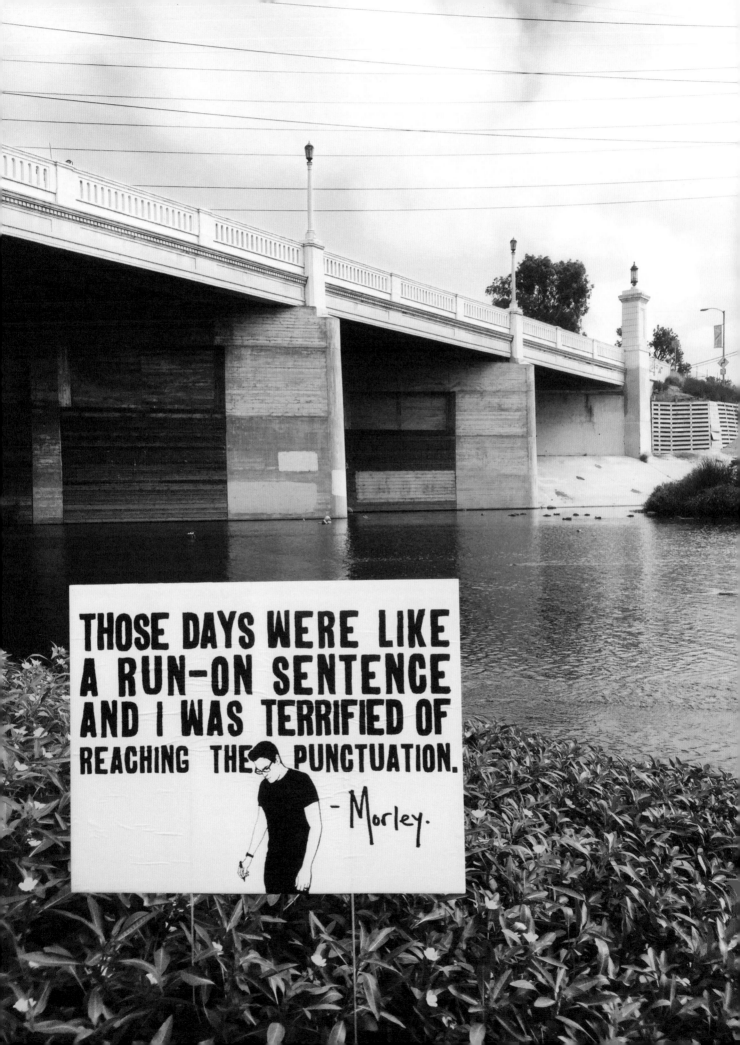

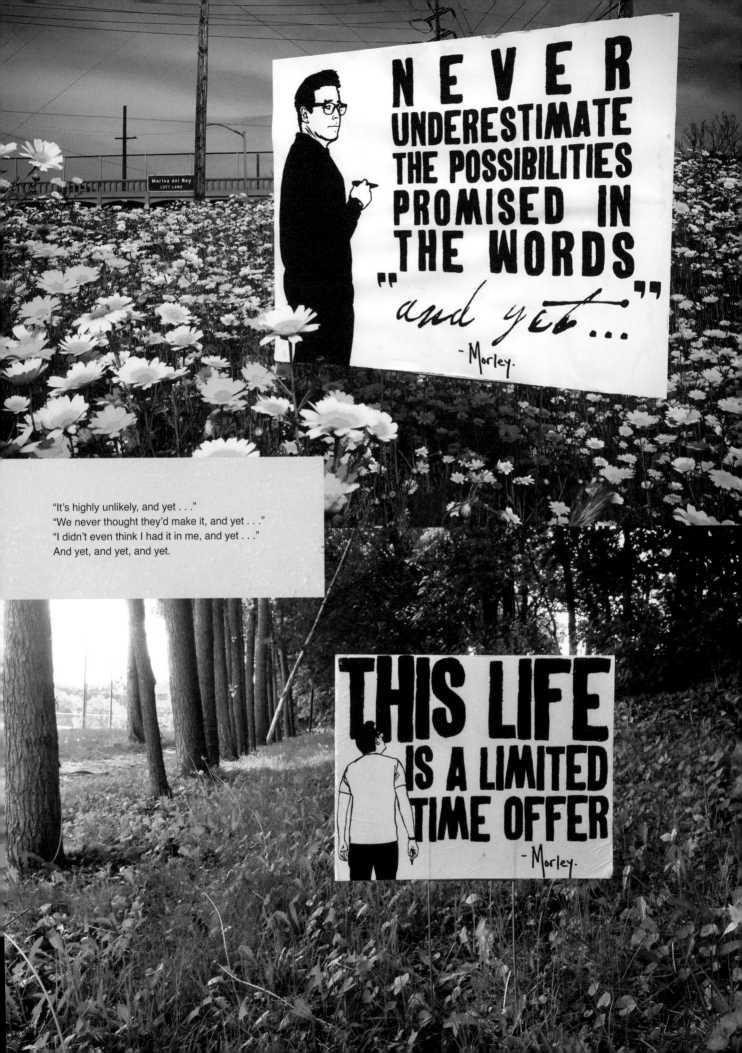

"It's highly unlikely, and yet . . ."
"We never thought they'd make it, and yet . . ."
"I didn't even think I had it in me, and yet . . ."
And yet, and yet, and yet.

IN CASE OF EMERGENCY

THAT WHICH UNLOCKS

A PREVIOUSLY UNKNOWN
BRAVERY

- Morley.

BREAK
GLASS

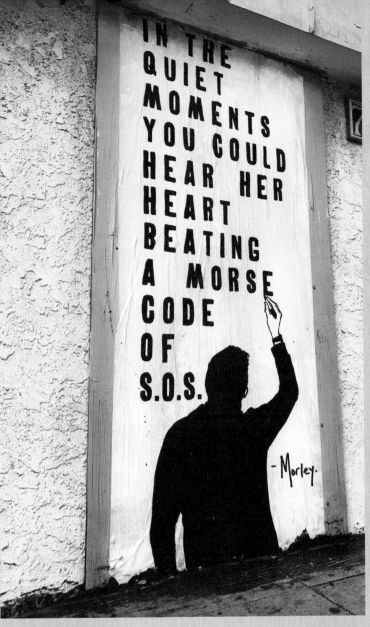

IN THE
QUIET
MOMENTS
YOU COULD
HEAR HER
HEART
BEATING
A MORSE
CODE
OF
S.O.S.

—Morley.

"A PLACE BELONGS FOREVER
TO WHOEVER CLAIMS IT HARDEST,
REMEMBERS IT MOST OBSESSIVELY,
WRENCHES IT FROM ITSELF, SHAPES
IT, RENDERS IT, LOVES IT SO
RADICALLY THAT HE REMAKES
IT IN HIS OWN IMAGE."

—JOAN DIDION

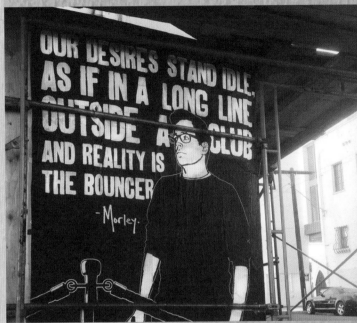

OUR DESIRES STAND IDLE,
AS IF IN A LONG LINE
OUTSIDE A CLUB
AND REALITY IS
THE BOUNCER

—Morley.

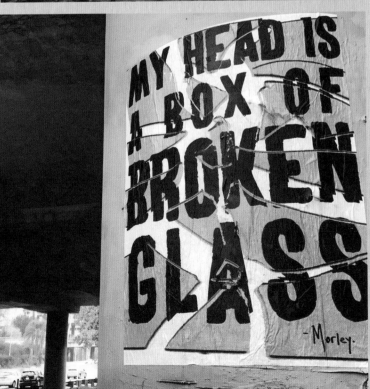

MY HEAD IS
A BOX OF
BROKEN
GLASS

—Morley.

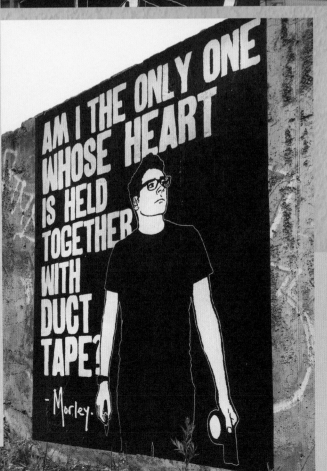

AM I THE ONLY ONE
WHOSE HEART
IS HELD
TOGETHER
WITH
DUCT
TAPE?

—Morley.

MORLEY VOUCHERS!

CUT THEM OUT!
GIVE THEM AWAY!

THIS CARD IS GOOD FOR THE RIGHT GIRL,
THE RIGHT SONG AND THE RIGHT FEW SECONDS.

THIS CARD IS GOOD FOR ONE EX-BOYFRIEND/GIRLFRIEND
WHO WILL SPEND THE REST OF HIS/HER LIFE
REGRETTING LETTING YOU GO.

THIS CARD IS GOOD FOR ONE GAME OF CHECKERS
WHERE I PROMISE TO MOVE MY BACK ROW OF GUYS.

THIS CARD IS GOOD FOR ONE INSTANCE
WHERE I DON'T HAVE TO CORRECT YOU
ABOUT SOMETHING THAT'S
NOT EVEN IMPORTANT.

THIS CARD IS GOOD FOR ONE MOMENT OF
CONFIDENCE IN THE FACE OF REJECTION.

THIS CARD IS GOOD FOR ONE BATHROOM
IN A DESPERATE MOMENT.

THIS CARD IS GOOD FOR
THE SMALLEST GLIMMER OF SOMETHING
DIFFERENT ON THE HORIZON.

THIS CARD IS GOOD FOR
ONE PERSON WHO JUST GETS IT.

THIS CARD IS GOOD FOR ONE
SLOW-MOTION STRUT.

THIS CARD IS GOOD FOR
THE STRENGTH TO LET GO.

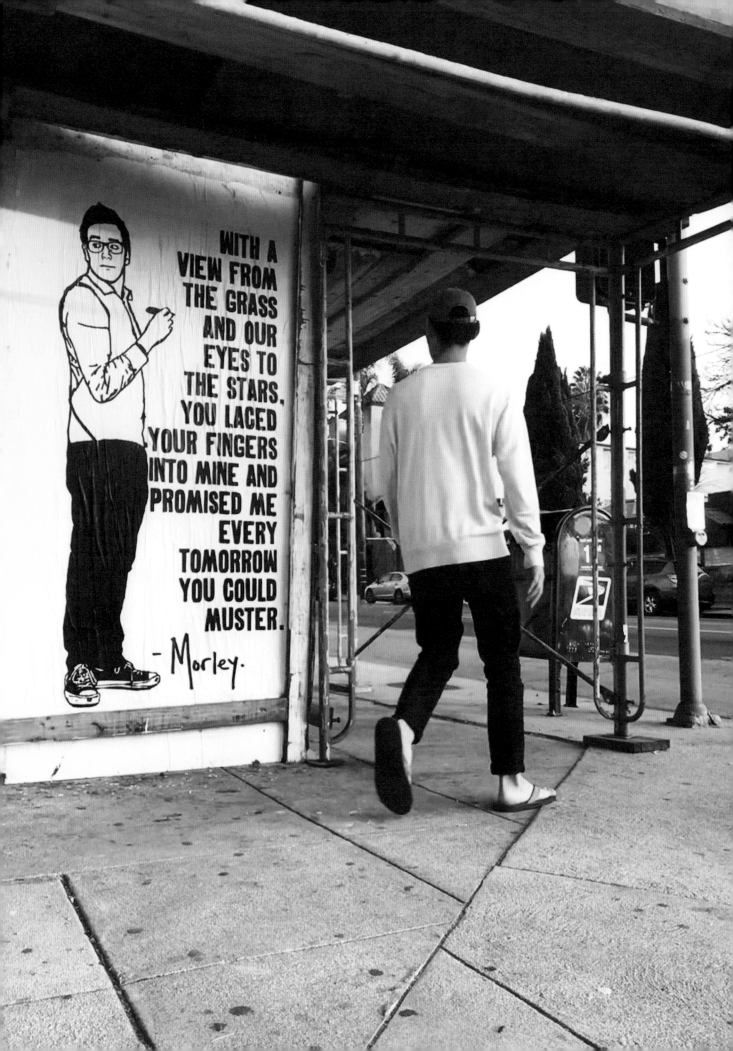

WITH A VIEW FROM THE GRASS AND OUR EYES TO THE STARS, YOU LACED YOUR FINGERS INTO MINE AND PROMISED ME EVERY TOMORROW YOU COULD MUSTER.

- Morley.

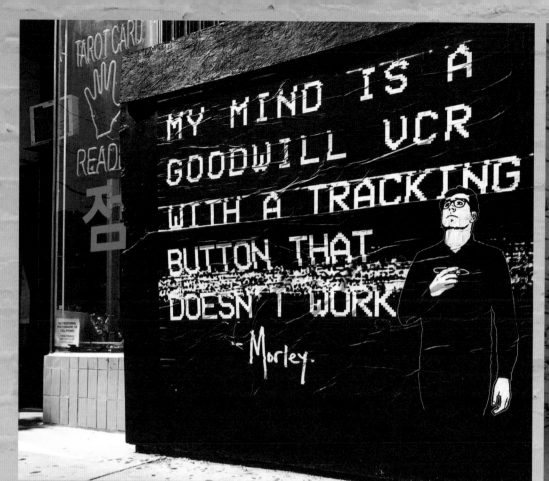

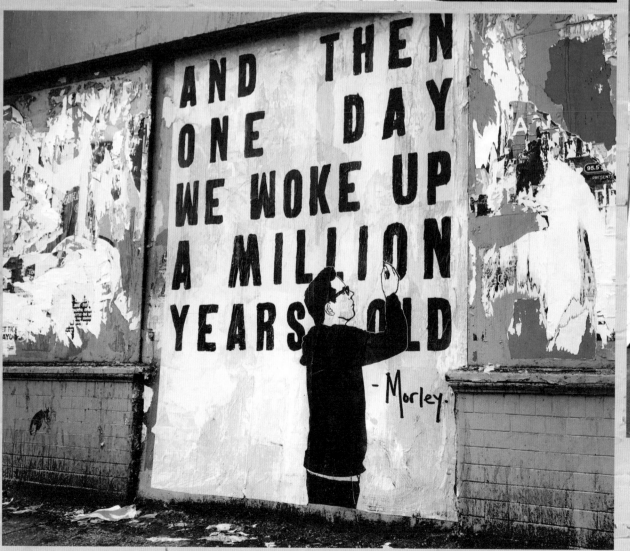

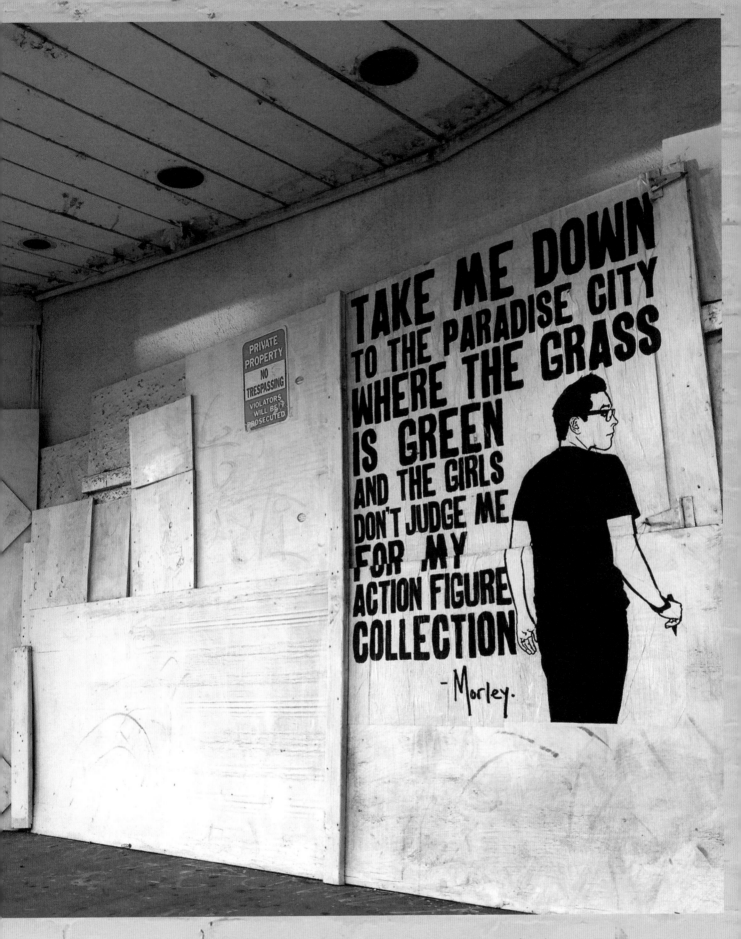

I am who I am. If you prick me, do I not bleed? If you break my Hawkman from the 1984 Kenner "Super Powers" line, do I not cry like a small child? Yes . . . Yes I do.

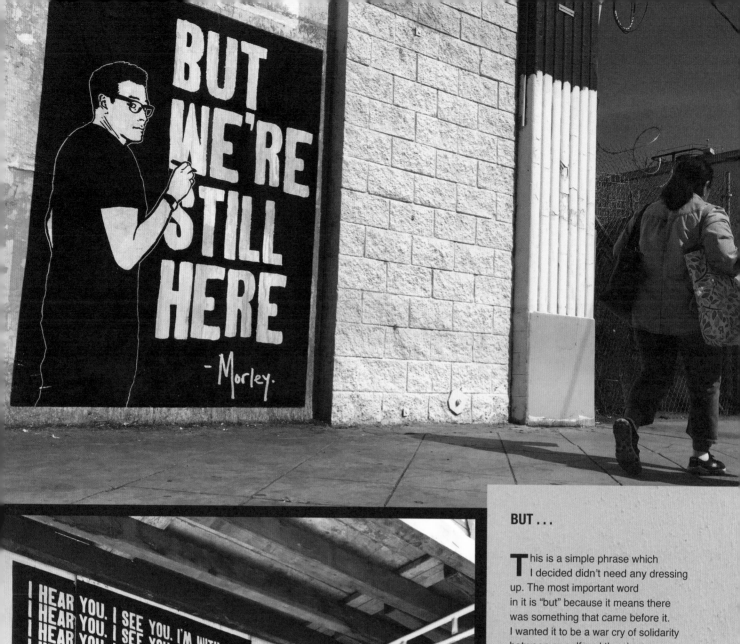

BUT . . .

This is a simple phrase which I decided didn't need any dressing up. The most important word in it is "but" because it means there was something that came before it. I wanted it to be a war cry of solidarity between myself and the viewer.

We may have had our hearts broken . . . but we're still here.

We may have faced countless rejections while chasing our dreams . . . but we're still here.

We may struggle to fight debilitating depression, loneliness, or a frayed sense of identity . . . but we're still here.

It could be anything. What's most important to remember is that you're still here, I'm still here, we're still here.

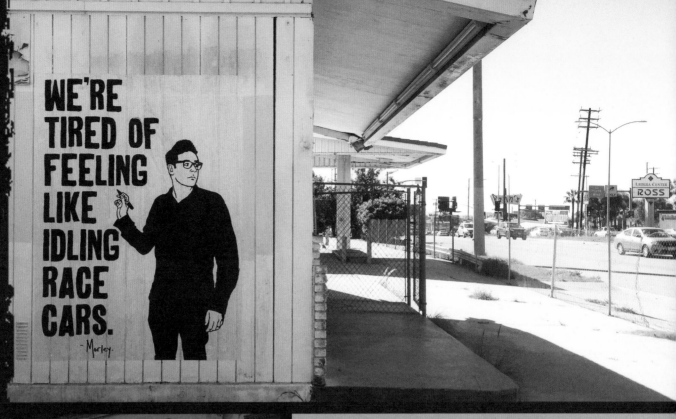

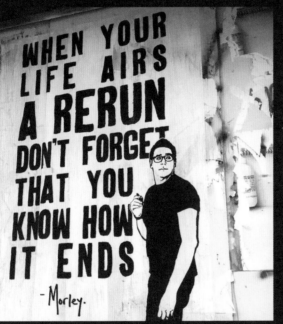

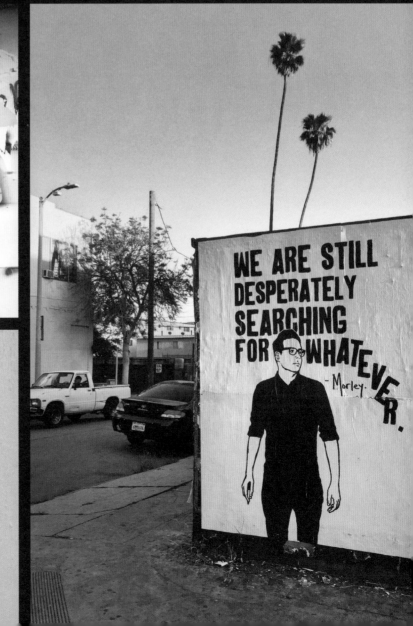

One of the existential dilemmas of modern man comes from the fact that we long for a feeling that masquerades as a goal. We think we're chasing a goal, but when we attain it, we discover we don't feel the sense of validation, satisfaction, comfort, security, or accomplishment that we'd hoped for, so we simply move on to the next thing, assuming that IT will be the thing that fulfills us.

Eventually we burn ourselves out as we're struck with the cold, hard reality of how unsatisfying accomplished aspirations can be. But until that moment comes, we keep chasing those fleeting moments of joy, the inevitable fade, the reassessment, the new goal, and the new chase. Finding a balance between our drive to succeed and our inability to find a sense of contentment within the moment we inhabit is one of the most difficult challenges we face in life.

LET'S
LIGHT UP
THE
DARK

-Morley·

In 2015, the artist Will Teran carved a series of pumpkins celebrating street art for the *Rise of the Jack O' Lanterns* event at Descanso Gardens. I was honored to have one of my pieces be among the pumpkins that referenced the scene. I contacted Will and asked if he would carve me a pumpkin the following year. He agreed and I sent him this design. The man is a veritable surgeon with pumpkins.

WE THE PEOPLE

In July of 2016, I was approached by Smirnoff Vodka. They asked me to create an art project that was in some way interactive and in some way promoted inclusivity. While initially hesitant to work with a corporation, I was encouraged that they didn't seem to have any other agenda. They didn't give me any caveats or requirements for the art, just that they wanted to promote something positive.

The idea I pitched to them was a series of posters that were inspired by real people with real stories: at the bottom of each poster would be a link the public could follow to hear a person tell their story. With the 2016 presidential election looming, immigration was as hot a topic as ever, so the focus became the many diverse people who come to this country seeking the American dream, and their affected families.

I was excited to give a platform for these people to tell their stories and help humanize the subject for people. I wanted to help illustrate that immigrants are more than just a burdensome puck for use in political air-hockey, but living, breathing human beings. Thankfully Smirnoff simply wanted to empower me to do this and didn't impose anything beyond that goal. Could it be viewed as selling out to a corporation? Perhaps, but to me it offered a minority group the chance to be heard, and at the same time, took the space reserved for mainstream advertising and used it to do something edifying. It felt like something worth trying. Here are the posters and if you visit the following links, you can hear who inspired them. These posters were featured in Los Angeles, New York, Chicago, and Houston.

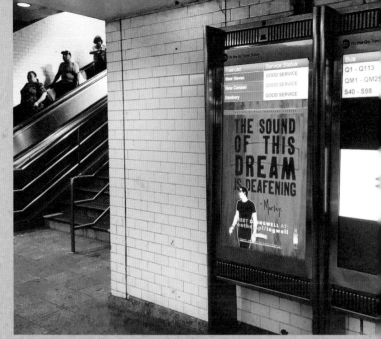

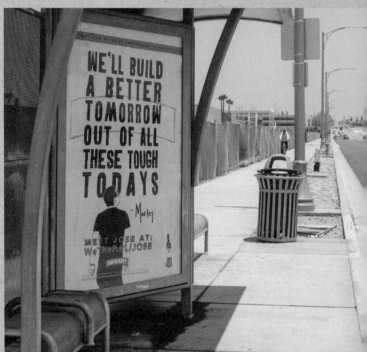

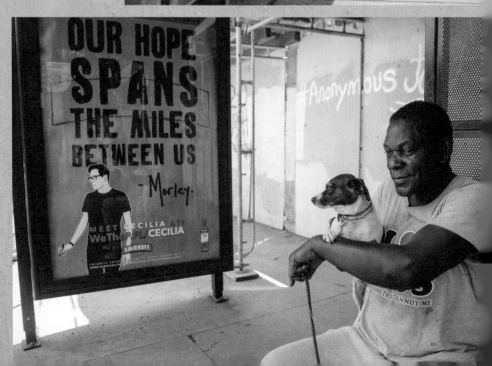

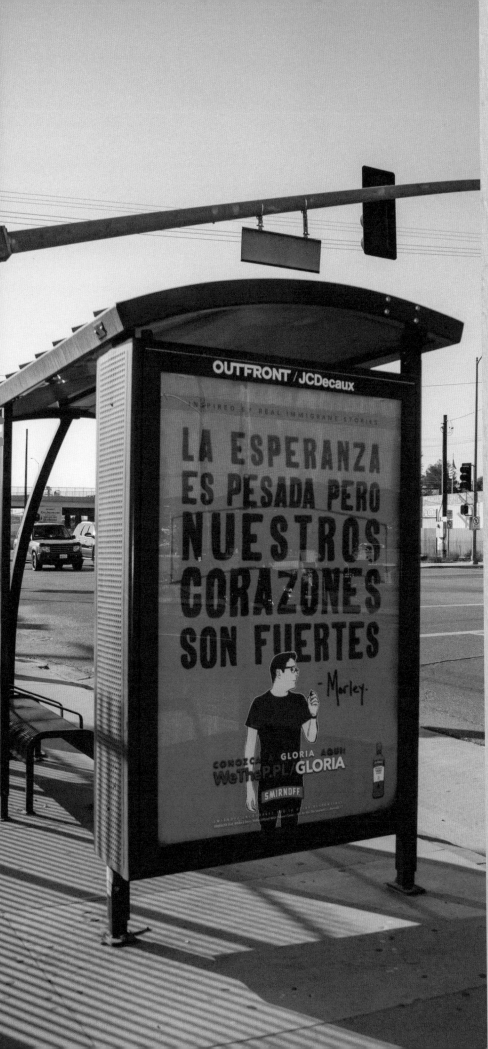

THE SOUND OF THIS DREAM IS DEAFENING
wethep.pl/djingwell

Growing up as the child of immigrants from the Philippines, DJ Ingwell always knew that he was different from most kids at his school. He discovered that music was a way he could express himself and find an identity that pushed beyond those differences. Today he's a successful DJ and producer.

OUR HOPE SPANS THE MILES BETWEEN US
wethep.pl/cecilia

Cecilia was only a sophomore in high school when her father was deported. It shook her family to the core and inspired Cecilia to study immigration law. As the first person in her family to go to and graduate college, she now works as an assistant to an immigration lawyer and hopes to one day reopen her father's case and make her family whole once more.

WE'LL BUILD A BETTER TOMORROW OUT OF ALL THESE TOUGH TODAYS
wethep.pl/jose

Fleeing El Salvador as a young man to escape the violence between the government and the guerrilla warfare rebellion, Jose left everything behind to start over in America. He worked tirelessly as a janitor, then a busboy, and now a barback. Raising his family with a strong emphasis on education, he is proud of what he has accomplished and the life he has built.

LA ESPERANZA ES PESADA PERO NUESTROS CORAZONES SON FUERTES
wethep.pl/gloria

When Gloria came to this country many years ago, she left behind a young daughter, knowing that taking her to America would prove difficult and dangerous. Nineteen years later, she hasn't seen her daughter since. Today she works tirelessly as a house cleaner to send money to her and give her a better life in Mexico, hoping that one day they will be reunited.

SOMETIMES HOME
ISN'T FOUND, IT'S EARNED
wethep.pl/jose

Growing up as an immigrant in Los Angeles, Jose's parents instilled in him a strong work ethic. As a child he would help his mother clean mansions in places like Beverly Hills and Brentwood, which gave him a sense of gratitude for a job that many of his peers never acquired. Today he's a barista at a coffee shop and encourages his coworkers to share his perspective toward hard work.

IN EVERY LIFE THERE'S A
BATTLE WORTH BELIEVING IN
wethep.pl/romben

Romben is an immigration lawyer who works to help keep immigrants from being deported as well as attain their citizenship. Growing up as the son of immigrants from the Philippines gave him an intimate understanding that many of his peers in law couldn't share. Today Romben strives to keep families together and create a law practice that his parents can be proud of.

DANCE ACROSS THE WORDS
THAT ONCE DEFINED YOU
wethep.pl/jm

JM grew up in an impoverished Hispanic community where he felt very constrained by the limitations, both economic and cultural, that it presented. Passionate about art and dance, he enrolled in a performing arts high school and discovered a vast and diverse world that lived beyond the community he grew up in. Today he's a professional dancer with the Los Angeles Contemporary Dance Company.

A DREAM UNTESTED
IS EASILY PUNCTURED
wethep.pl/victor

After his family fled the civil war of Nicaragua, Victor grew up noticing the differences between his family and the families of his friends. Discovering a passion in filmmaking, he now works to achieve a dream of his own despite the challenges that come with chasing it.

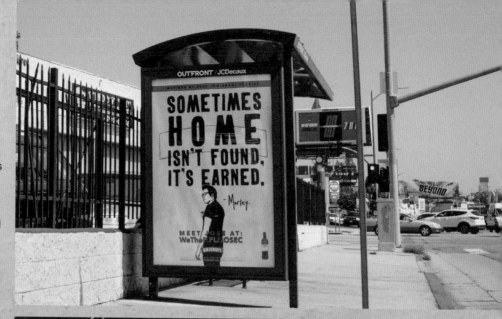

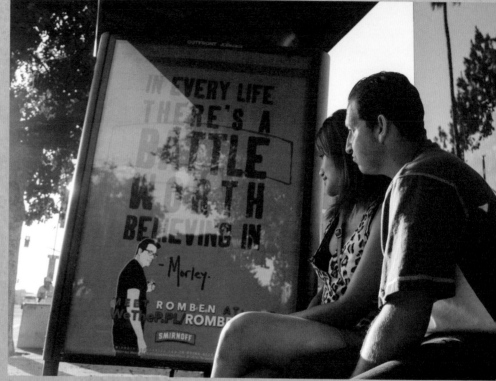

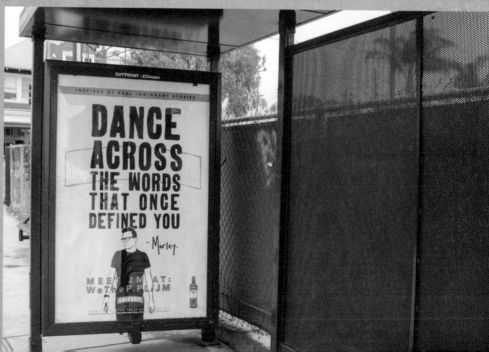

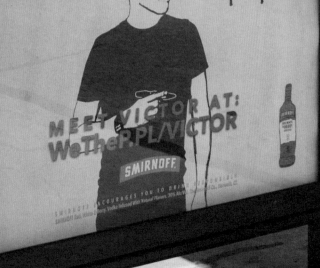

OUTFRONT / JCDecaux

INSPIRED BY REAL IMMIGRANT STORIES

A DREAM UNTESTED IS EASILY PUNCTURED

— *Morley.*

MEET VICTOR AT:
We.ThePPL/VICTOR

SMIRNOFF.

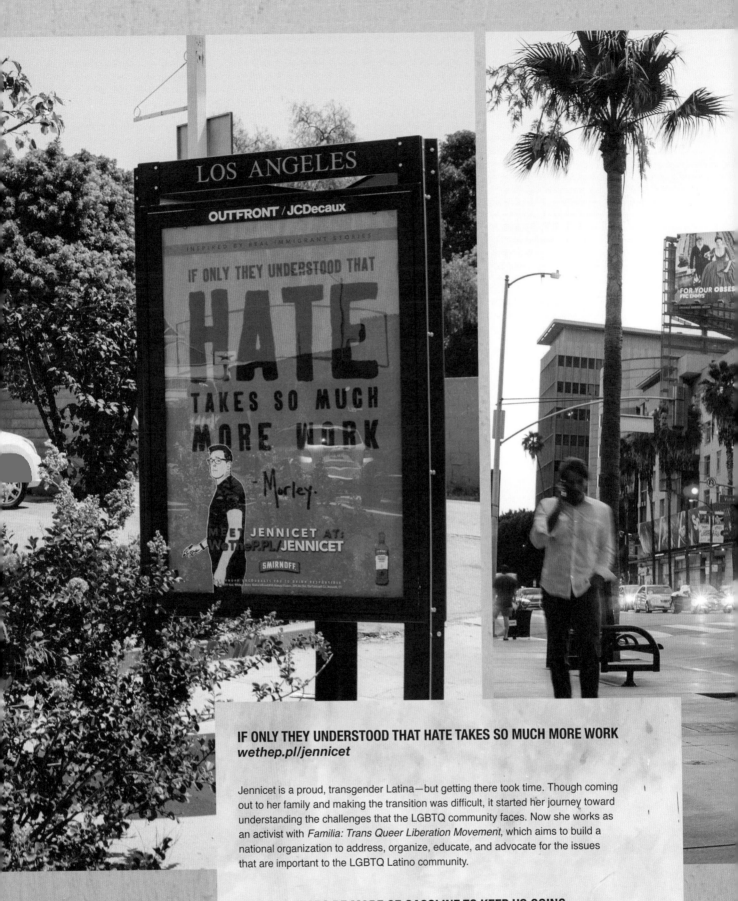

IF ONLY THEY UNDERSTOOD THAT HATE TAKES SO MUCH MORE WORK
wethep.pl/jennicet

Jennicet is a proud, transgender Latina—but getting there took time. Though coming out to her family and making the transition was difficult, it started her journey toward understanding the challenges that the LGBTQ community faces. Now she works as an activist with *Familia: Trans Queer Liberation Movement*, which aims to build a national organization to address, organize, educate, and advocate for the issues that are important to the LGBTQ Latino community.

MAY OUR TEARS BE MADE OF GASOLINE TO KEEP US GOING
wethep.pl/armando

Armando came to this country as a teenager, but it wasn't until he was thirty-three years old that he came out to his mother as gay. Though her response was unsupportive, he hopes to one day find acceptance.

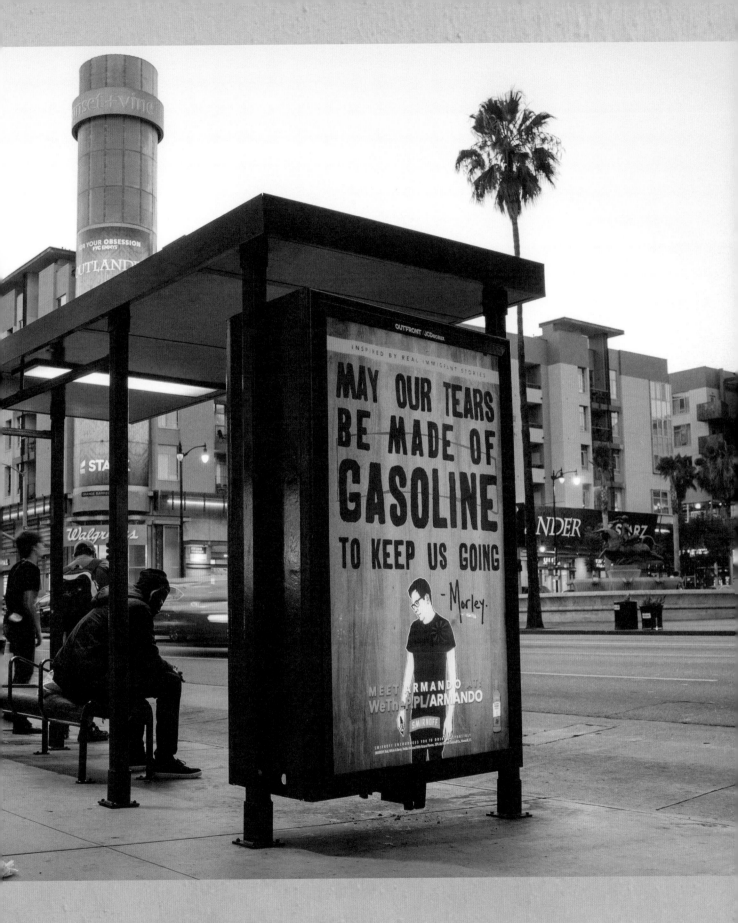

GIVE THANKS

Sincere gratitude requires continual realignment of perspective and effort to really appreciate how fortunate many of us are. It's not enough to value what you have on the rare occasions that gratitude is thrust upon you, it takes real work to remind yourself to be grateful in the face of frustration and disappointment. Here are a few basic facts to remember...

IF YOU HAVE FOOD IN YOUR FRIDGE, CLOTHES ON YOUR BACK, A ROOF OVER YOUR HEAD AND A PLACE TO SLEEP TONIGHT, YOU ARE RICHER THAN 75 PERCENT OF THE WORLD.

IF YOU HAVE MONEY IN THE BANK, YOUR WALLET, AND SOME SPARE CHANGE IN YOUR POCKET YOU ARE AMONG THE TOP 8 PERCENT OF THE WORLD'S WEALTHY.

IF YOU WOKE UP THIS MORNING WITHOUT SIGNIFICANT ILLNESS YOU ARE MORE FORTUNATE THAN THE MILLION PEOPLE WHO WILL NOT SURVIVE THIS WEEK.

IF YOU CAN ATTEND ANY MEETING YOU WANT: POLITICAL, RELIGIOUS, SOCIAL... THEN YOU ARE LUCKIER THAN 3 BILLION PEOPLE IN THE WORLD.

IF YOU HAVE NEVER EXPERIENCED THE DANGER OF BATTLE, OR THE AGONY OF IMPRISONMENT, TORTURE, OR STARVATION, YOU ARE LUCKIER THAN 500 MILLION PEOPLE ALIVE AND SUFFERING.

IF YOU CAN READ THESE STATISTICS, YOU ARE MORE FORTUNATE THAN THE 3 BILLION PEOPLE IN THE WORLD WHO CANNOT.

statistics courtesy of Canadian Red Cross

GRATITUDE TAKES WORK

- Morley.

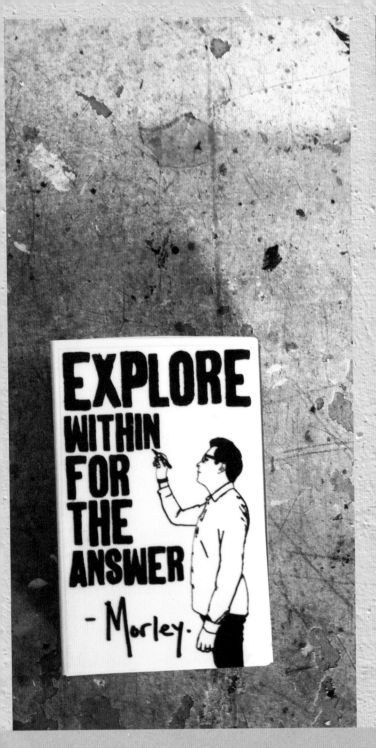

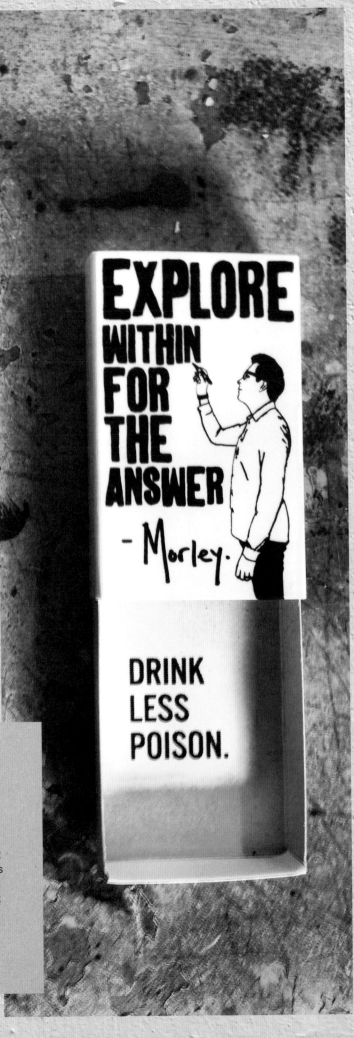

THE MATCHBOX PROJECT

I always loved those Magic 8-Ball toys as a kid. Well, actually, I always loved the *idea* of them. In reality, I would quickly grow frustrated by the frequency with which it told me to "ask again later" or became filled with air bubbles. My biggest problem with them was that they were never specific enough. I understand that if they weren't vague, the answers would not apply to most questions. But the more specific they were, the more it would blow the minds of the few that it resonated with. So I decided to create my own version of a Magic 8-Ball. I took a bunch of matchboxes, emptied out the matches, stuck a magnet on the back, and turned them into little street fortune tellers.

I can only hope that perhaps a few people had their minds blown.

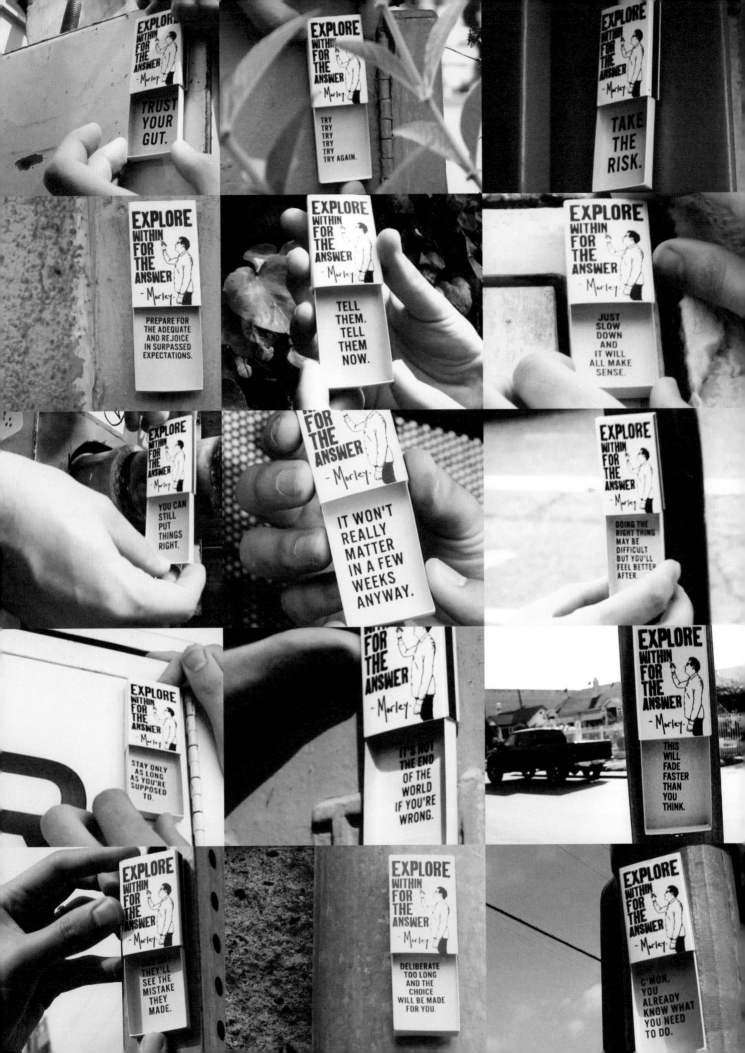

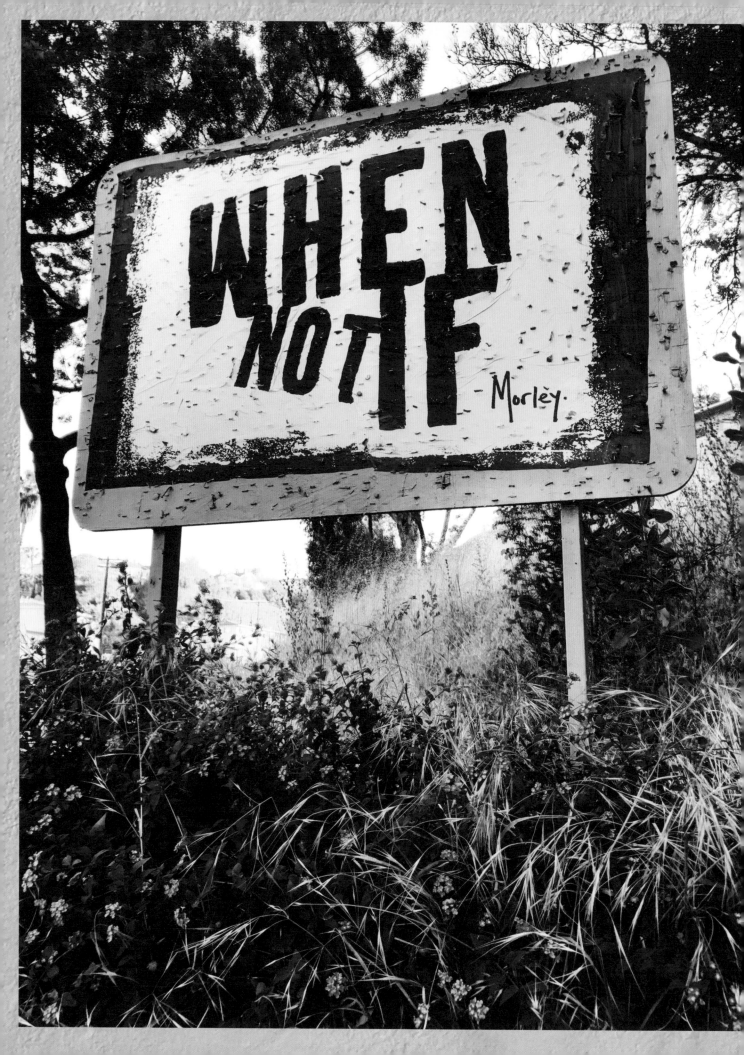

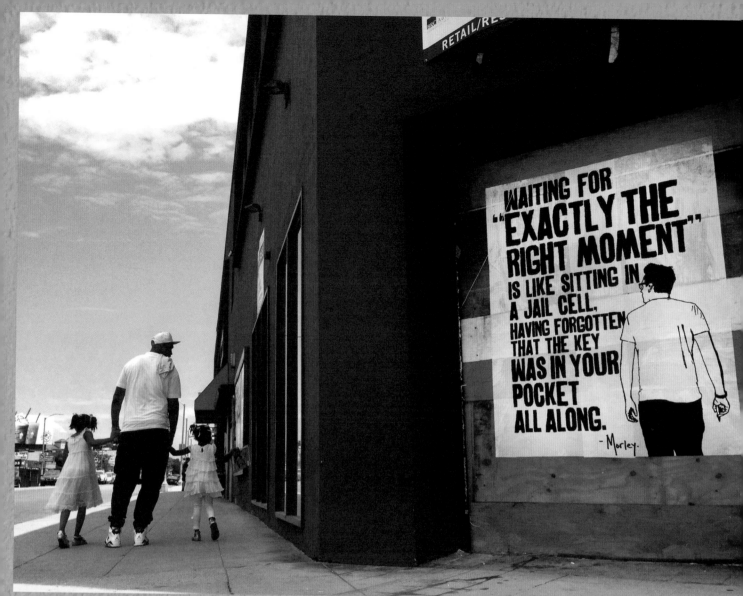

WAITING FOR "EXACTLY THE RIGHT MOMENT" IS LIKE SITTING IN A JAIL CELL, HAVING FORGOTTEN THAT THE KEY WAS IN YOUR POCKET ALL ALONG.
—Morley.

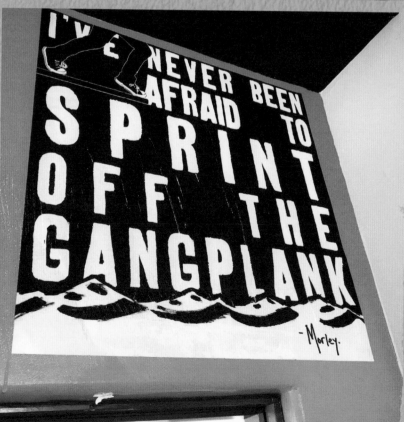

I'VE NEVER BEEN AFRAID TO SPRINT OFF THE GANGPLANK
—Morley.

"FAR BETTER IS IT TO DARE MIGHTY THINGS, TO WIN GLORIOUS TRIUMPHS, EVEN THOUGH CHECKERED BY FAILURE... THAN TO RANK WITH THOSE POOR SPIRITS WHO NEITHER ENJOY NOR SUFFER MUCH, BECAUSE THEY LIVE IN A GRAY TWILIGHT THAT KNOWS NOT VICTORY NOR DEFEAT."

—THEODORE ROOSEVELT

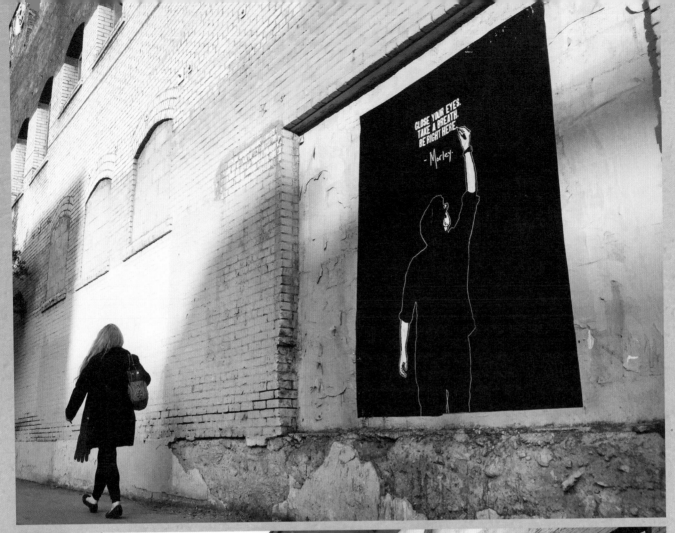

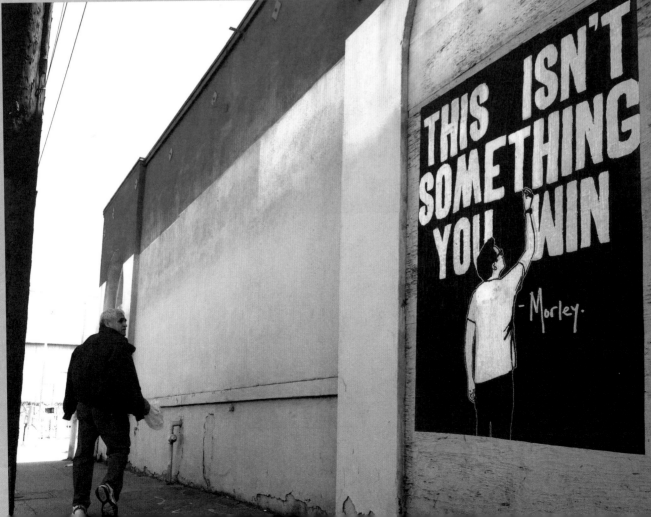

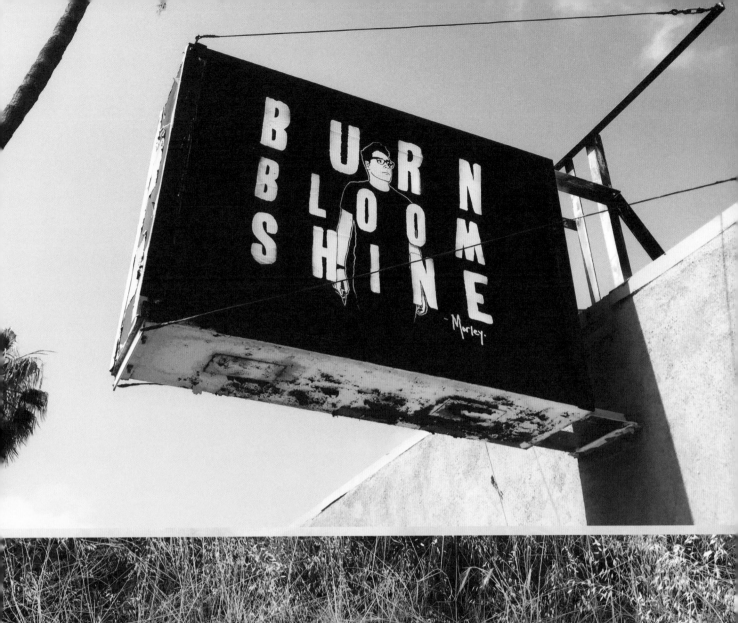

per·se·ver·ance

/ pərsə'virəns/

noun

Often confused for simply waiting for success, rather it actually means wading through one rejection after another after another after another after another after another after another after another...

"Through **perseverance**, she didn't just achieve her goals, she earned them."

Synonyms: persistence, tenacity, determination, staying power, indefatigability, steadfastness, purposefulness, patience, endurance, application, diligence, dedication, commitment, doggedness, assiduity, tirelessness, stamina, intransigence. More...

— Morley.

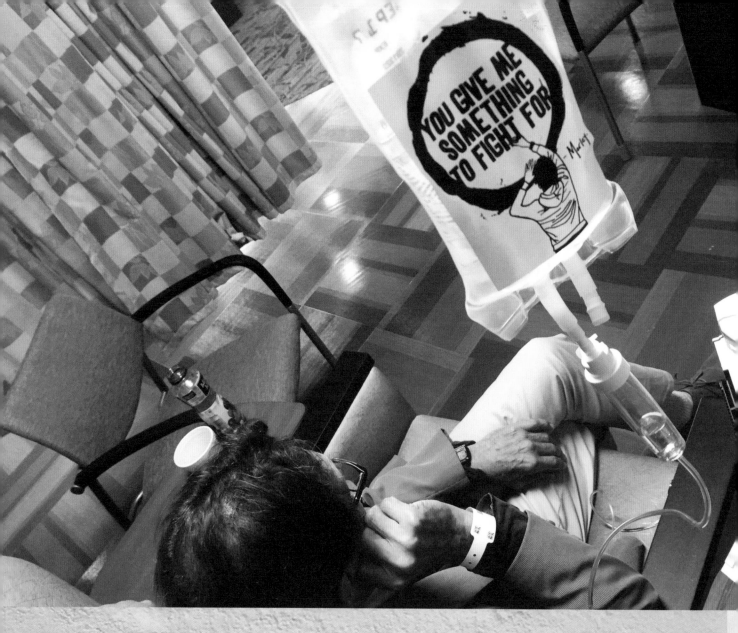

FIGHTING WORDS

I was standing outside a Buffalo Wild Wings waiting for a takeout order when I got a call from my dad. "Hey," I said. "How's it going?" "Well, I have cancer," he said, matter-of-factly. My dad and I share a pretty dry and sometimes dark sense of the absurd so I assumed he was kidding. "That's a terrible joke, Dad," I said, but was met with only awkward silence. The kind of silence that makes you sick to your stomach. An endless, black hole that absorbs everything in its proximity.

"Wait, seriously?" I asked, finally. He went on to tell me that he had been diagnosed with stage four esophageal cancer. That it had metastasized into his liver and lungs as well. The outlook was grim, and the news hit me with a fierce kind of whiplash. In these kinds of moments it's difficult to know what comes next. I tried to think of books and films that could provide a reference, some kind of example of how normal people respond, but nothing felt sincere or applicable to how I felt in that moment. Is sobbing appropriate? Or rage? Should I fling my phone to the ground or just collapse in a heap? All I remember was a numbness that spread across my whole body.

"Mac and Cheese to go?" said the perky young waitress, a plastic sack in her hands. I turned and reflexively smiled. I thanked the girl, careful not to shake the welling of tears loose, and took the bag. "They always give you too many napkins at Buffalo Wild Wings, it's such a waste." This thought briefly flittered through my mind and shed only the word "waste" as it evaporated. "What a waste." I now thought. "It's all such a waste."

At the time, my dad had very little information. His doctor had said there would be scans and tests and treatments before they could give him an idea of how much time he had left. But that would all come later. I felt obligated to offer encouragement. Having briefly had the verbal wind knocked out of me, I was determined to fill that black hole of silence with more words than it could consume. Stories of survivors I'd known, inspiring memes I'd read on Facebook, promises of the many exciting advancements in treatments that were being developed every day. Knowing that the moment I stopped I'd be faced with the sobriety of a reality that didn't necessarily include victory. I don't even remember how we ended that phone call.

The weeks would pass and the prognosis wouldn't seem to improve. My dad, for his part, spent the days coming to terms with his fate. Not resigned so much as comfortable with the concept of "the end."

Days later I was in a Home Depot when he called.

"I want you to know that I don't plan to suffer," he said. I think he had meant to comfort me with this knowledge, but at the moment it felt premature and ominous.

"Well, I respect that, but I mean, we're gonna fight this thing, right? We're gonna do everything we can to beat it? Right? I don't want you giving up on me."

"WE NEED MORE CHECKERS UP FRONT PLEASE," squawked the loudspeaker looming high above like an omniscient narrator for someone else's book.

.
"I didn't catch that," said my dad.

"I said I respect that but we're gonna fight this thing, right?"

"COULD WE GET MORE EMPLOYEES AT CHECK OUT?" reiterated the frustrated loudspeaker.

"You're breaking up."

I repeated myself again, raising my voice as I passed some bewildered-looking shoppers in the paint aisle, my voice beginning to tremble.

"ADDITIONAL CHECKERS UP FRONT, CHECKERS UP FRONT PLEASE."

"I think I have to call you back, the reception keeps going in and out."

He called me back moments later, the loudspeaker's plea finally being satisfied.

"Hello?" I said. "Can you hear me now?"

"Yes much better," he said.

"Well," I said. "What I was saying was that I respect your wishes to not suffer, I get it. I know you don't want to spend the time you have left in pain and discomfort . . . but I just need to know that you're going to do everything you can to fight this thing. That you're going to try. I just need to hear you tell me that you're gonna try to beat this." Once again my eyes began to well up as I fought to keep my composure amongst the strangers populating the isle. "I feel like one of the biggest things you can do is keep your spirits up. That if you really maintain a resolve, it'll help. That you can't let this thing trick you into giving up. Y'know?"

In vain I tried to clear my throat of the knot that was tightening like a clenched fist and exhaled.

A moment passed and finally,

"I . . . I'm sorry you just keep cutting out. Maybe I should just call you back when you're somewhere with better reception."

"ARE YOU KIDDING ME?!" I yelled as I hung up, finally feeling the sincere urge to dramatically throw my phone to the ground.

"Sorry." I said meekly to a nearby parent as her eight-year-old child looked on.

I flew out to Iowa a week later. My dad began a heavy chemotherapy regiment. I sat with him during a session and stuck this sticker on his chemo IV. It felt weird to, in a way, speak for him. When I put my posters up, they're usually for the unknown masses. For a series of "someones" whose connection to me is unspecific. My work is for everyone who can relate, but whom I may never actually speak to.

This was different, not only was this for someone I've known and loved all of my life, but in a way, I was using my sticker as if to say on his behalf that I was his "something to fight for." And yet it gave me comfort, as though I could will him the ferocity to defy cancer. As though my meager words could act as a totem. It dawned on me then that for as long as I've put up posters across the city I live in, I've never given much thought to how much power they might actually have. Do they really offer anything to the people that see them? To the people that need them? Do they really give people strength when they need it most?

Can they work for my father? They're just words. They only have the power we give them. So I stood there, as my dad had poisonous chemicals pumping through a port in his body, and I asked God to give my words real power. To make them more than words. More than a declaration. To inject them into my dad along with the liquid in the IV bag they were stuck to. "Please," I thought. "Even if nothing I've ever done has made a practical difference to anyone, let this be the one that does. Let this one matter."

As I sit here writing this, my Dad is still battling cancer. There have been victories and setbacks. Test results that have come back overwhelmingly positive, only to have the cells regroup and wreak fresh havoc.

My dad keeps fighting and that's all that I can ask for. I don't know why some people beat cancer and some don't. I don't know why cancer continues to take so many of our fathers and mothers, children, siblings, and friends. There are some things that will just never make sense. What's become clear to me though is that cancer is something that requires a fight not just for the one directly affected, but for those who love them as well. Looking at this photo, I realize that I wasn't just urging my father to fight for his survival, but for my own fight to keep hope alive in my heart. It's a fight to not give in to what can feel like an unstoppable inevitability. The ones we love won't live forever. It's a fact that we have to accept—but to allow the malignancy of hopelessness to take hold of us is a fight none of us can afford to surrender to.

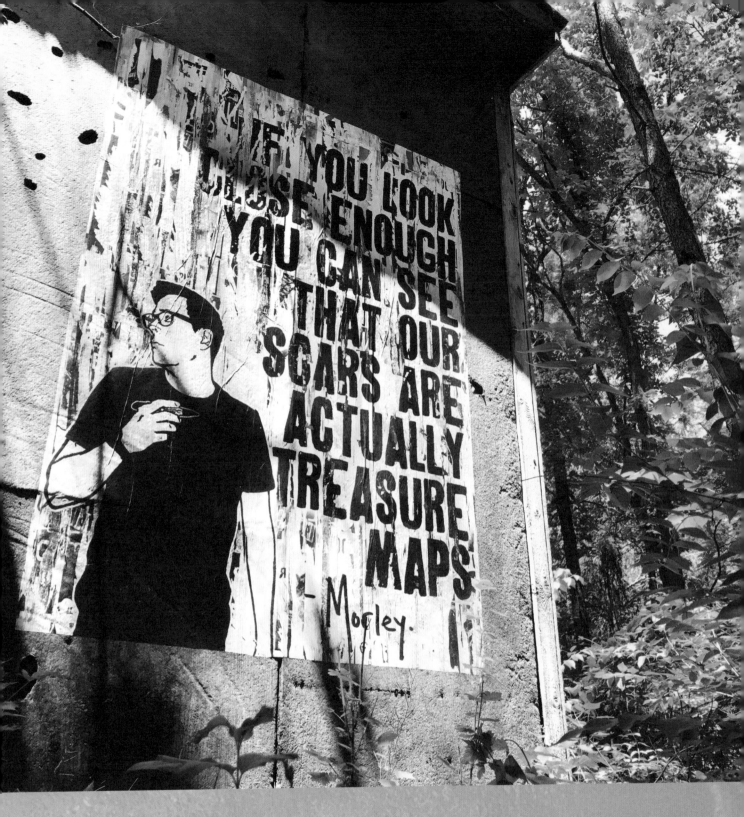

X MARKS THE SPOT

At the end of the jagged trail of a scar, you'll find it leads to the realest parts of who you are. The battle scars of a life you've survived, that have left you stronger, wiser. That have left you with the knowledge of just what you are capable of taking, of enduring. These are the reminders that our past is real. That it wasn't all just a figment of our imagination. They are the physical proof that the healing our bodies experienced was just as real as the pain. We are our scars. Our blows suffered. Our hearts broken and stitched and broken and stitched. Scars are the winding paths that lead to the treasure that is you.

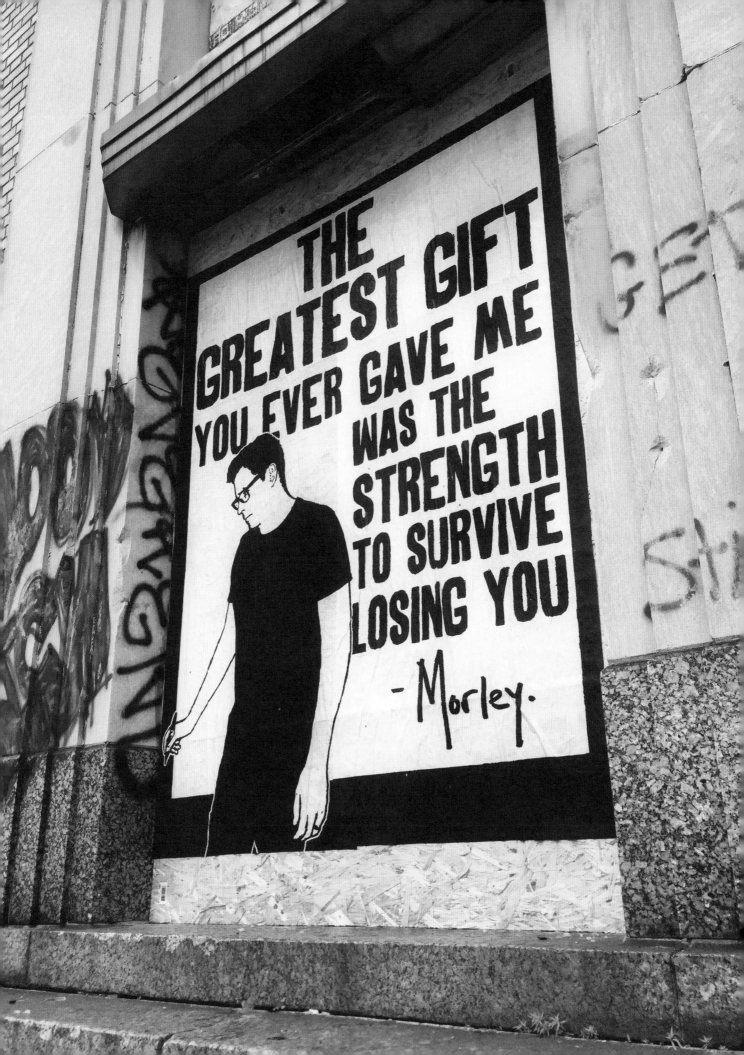

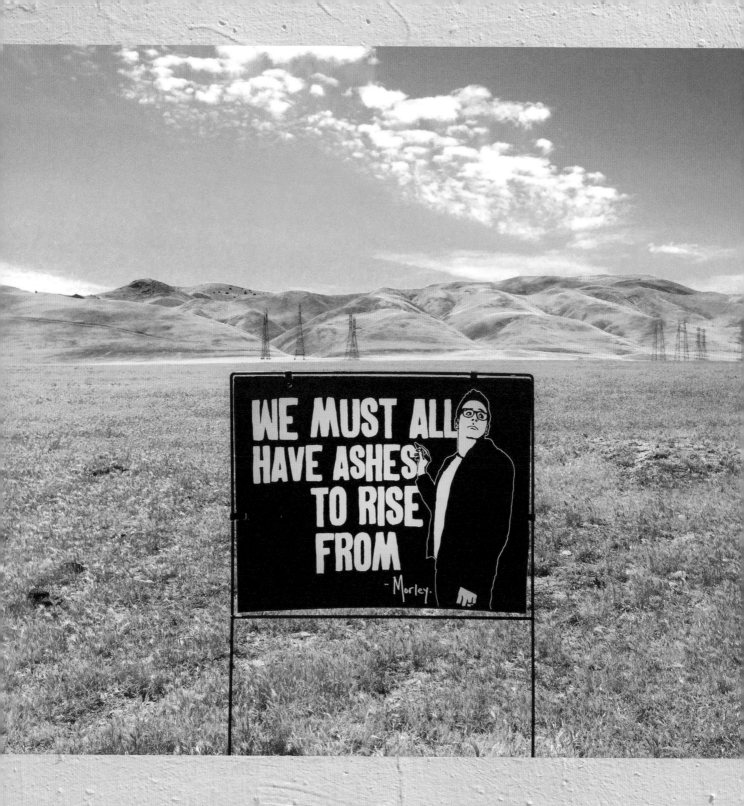

"ALL THINGS OF GRACE AND BEAUTY SUCH
THAT ONE HOLDS THEM TO ONE'S HEART
HAVE A COMMON PROVENANCE IN PAIN.
THEIR BIRTH IN GRIEF AND ASHES."

—CORMAC MCCARTHY

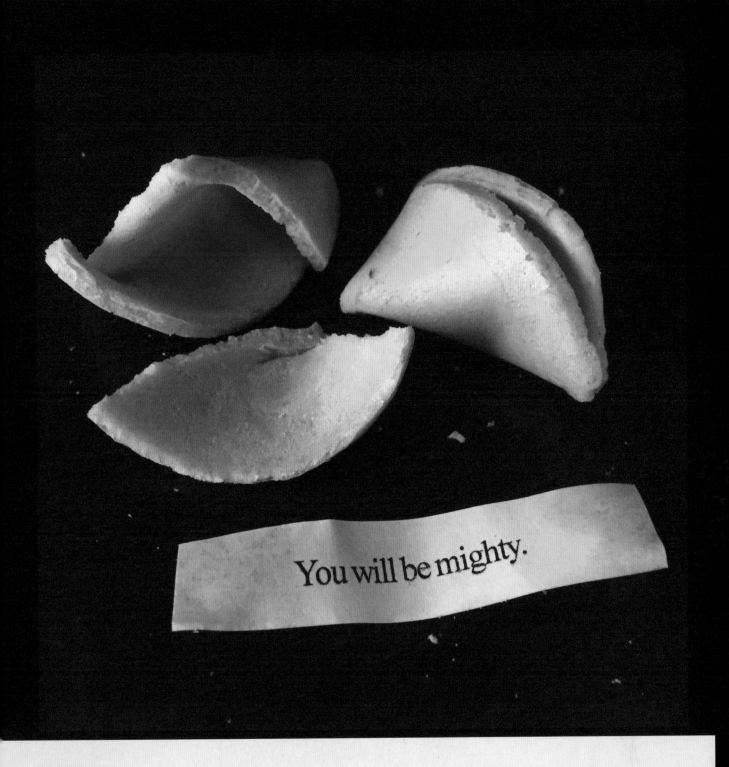

You will be mighty.

FORTUNATE

Unlike my Matchbox Project, when I decided to make fortune cookies, I wanted something that was guaranteed to come true for every person who might see it. At some point in our lives, we will all face moments that require us to be stronger than we feel we are capable of being. A good analogy might be whitewater rafting. With whitewater rafting, surviving the experience can seem as though you're just being passive, that you're not so much fighting the water as just kind of letting it push you around—and it's true,

the best you can hope for is to navigate it well. You can't alter the direction that the water is flowing or reason with it to be more accommodating, but if you get thrown from the boat, you can get back in and keep going—which requires more than you might think. You can face the coming adversity and not just close your eyes 'til it's over. That takes real strength, and at some point in your life, you'll see just how mighty you are.

If you let it guide you, it will take you in the wrong direction.

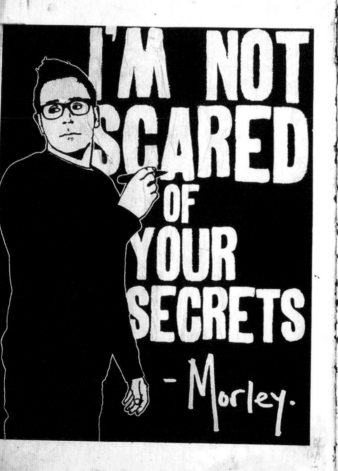

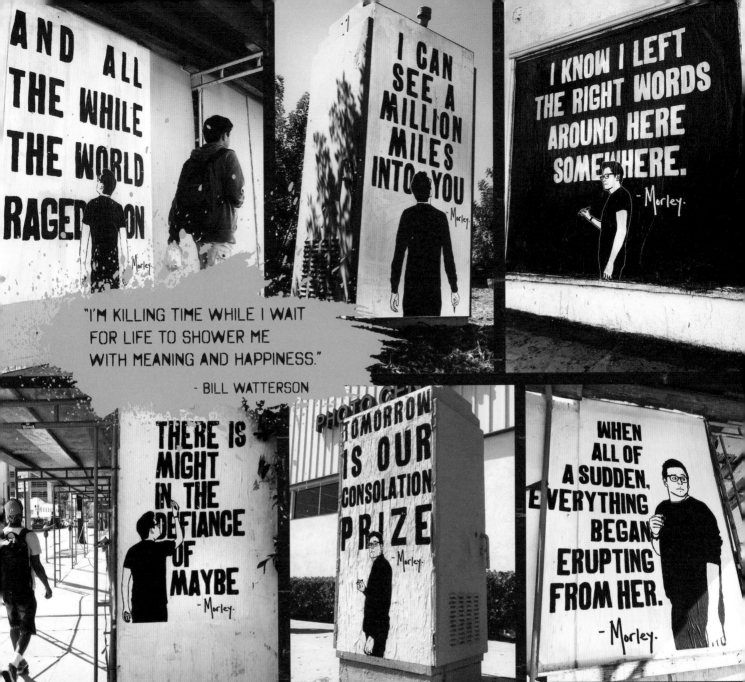

"I'M KILLING TIME WHILE I WAIT
FOR LIFE TO SHOWER ME
WITH MEANING AND HAPPINESS."

- BILL WATTERSON

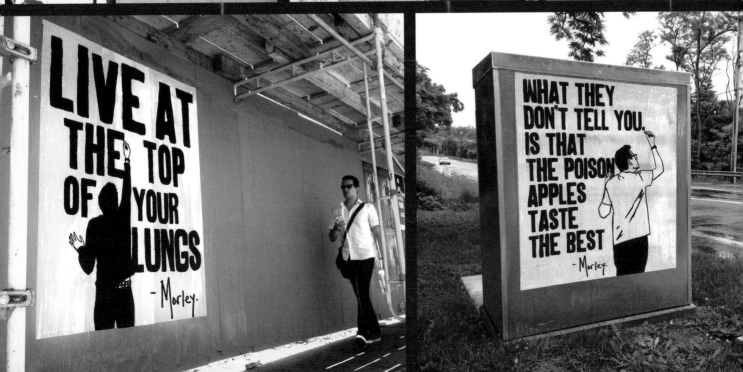

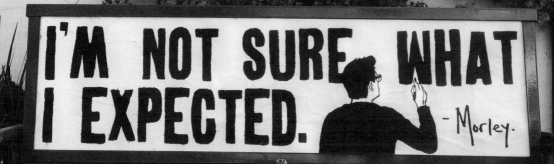

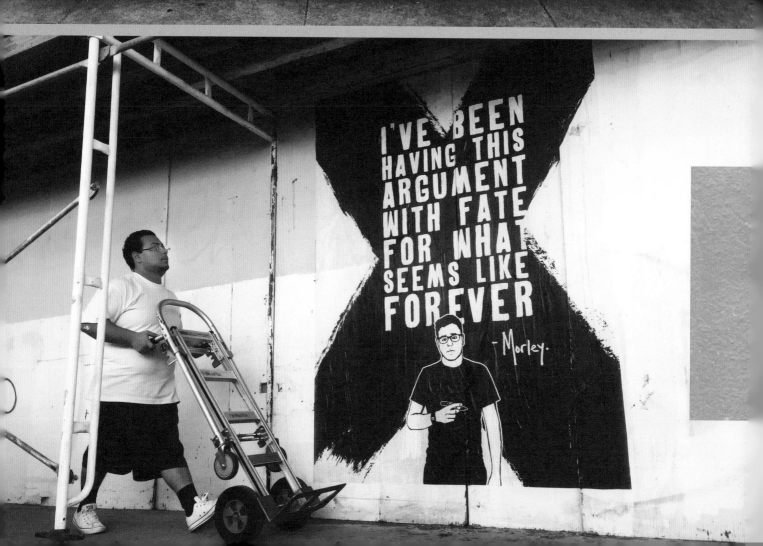

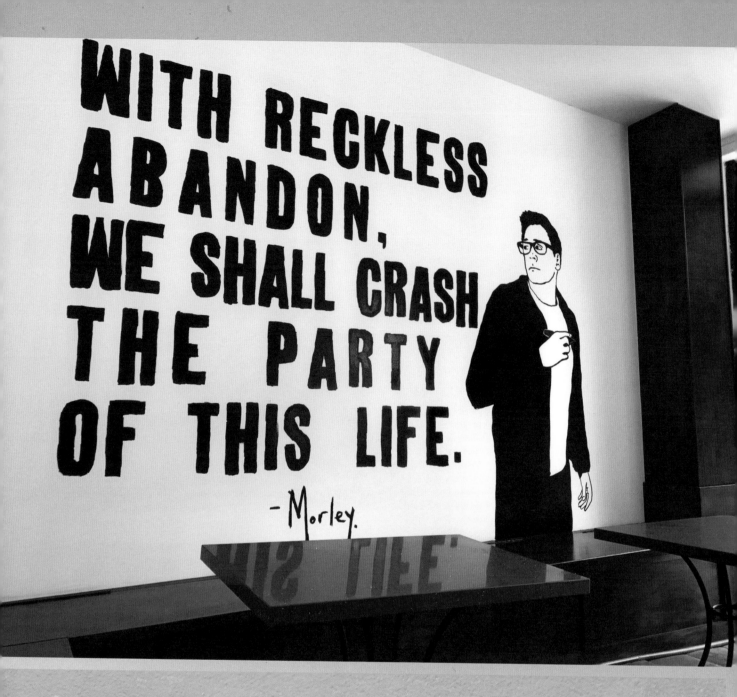

WITH RECKLESS ABANDON, WE SHALL CRASH THE PARTY OF THIS LIFE.

—Morley.

LET'S GET METAPHYSICAL

There is a philosophical debate that has raged for as long as anyone can remember. It pits the dueling concepts of predetermination and free will against each other. Predeterminism is the idea that a higher power has created a narrative for us; that our past, present, and future have all been defined already and cannot be deviated from. Free will, on the other hand, is the idea that our actions are freely chosen and thus our fortunes are free to twist and turn with the consequences they inflict. I tend to fall more on the free will side of this conceptual coin. Often though, in the midst of frustration and disappointment, it's easy to feel destined for failure. In those moments, our refusal to give up can feel like trying to convince Fate to change its mind and give us the life it has thus far been withholding. I've never been good at accepting something I deem unfair. I've never been good at accepting someone else's idea of what my life should look like, even if that "someone else" is the metaphysical concept of fate. Fate may have left us off the guest list to the VIP party of life but we sure as hell can crash it, and once we're inside, let's turn the music up, okay?

GO FORTH AND BOLDLY LISTEN

— Morley.

There is a misconception that listening is passive in a conflict, but actively taking the time to respectfully hear someone without just waiting to talk, and thoughtfully considering it, takes a lot more strength of character than expectorating condescension upon anyone who holds a differing opinion. To me, this message is a challenge to everyone (myself included) to aspire to listening as often as we aspire to "winning" every conversation.

WE WON'T LAUGH IF YOU FALL

— Morley.

Hook a car battery up
to a projector and you can,
if ever so briefly,
make a 90 foot promise.

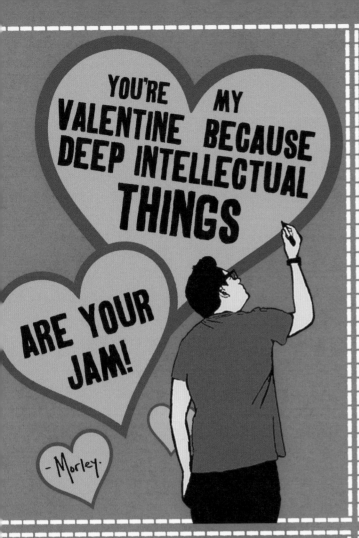
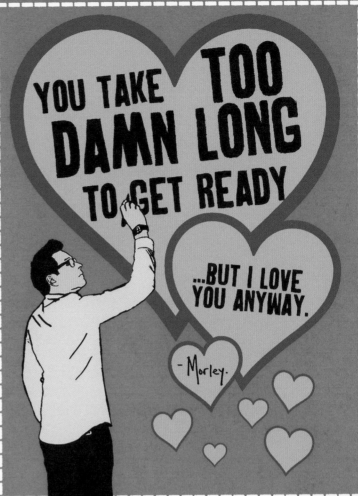
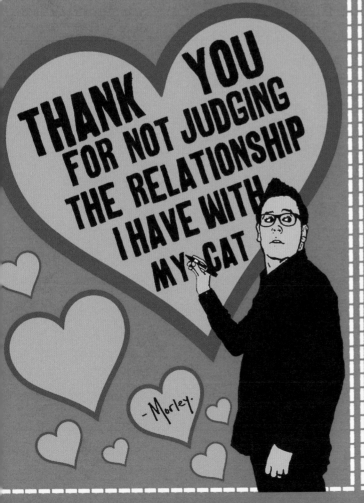
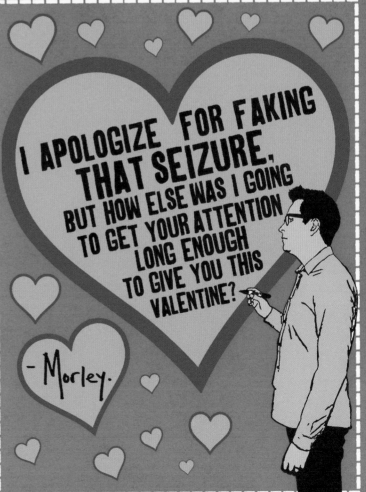

TO:

FROM:

MESSAGE:

TO:

FROM:

MESSAGE:

TO:

FROM:

MESSAGE:

TO:

FROM:

MESSAGE:

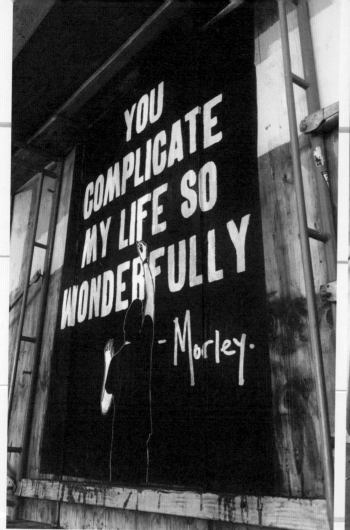

YOU COMPLICATE MY LIFE SO WONDERFULLY

-Morley.

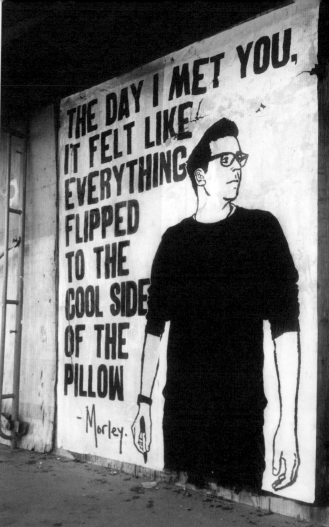

THE DAY I MET YOU, IT FELT LIKE EVERYTHING FLIPPED TO THE COOL SIDE OF THE PILLOW

-Morley.

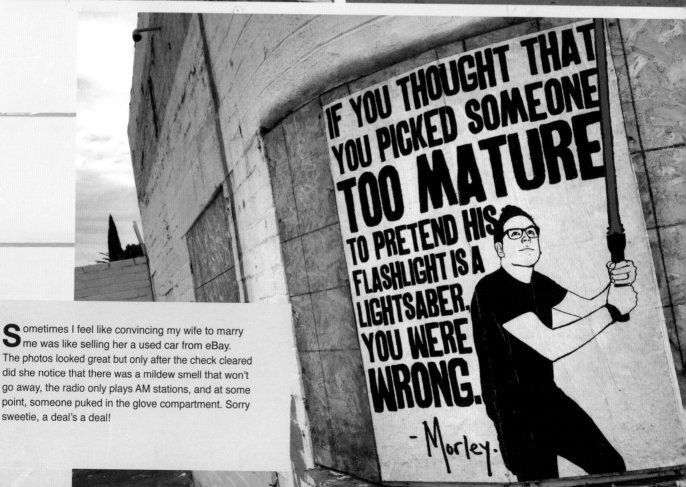

IF YOU THOUGHT THAT YOU PICKED SOMEONE TOO MATURE TO PRETEND HIS FLASHLIGHT IS A LIGHTSABER, YOU WERE WRONG.

-Morley.

Sometimes I feel like convincing my wife to marry me was like selling her a used car from eBay. The photos looked great but only after the check cleared did she notice that there was a mildew smell that won't go away, the radio only plays AM stations, and at some point, someone puked in the glove compartment. Sorry sweetie, a deal's a deal!

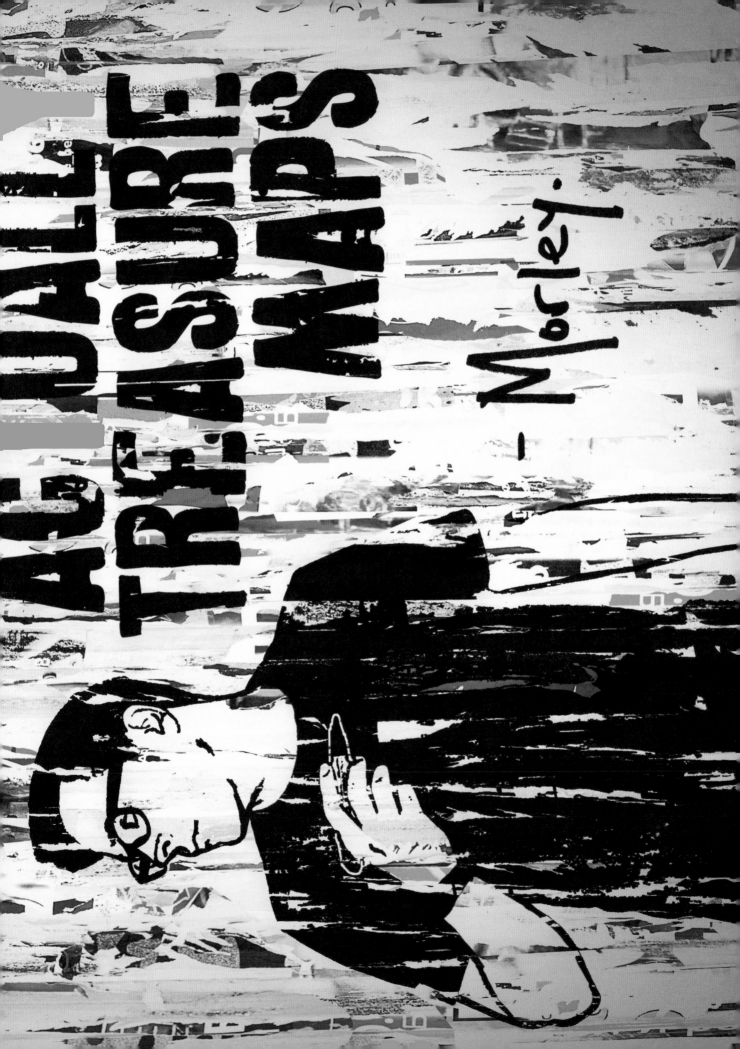

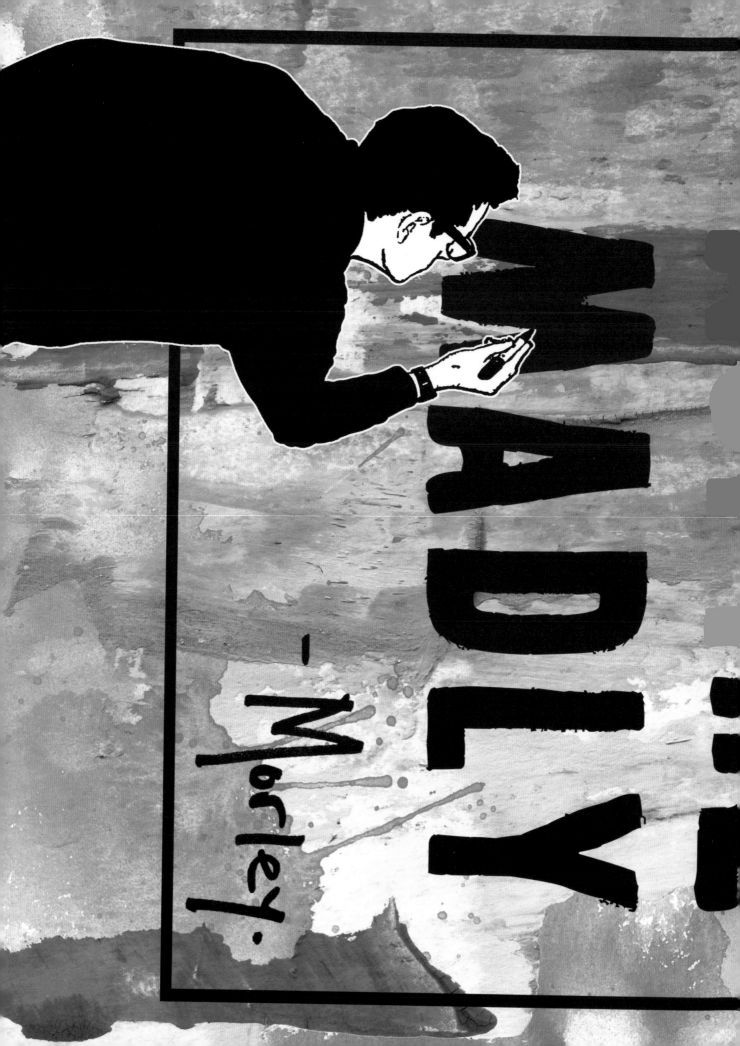

IN ALL THINGS ASPIRE

IF YOU LOOK HARD ENOUGH YOU CAN SEE YOUR FUTURE THOSE ARE THE CARS THAT YOU LOST

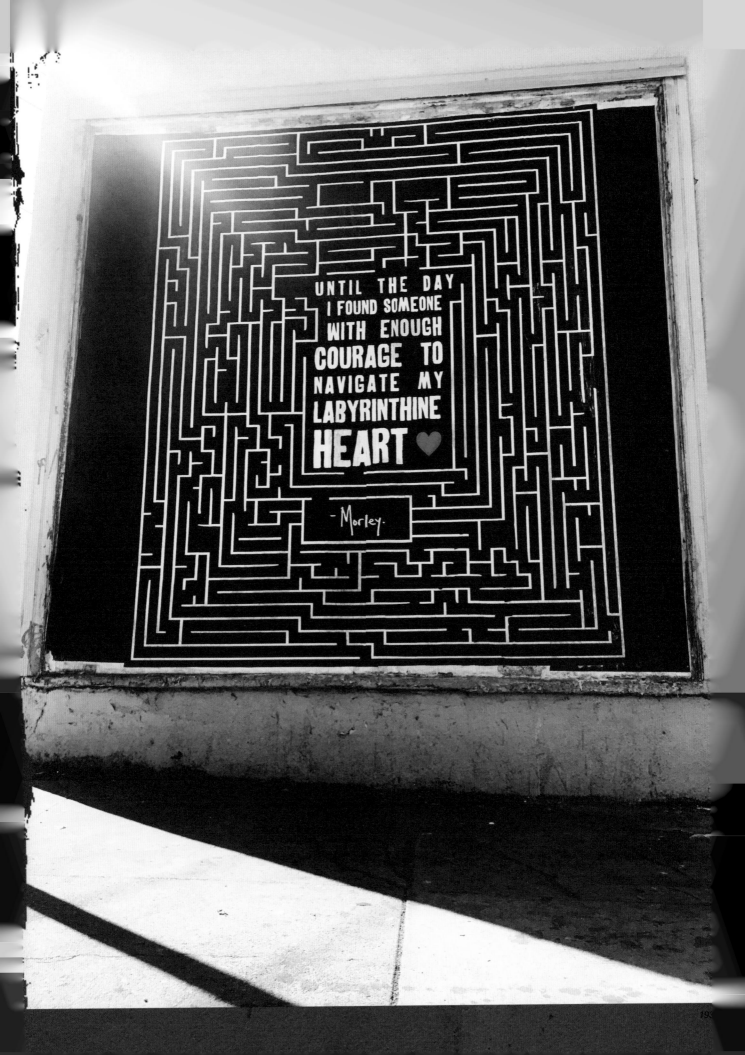

NIGHT VISION

Whenever I watch a film that hinges on whether two people will fall in love and end up together, I'm almost always left with the thought of "yeah, but what happens after the credits? What happens when they have their first big fight? What happens when they start to notice all the flaws the other has, the frustrating quirks that seemed cute during the film but now, when no one's watching, drive the characters crazy?"

I can't be too hard on these films, I doubt that a film that covers the less-exciting minutiae of a relationship would be a huge box office hit. I do, however, think it's important to consider how this has shaped the way we conceptualize love. What true love really is can't be covered in ninety minutes. And yet, we dream. We fantasize about how it will be once we "get" him or her. Living life means giving up the fantasy of tidy endings.

The sentiment of this poster is that as the hero rides off into the sunset on his horse with a beautiful woman at his side… whether they know it or not, it's gonna get dark soon. That sun will finish setting and they're gonna wish they had something to point them in the right direction, just like the rest of us.

Let's hope they brought a couple flashlights.

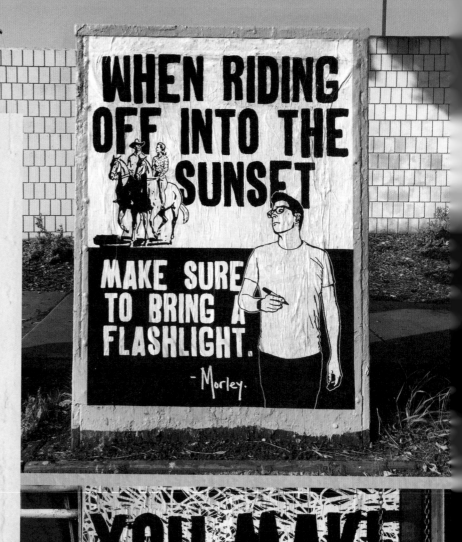

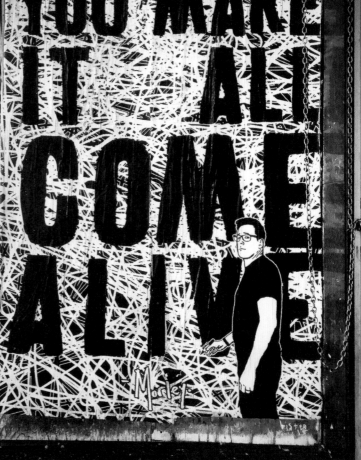

IT WAS THE KIND OF LOVE
THAT DYES ALL YOUR
WHITE PARTS PINK

-Morley.

IN CASE OF
EMERGENCY

A CHANCE TO TELL HER
YOU'RE SORRY
BREAK -Morley.

GLASS

I'LL LOVE YOU EVEN WHEN YOU FORGET HOW TO LOVE YOURSELF

— Morley.

FOSTER / ADOPT / SUPPORT. FACEBOOK.COM/LUXEPAWS

TO ME, YOUR BEST OUTFIT IS SWEATPANTS AND COUCH.

Morley.

FOSTER / ADOPT / SUPPORT. FACEBOOK.COM/LUXEPAWS

LUXE PAWS

In October of 2015, a pair of kittens were discovered in a cardboard box that had been taped closed and left on a street corner. They were rescued by an organization called Luxe Paws. My wife and I had been fostering cats for a while with them and were happy to take care of these two cats until they found a forever home. Well, we quickly fell in love with them and decided we couldn't let them go. We adopted them and named them Howie and Hattie.

I decided that for their first birthday I'd make a pair of posters that celebrate why pet owning is so special, and specifically why adopting rescued pets can be so rewarding. If you live in the Echo Park/ Silverlake area of Los Angeles and want to foster or adopt or just support this organization, I highly recommend that you do so. They are committed to not only rescuing but spaying and neutering so that we can curb the flood of homeless animals in the city.

My cats and so many more would surely have died if it wasn't for Luxe Paws and the people that support them. I'm thankful every day that I know they're out there, helping homeless cats and dogs find better lives.

FACEBOOK.COM/LUXEPAWS

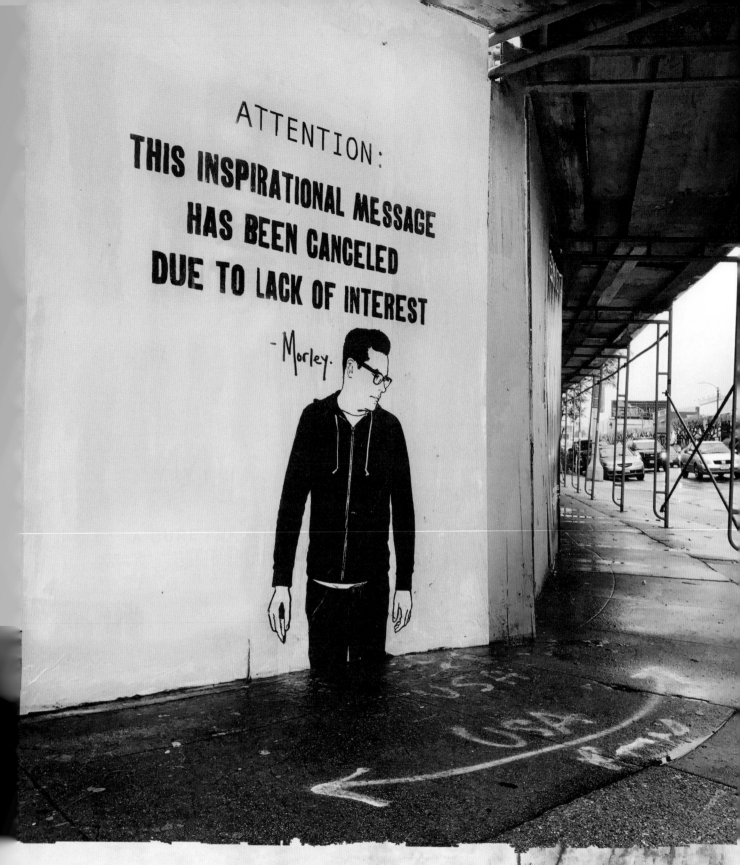

TWO VOICES

Like most people, I hear both of the voices. The one that says my mission has value and the other that does its very best to convince me that no one cares. That everyone who accuses me of offering only empty aphorisms is right. That, at best, my posters, awash in the overwhelming stimuli of the city, are simply singing opera underwater.

Occasionally, I allow this voice to drone on his litany of denouncements, and once he's run out of breath, I ask him where instead I should be thrusting my energy. And here is where he goes quiet. You can always spot a fraudulent voice of reason by its dearth of inspiration. It finds fault in every path except the path of stagnation. It's at that point that I tell the voice to kindly shut the fuck up.

I RESOLVE TO CARE MORE ABOUT HOW PEOPLE FEEL WHILE CARING LESS ABOUT WHAT PEOPLE THINK.

- Morley.

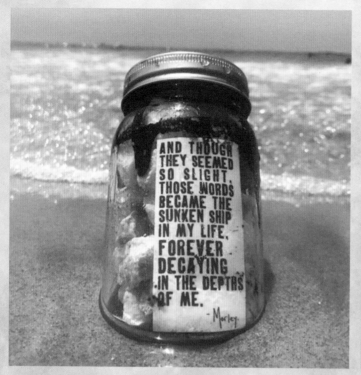

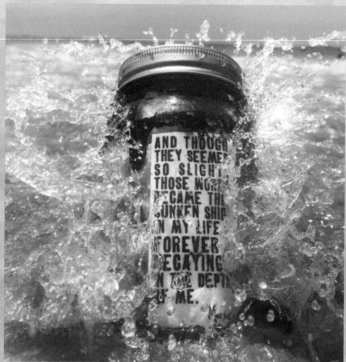

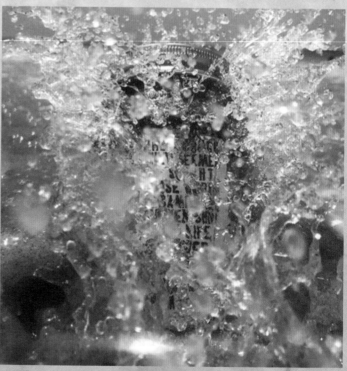

Some words can be weighed by the ton.
Others appear to have no substance
at all, yet have the ability to stem
even the most relentless of tides.

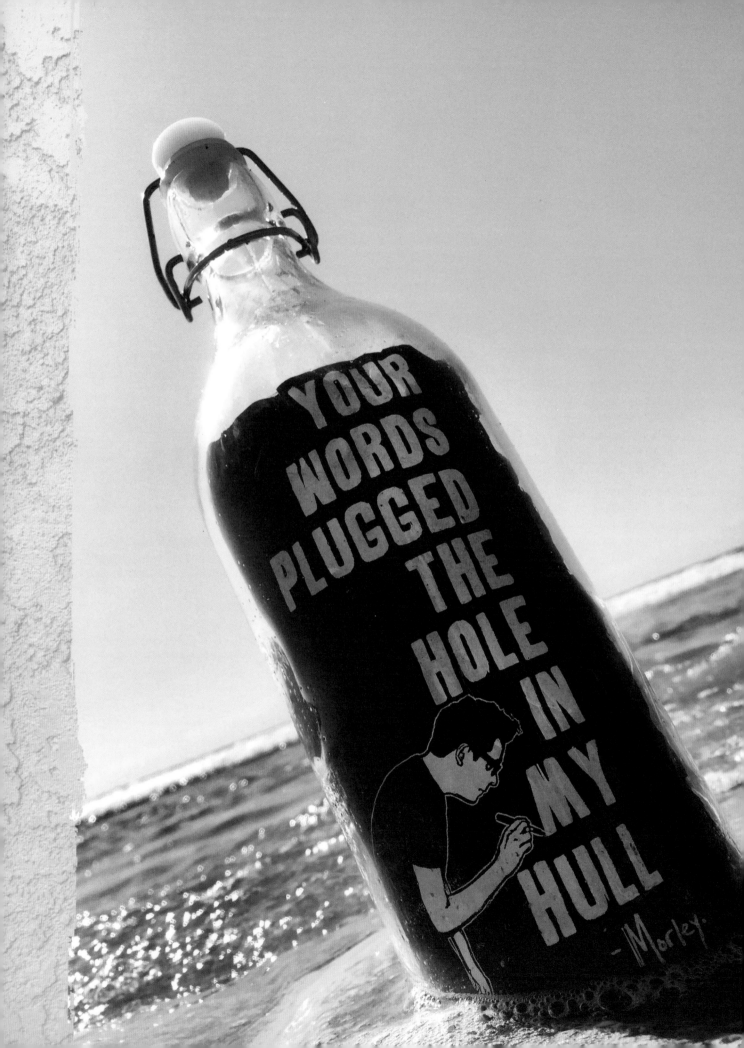

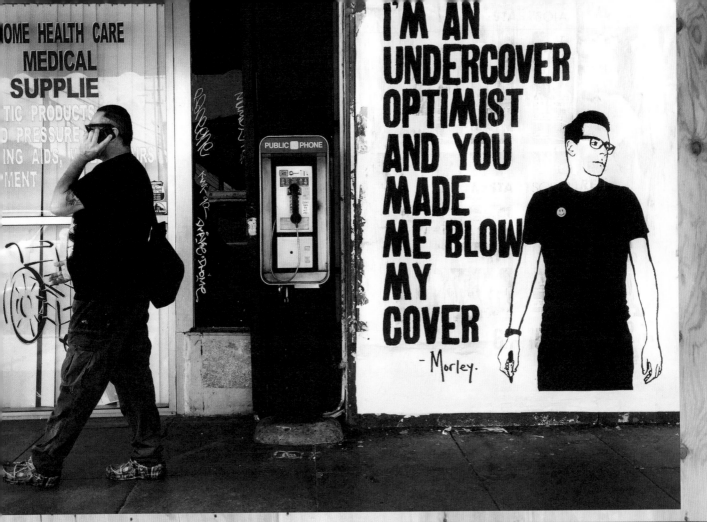

I'M AN UNDERCOVER OPTIMIST AND YOU MADE ME BLOW MY COVER

— Morley.

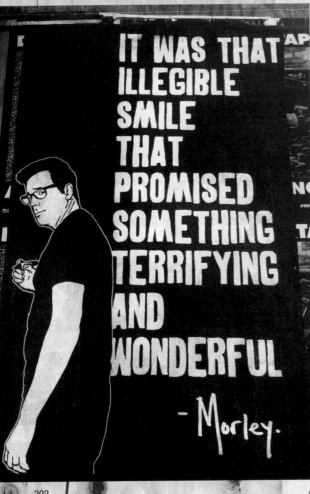

IT WAS THAT ILLEGIBLE SMILE THAT PROMISED SOMETHING TERRIFYING AND WONDERFUL

— Morley.

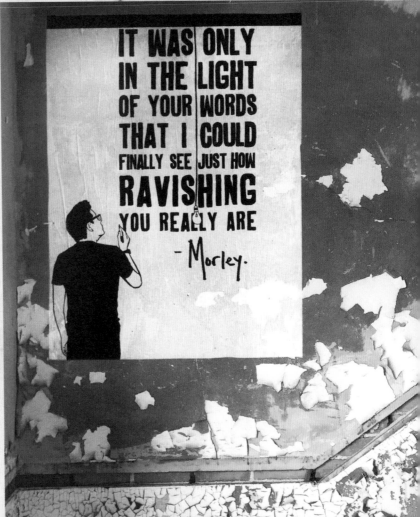

IT WAS ONLY IN THE LIGHT OF YOUR WORDS THAT I COULD FINALLY SEE JUST HOW RAVISHING YOU REALLY ARE

— Morley.

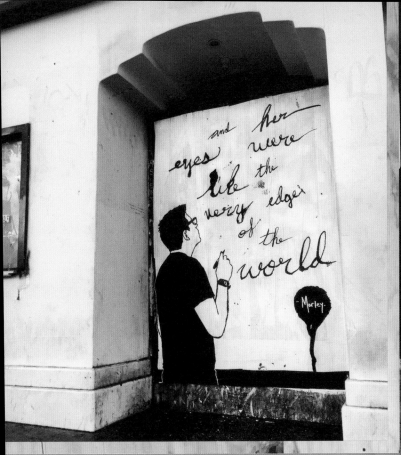

and her eyes were like the very edge of the world

— Morley.

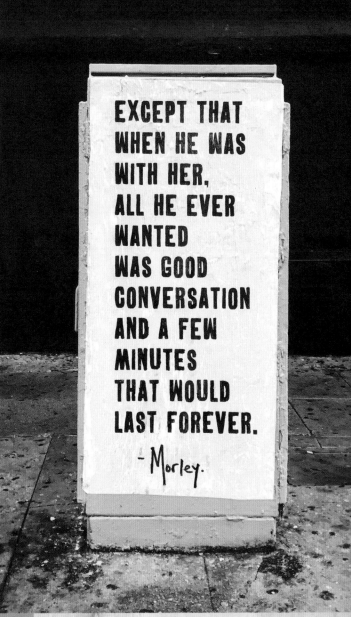

EXCEPT THAT WHEN HE WAS WITH HER, ALL HE EVER WANTED WAS GOOD CONVERSATION AND A FEW MINUTES THAT WOULD LAST FOREVER.

— Morley.

"I'M SELFISH, IMPATIENT, AND A LITTLE INSECURE. I MAKE MISTAKES, I AM OUT OF CONTROL AND AT TIMES HARD TO HANDLE. BUT IF YOU CAN'T HANDLE ME AT MY WORST, THEN YOU SURE AS HELL DON'T DESERVE ME AT MY BEST."

—MARILYN MONROE

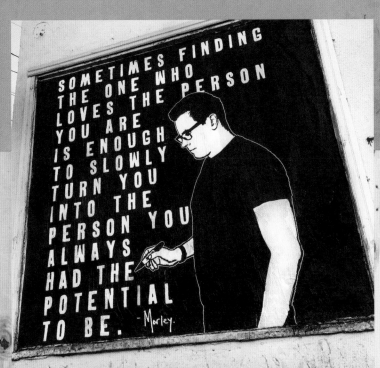

SOMETIMES FINDING THE ONE WHO LOVES THE PERSON YOU ARE IS ENOUGH TO SLOWLY TURN YOU INTO THE PERSON YOU ALWAYS HAD THE POTENTIAL TO BE.

— Morley.

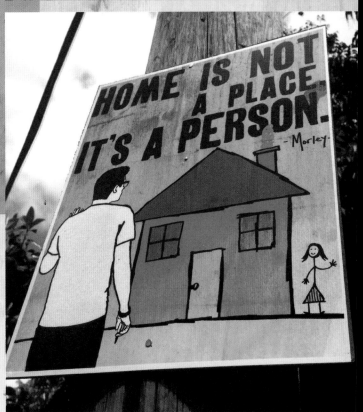

HOME IS NOT A PLACE. IT'S A PERSON.

— Morley.

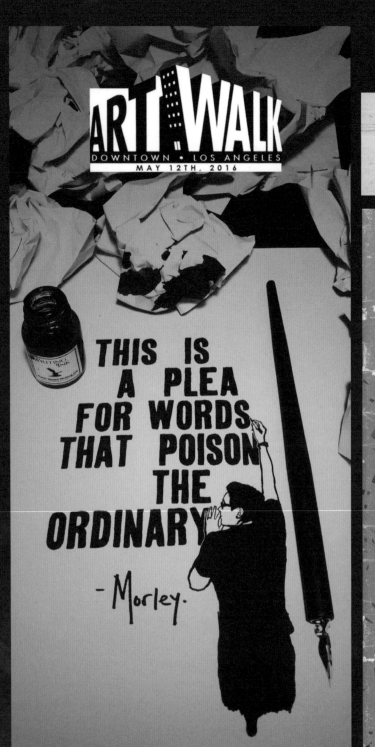

THIS IS A PLEA FOR WORDS THAT POISON THE ORDINARY

- Morley.

Gallery Guide compliments of Los Angeles Times

The cover I designed for the May 2016
Los Angeles Downtown Artwalk gallery guide.

A promotional postcard I designed for a gallery
show at Los Angeles's Gabba Gallery.

INSTRUCTION MANUAL

A BEGINNER'S GUIDE TO MENDING

AN ART EXHIBIT BY MORLEY

OPENING SEPTEMBER 9TH 7PM-11PM
GABBA GALLERY
3126 Beverly Blvd Los Angeles, CA 90057
310-498-2697 • GABBAGALLERY.COM
ON VIEW UNTIL SETPEMBER 30TH

SPONSORED BY:
ORIGINAL NEW YORK SELTZER
FORT POINT BEER Cº

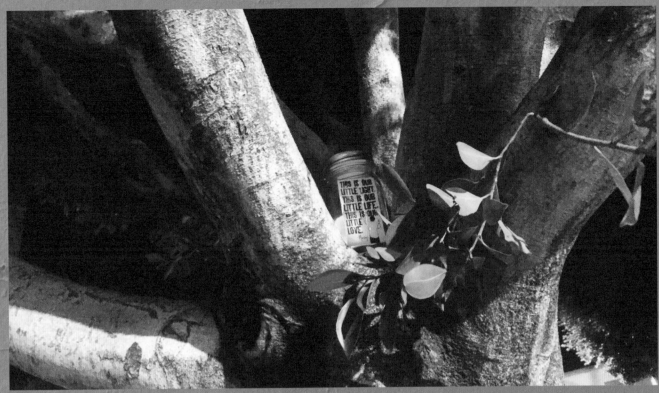

FIREFLIES

Sometimes I only figure out what to do with certain materials after I've bought them. In this case, I saw a box of mason jars for sale and thought, "I can figure out something to do with these!" Weeks later it finally came to me. I wanted to evoke the memories I had of catching lightning bugs as a child, so I approximated it with electronic tea light candles and an accompanying message, then hid them around the city, posting clues online as to their locations for people to find and keep.

Maybe for some, catching the jars was as exciting as catching fireflies. The warm glow still makes me think of the summer nights all those years ago when everything felt magical.

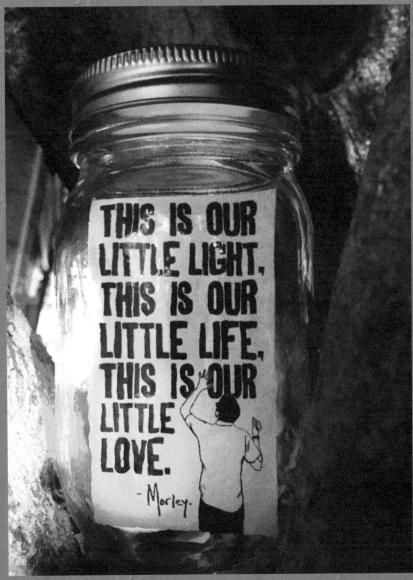

THIS IS OUR LITTLE LIGHT, THIS IS OUR LITTLE LIFE, THIS IS OUR LITTLE LOVE.

— Morley.

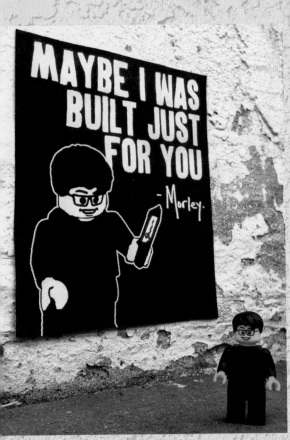

MAYBE I WAS
BUILT JUST
FOR YOU
– Morley.

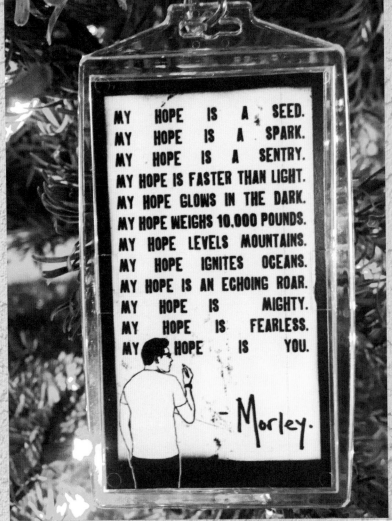

MY HOPE IS A SEED.
MY HOPE IS A SPARK.
MY HOPE IS A SENTRY.
MY HOPE IS FASTER THAN LIGHT.
MY HOPE GLOWS IN THE DARK.
MY HOPE WEIGHS 10,000 POUNDS.
MY HOPE LEVELS MOUNTAINS.
MY HOPE IGNITES OCEANS.
MY HOPE IS AN ECHOING ROAR.
MY HOPE IS MIGHTY.
MY HOPE IS FEARLESS.
MY HOPE IS YOU.

– Morley.

Here are a few other odds and ends I've hidden about the city for people to find. Lego Morleys, Christmas tree ornaments, snow globes, and Easter eggs. With every scavenger hunt, I debate how hard I should make the clues. If you make it too easy, the whole thing is over in minutes, but too hard, and you start getting angry emails.

I usually try to fall somewhere short of getting "THIS ISN'T FAIR, I CAN'T READ SANSKRIT!"

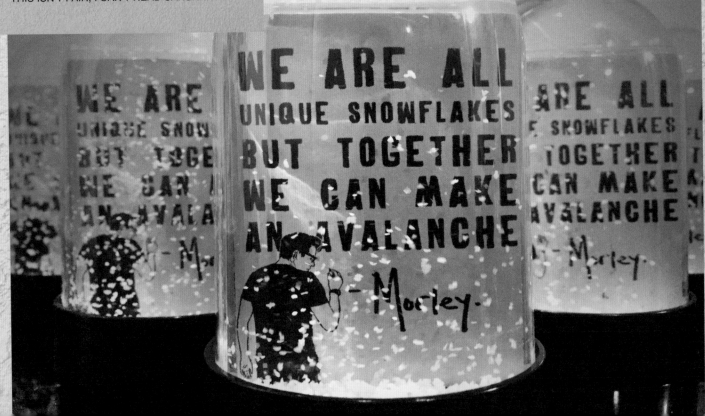

WE ARE ALL
UNIQUE SNOWFLAKES
BUT TOGETHER
WE CAN MAKE
AN AVALANCHE
– Morley.

THERE ARE
WORSE Things
TO BE THAN
BREAKABLE.

-Morley

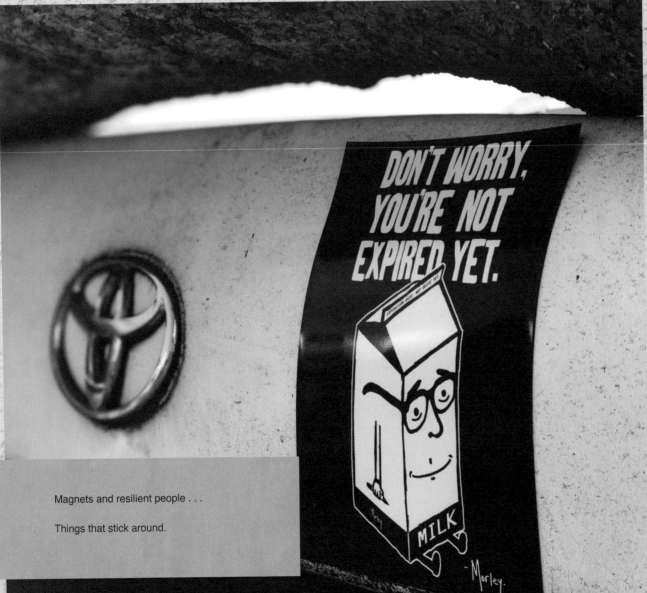

Magnets and resilient people . . .

Things that stick around.

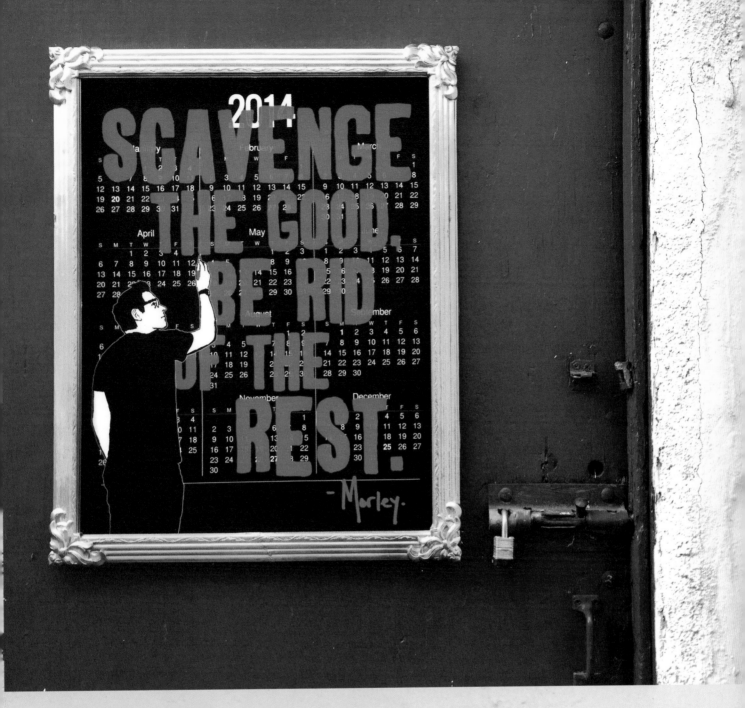

THE JUNKYARD PHILOSOPHY

As the old saying goes from *A Tale of Two Cities*: "It was the best of times, it was the worst of times." The year 2014 was a pretty big one for me. It held accomplishments, new friends, fresh starts, and memories I hold close. And yet, it had also been one of the more challenging years of my life. Close to the start of it, my wife and I suffered a miscarriage for what would have been our first child.

I wish I could say that the disappointment didn't dampen the rest of the year and its gifts, but it did. I didn't really talk about it too much. It was somewhat early, and we hadn't told many of our friends that we had become pregnant, and so it seemed best to simply avoid the subject entirely and evade the well-meaning but uncomfortable exchanges they would offer. I only bring it up now because so many people suffered tragedies that make mine seem so insignificant.

Blows I cannot imagine, not just in 2014, but before and since. While it's tempting whenever we approach a new year to say, "So long year and good riddance, don't let the door hit you on the way out, you lousy bastard!" I know that there are many things about every trip around the sun that we should hang on to. Not just the pleasant experiences but the lessons we've acquired from the unpleasant ones.

So I tend to look at the past like a junkyard. Full of junked-out plans and schemes . . . of hopes and dreams that crapped out on you—and just after you finished making the payments. But it's not all worthless. You can still make use of the parts and pieces. The valuable scrap that lay dormant amongst the refuse. I think that as we look back at each year, we scavenge the good and jettison the rest. Then rinse, and repeat.

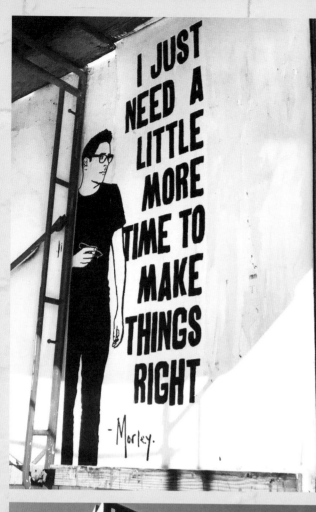

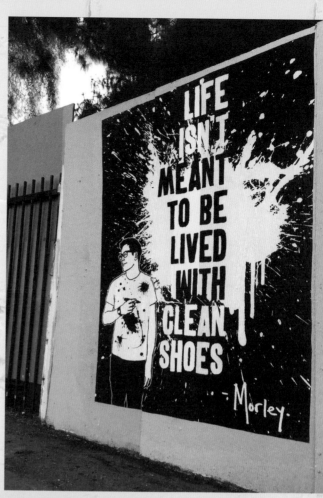

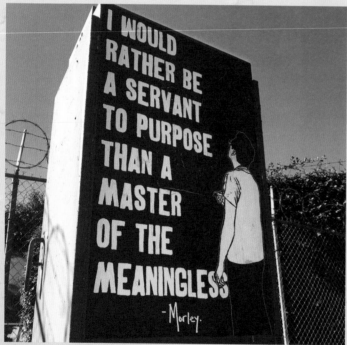

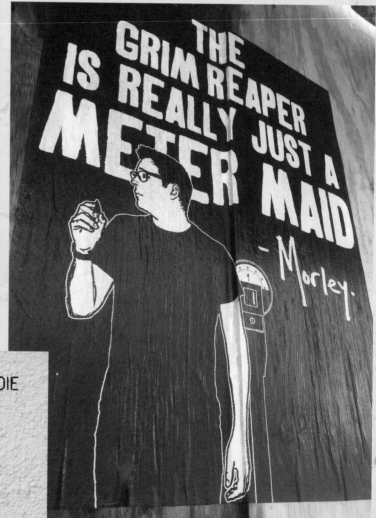

"ALAS FOR THOSE THAT NEVER SING, BUT DIE WITH ALL THEIR MUSIC IN THEM."

—OLIVER WENDELL HOLMES

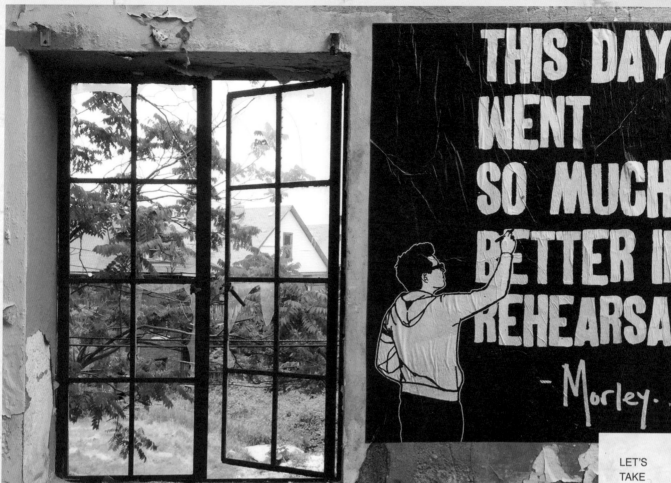

THIS DAY WENT SO MUCH BETTER IN REHEARSAL

— Morley.

LET'S TAKE IT FROM THE TOP, SHALL WE?

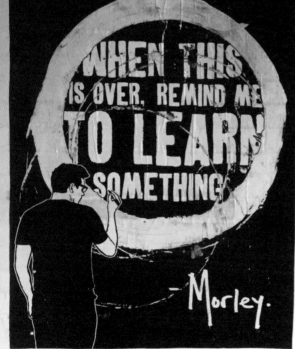

WHEN THIS IS OVER, REMIND ME TO LEARN SOMETHING

— Morley.

ONE DAY
I HOPE
TO MASTER
STANDING
STILL
— Morley.

We all have a few skills we need to acquire . . .

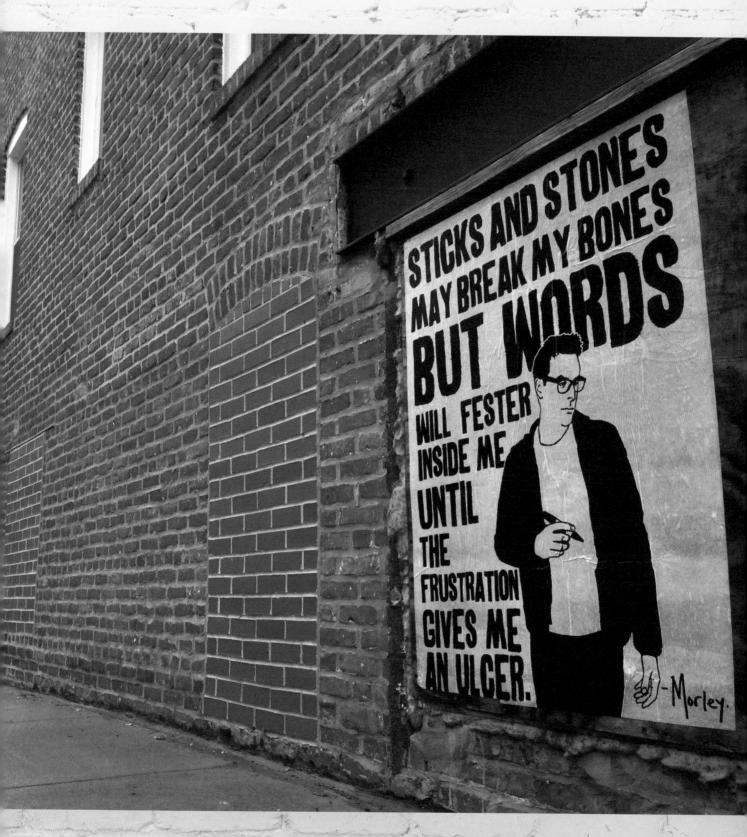

The poster reads:

STICKS AND STONES
MAY BREAK MY BONES
BUT WORDS
WILL FESTER
INSIDE ME
UNTIL
THE
FRUSTRATION
GIVES ME
AN ULCER.

-Morley.

and a few old habits to shed.

And my dreams are always
waking up next to you.

214

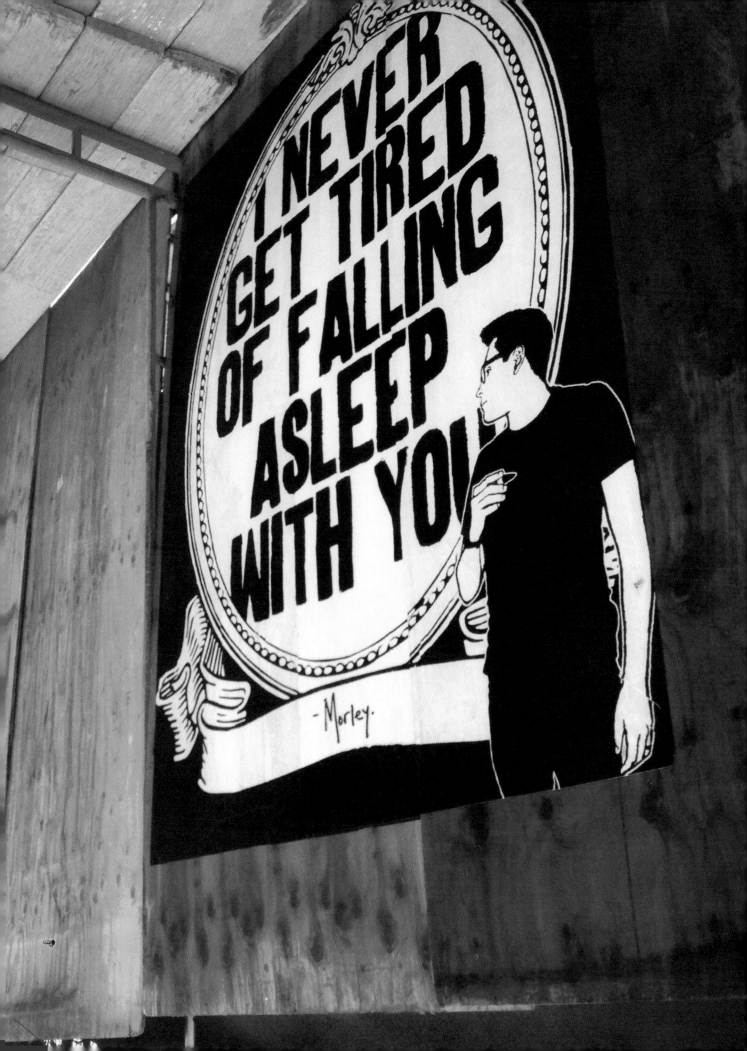

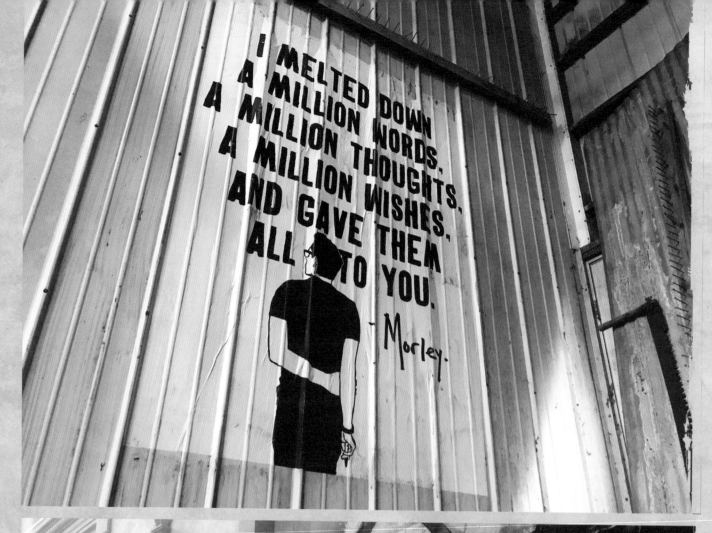

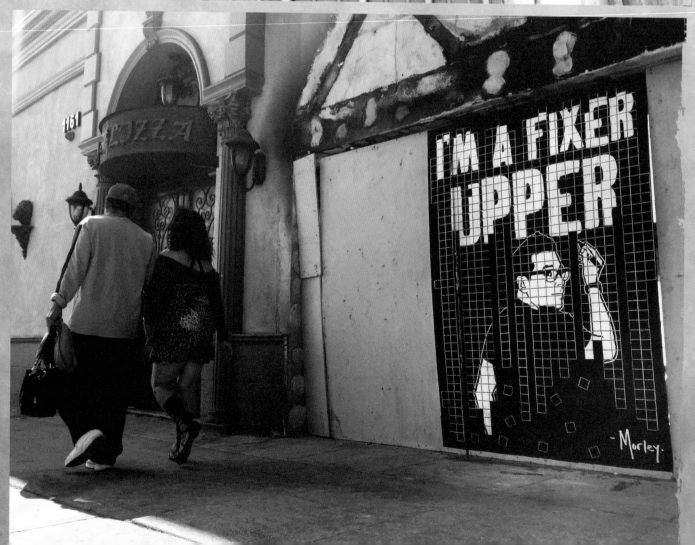

NO LONGER SHALL
I LET THESE HOURS
DEFEAT ME. -Morley.

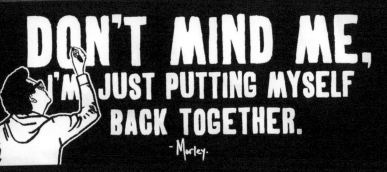

DON'T MIND ME,
I'M JUST PUTTING MYSELF
BACK TOGETHER.
-Morley.

THE THINGS I'VE SEEN

I created a series of pieces following the notion of "seeing is believing." The idea of playing a literal witness to a figurative experience was interesting to me. Whether it's observing someone discover through sheer force of will an ability to elevate beyond their circumstances, or a dream that's cast aside in favor of a rigid and limiting logic. From the moment when you make use of the wisdom that a wound can offer, to the inability some of us have to recognize our ambition as the paradoxical weight that holds us back.

These events transpire every day. Most of us simply don't notice.

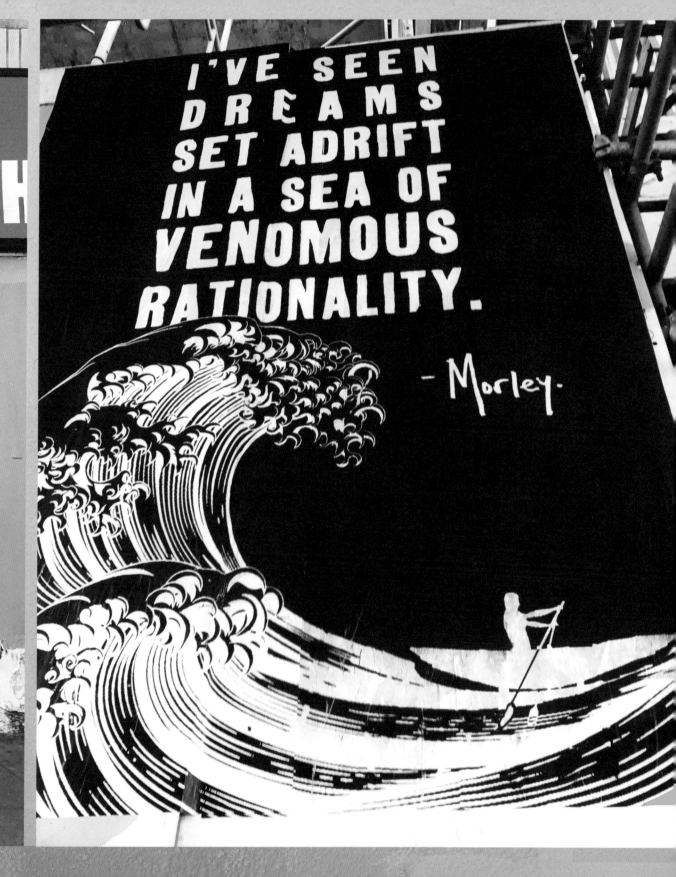

"WHAT LIES BEHIND YOU AND WHAT LIES IN FRONT OF YOU,
PALES IN COMPARISON TO WHAT LIES INSIDE OF YOU."

—RALPH WALDO EMERSON

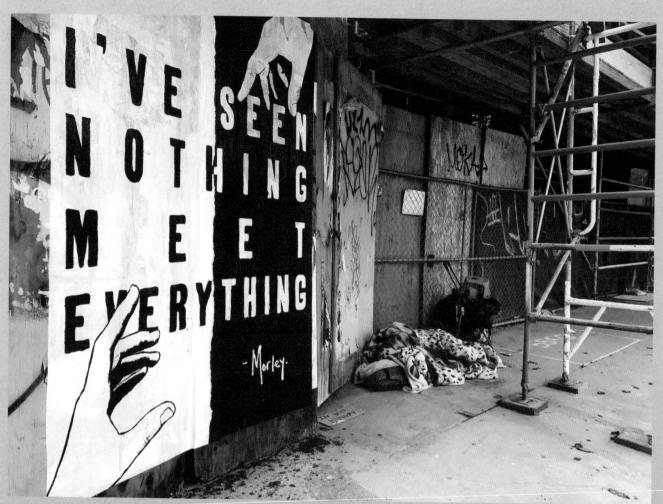

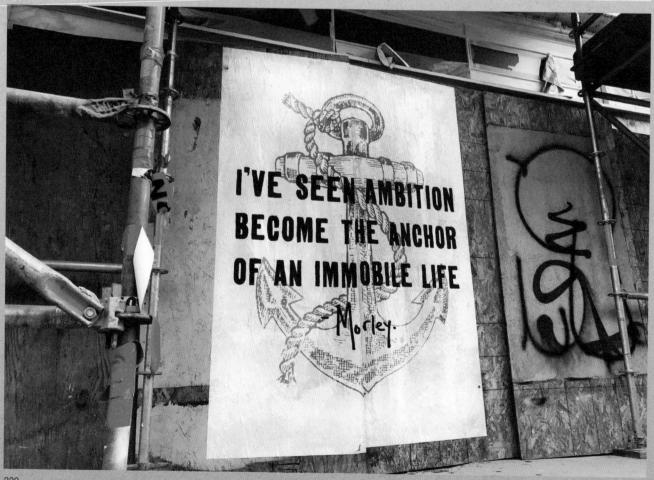

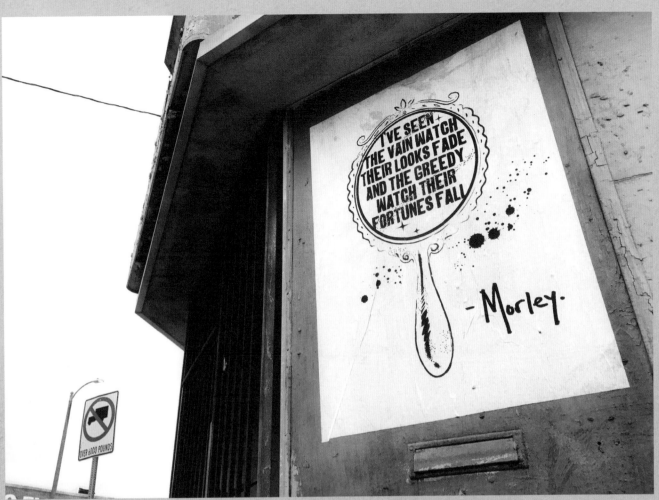

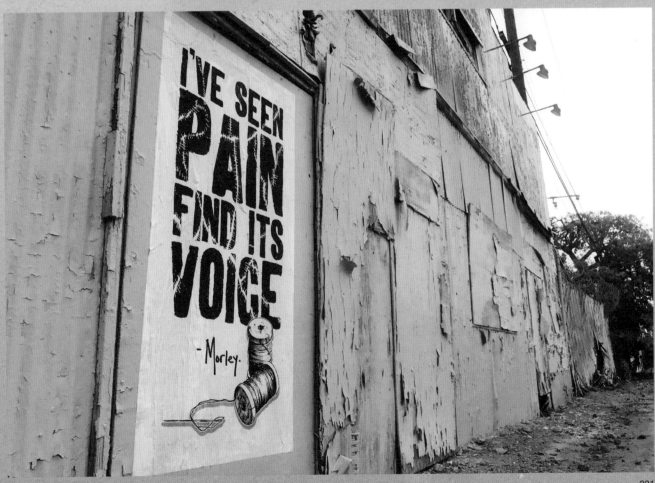

g lasts forever. No matter how well we build something, will erode and erase it. Our lives, our works, and our nts will crumble and be carried away by the wind. On the his might be depressing, but maybe it shouldn't be. Maybe unshackle us from forever and set us free into right now. s seductive, it's the promise in the distant horizon that we

swear we can see if we squint, but it's nothing more than a mirage that's always the same distance away, no matter how far we run. We can stop running. We can catch our breath. We can shrug off immortality and revel in the joys of right here and right now. You'll be surprised at everything you've been missing.

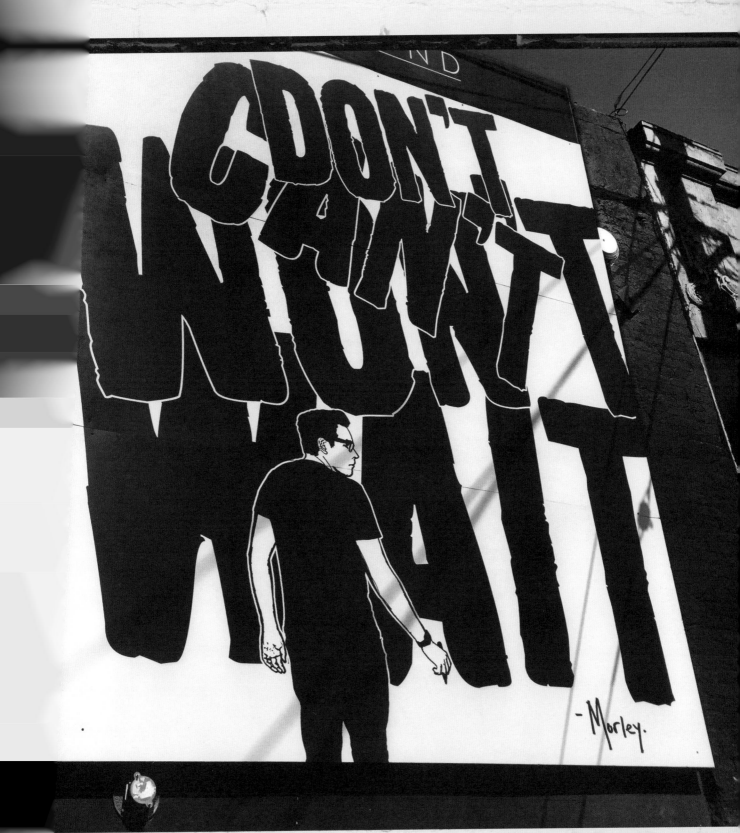

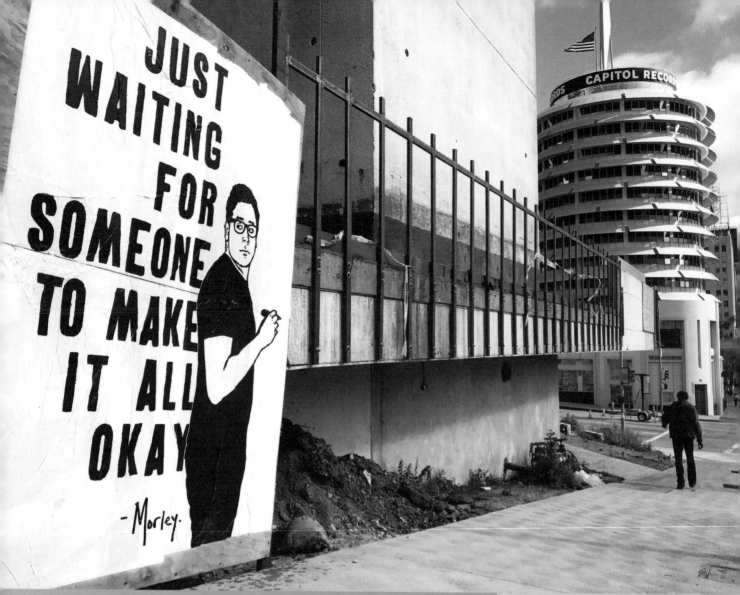

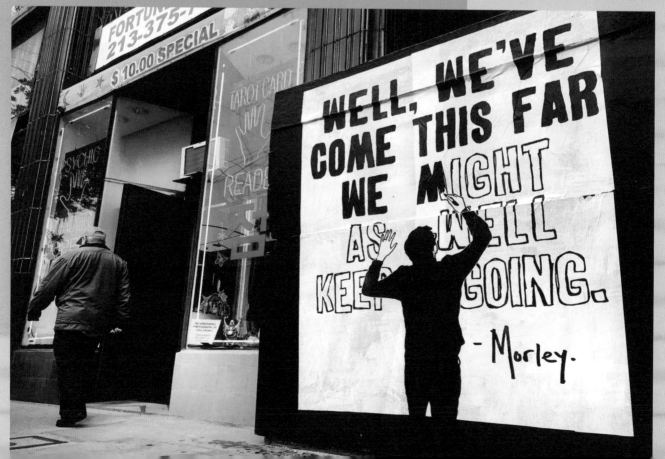

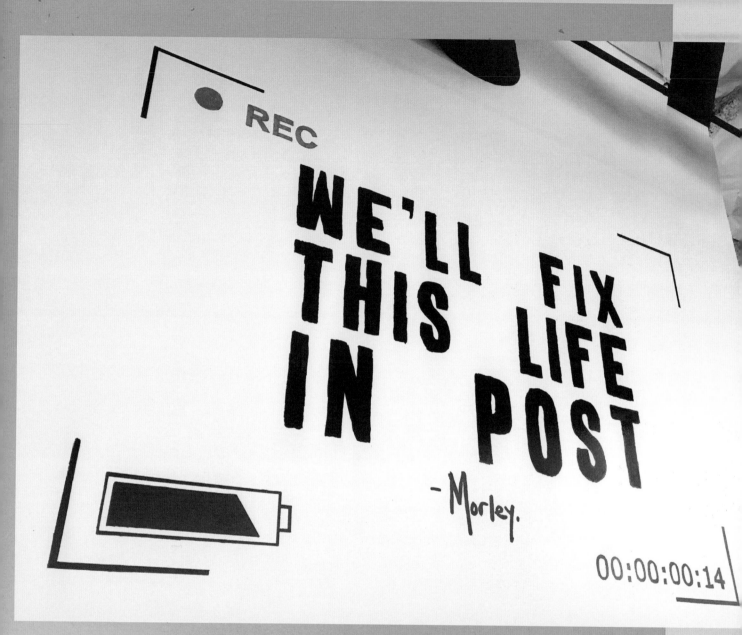

REC

WE'LL FIX
THIS LIFE
IN POST

— Morley.

00:00:00:14

POST PRODUCTION

I painted this on the wall of a TV production office. For those who aren't familiar with industry lingo, there's a running joke that when things go wrong while shooting a show or a movie, people just say, "Ah, we'll fix it in post!" which means we'll fix it later, when it's the editor's problem.

The notion of doing this with our lives made me chuckle.

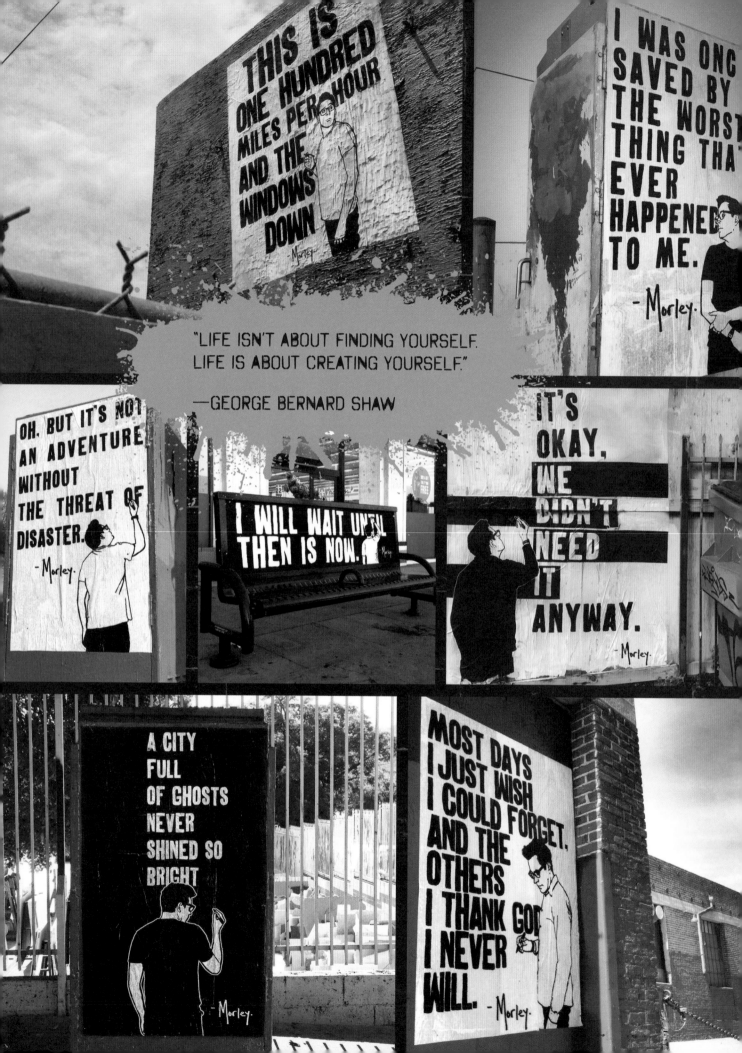

"LIFE ISN'T ABOUT FINDING YOURSELF.
LIFE IS ABOUT CREATING YOURSELF."

—GEORGE BERNARD SHAW

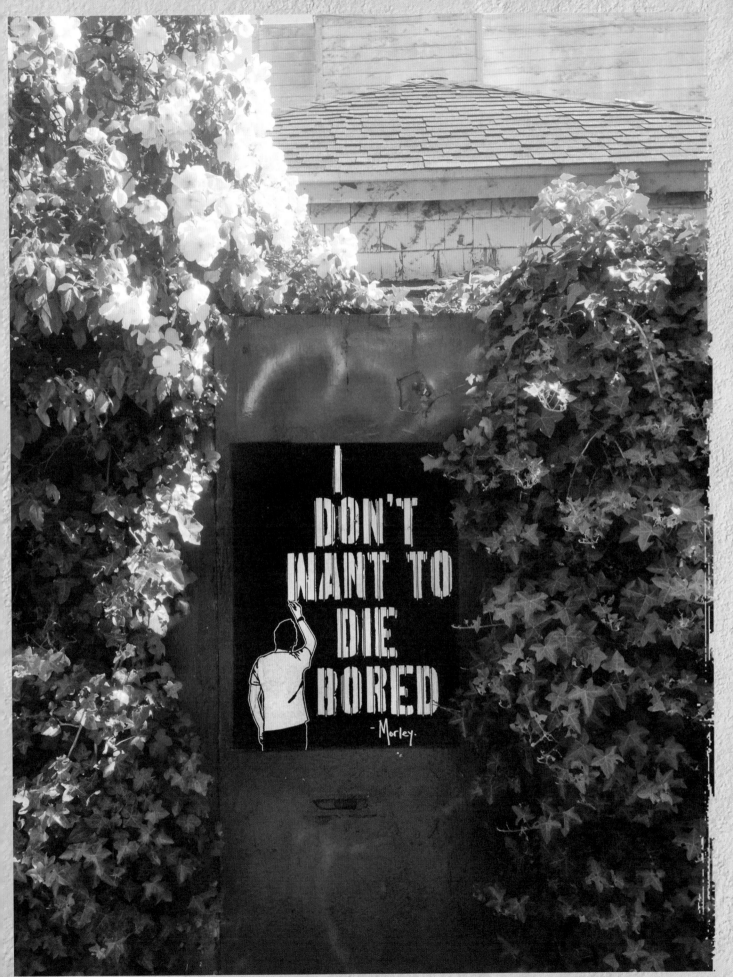

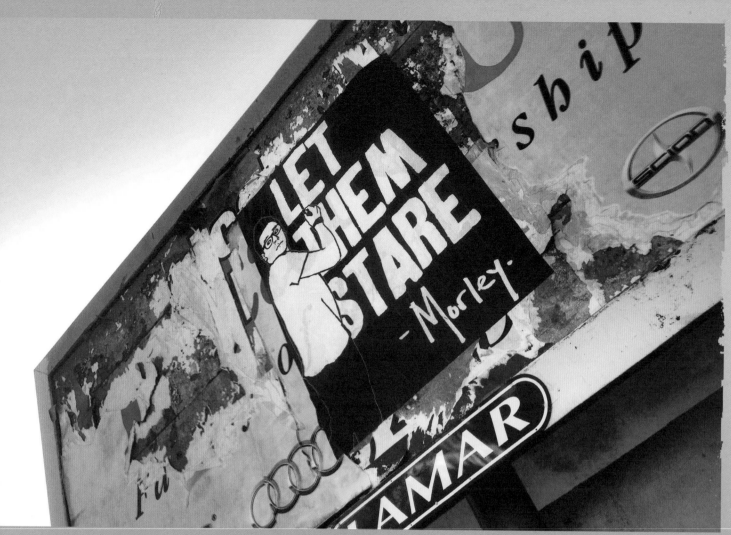

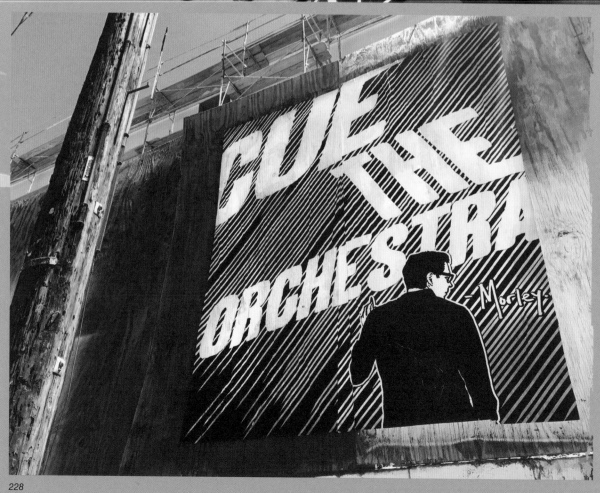

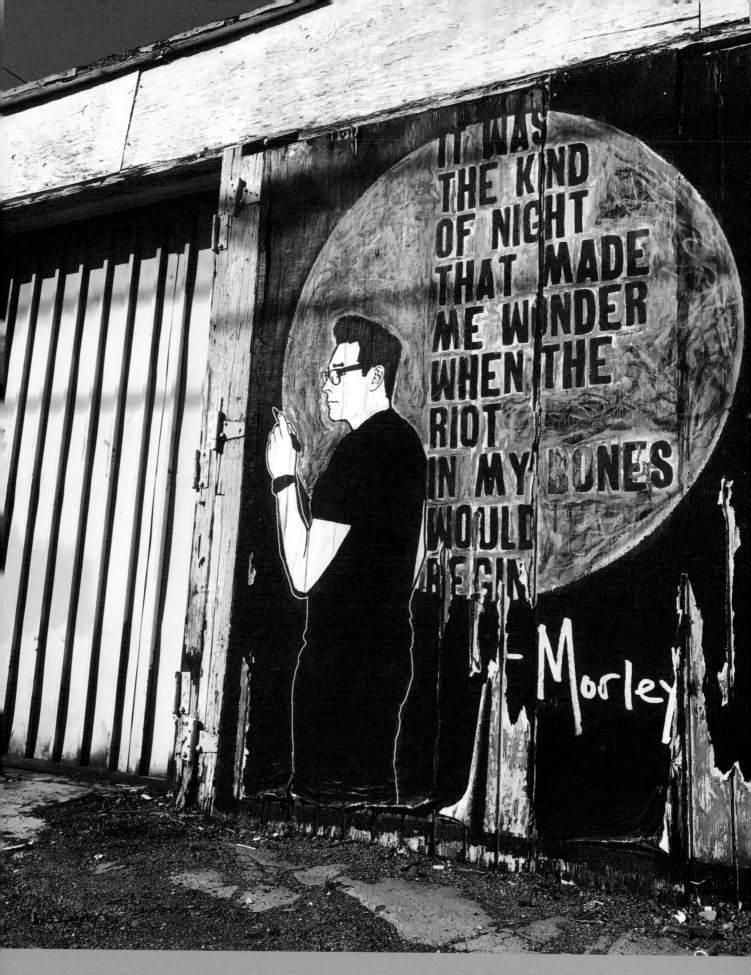

Eighteen months on the street and this poster is still ready to riot.

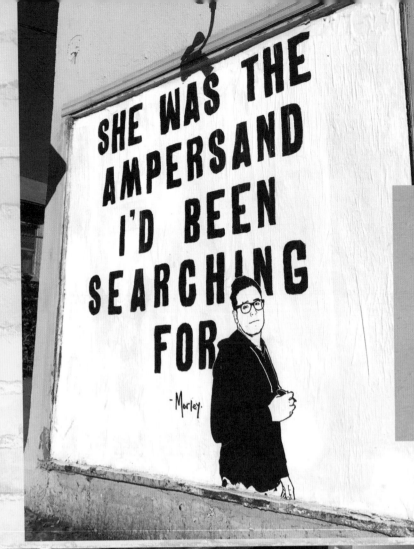

SHE WAS THE AMPERSAND I'D BEEN SEARCHING FOR

— Morley.

The AMPERSAND symbol (&) is a character typically standing for the word "and."

I've spent most of my life searching for the & to go next to my name. The friends and lovers that you trudge through life alongside.

The ampersands I've collected over the years are my most valued treasure.

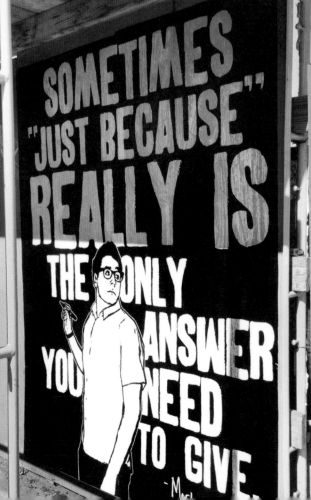

SOMETIMES "JUST BECAUSE" REALLY IS THE ONLY ANSWER YOU NEED TO GIVE

— Morley.

Sample questions to which I believe "just because" is the appropriate answer.

1. Why are you wearing your Spider-Man Halloween costume in June?

2. Why did you tell that random guy at the party that you read that book if you haven't?

3. Why is it a vital necessity to finish an entire pint of Ben & Jerry's once you've opened it?

4. Why do you know every lyric to the song "Whatta Man" by Salt-N-Pepa?

5. Why does it matter so much who would win in a fight between two fictional characters?

The list goes on.

WE'LL GIVE BACK TONIGHT

HOLLYWOOD

WHEN WE'RE DONE WITH IT

-Morley.

"I HAVE DRUNKEN DEEP OF JOY, AND
I WILL TASTE NO OTHER WINE TONIGHT."

—PERCY BYSSHE SHELLEY

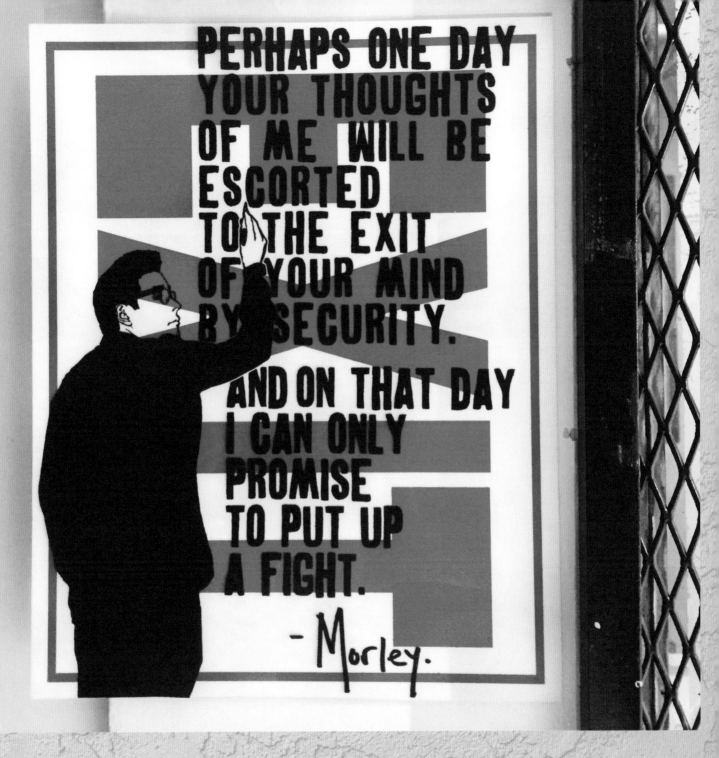

MIC DROP

I've always wanted to be the kind of person who knows how to leave people wanting more. A person who is defined as much by his absence as by his presence. The kind of person who leaves a party at just the right time, says just enough in a conversation, and knows the value of taking a bow when there's still enough people around to ask for an encore. Sadly, timing's never been my forte. I struggle to notice the foreshadowed fatigue until I've already worn out my welcome. So, often I'll overcompensate, opting for the premature or the abrupt. But leaving people wanting more is a tricky thing; it's as much knowing when to speak or perform as when to stop. You have to grab hold of the elusive moment between

a satisfying conclusion and fully satiating someone's interest. It's figuring out the best moment to drop the mic and knowing that picking it back up and saying "oh and also" means losing any significance you once had grasped. Maybe it's a talent I'll never quite master. In that way that I'll probably never be a "hat guy" or someone who can decline birthday cake, I'll never be a mysterious charmer who can gauge intrigue amongst hearts and minds with accuracy. Instead of dropping the mic, I'll no doubt have to settle for someone cutting the power and telling me to go home. I can only hope that as I do, the janitor sweeping up will tell me he was bummed to miss the ending.

MAY
THE
WHAT
THE
SCREEN.

WE
EYES
WE
GLOW

FIND
OF
LOST
OF

— Morley.

IN
ANOTHER
IN A

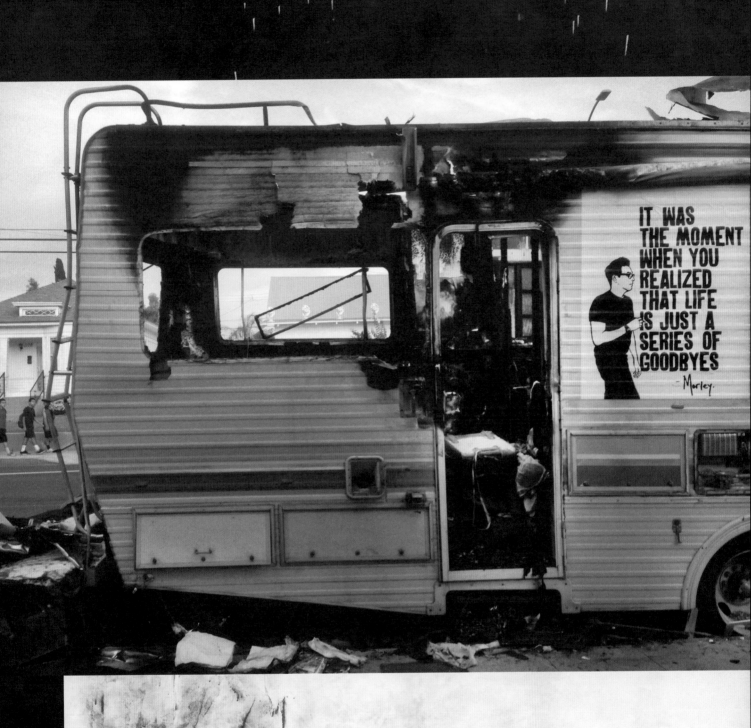

IT WAS
THE MOMENT
WHEN YOU
REALIZED
THAT LIFE
IS JUST A
SERIES OF
GOODBYES
— Morley.

"WHAT MATTERS MOST IS HOW WELL YOU WALK THROUGH THE FIRE."

— CHARLES BUKOWSKI

ONE LAST THING...

I've never been great with parting words. The finality of them always trips me up. People often ask me if I have a favorite poster. I can never really give them an answer because for me, they all hold some measure of significance. Each one carries a little piece of my spirit. The encouragements, the jokes, the confessions. The hard-won insight, the poetic musings. All of the words pieced together from fragments of me. Pasting them up is a bit like releasing a wounded bird that has finally healed. Sometimes, the bird misjudges the strength of its mended wing and plummets back to the earth, "I don't get it" sounding its thud. Other times, it takes to the air spectacularly. This routine occurs and reoccurs with each new person that passes and takes a moment to notice this strange piece of paper glued to a wall that impossibly isn't trying to sell you something. As I cannot control the avian nature of my work, it makes picking a favorite a futile act. I like the pieces that seem to be effective, and as that's defined by each person, I like them all equally.

My words aren't meant to last forever. If they were, I'd use something sturdier than paper and paste. If I thought that each poster was my last, I'd etch it in stone or I'd cast it in bronze. To be honest, I probably wouldn't even get that far. I'd get so hung up on making it perfect that I'd just stand there, chisel in hand, starring at the marble slab and pondering what people might make of this in five hundred years. "And here we have a primitive-looking piece from the early twenty-first century," a museum robot would say, in his Jetson-style hover car. "As you can see, it was created by a slightly awkward man in his mid-thirties who obviously enjoyed dressing his cats up in silly outfits." "How would they know that about me and my cats?" I'd ask of my own reverie. "Well, if you don't get the phrasing right, they'll assume all kinds of things!" it would reply.

Needless to say, I'll stick with printer paper.

And yet here we are, the end of my book, and I feel obligated to offer some kind of thesis statement. Something that sums up my life's work. Something that encapsulates all the words that have led you here. Something that thanks you for taking this journey, for buying this book (or even just thumbing through it before returning it to your friend's coffee table). Something that encourages you to be compassionate to others and to yourself, to appreciate the finite time you have and all the beauty that swirls around us in every moment. To continue to chase what drives you and to defy the varied voices that mock your mission. Something that encourages you to forgive and seek forgiveness, to bet on the long shots and believe in the magic that turns the unlikely triumphant. To find value in being broken, in slowly healing, and finally, finding restoration. To laugh in every season, no matter how windy, and above all else, to love hard. If I can sum all that up with a few words, a Cheshire grin, and a bow, I'll be set.

But like I said, I'm not great with parting words so I'll just say that I hope this book and all that it contains is of service to you. Either with wisdom or as a coaster, I'll take what I can get.

Be well and stay kind.

Sincerely,

- Morley.

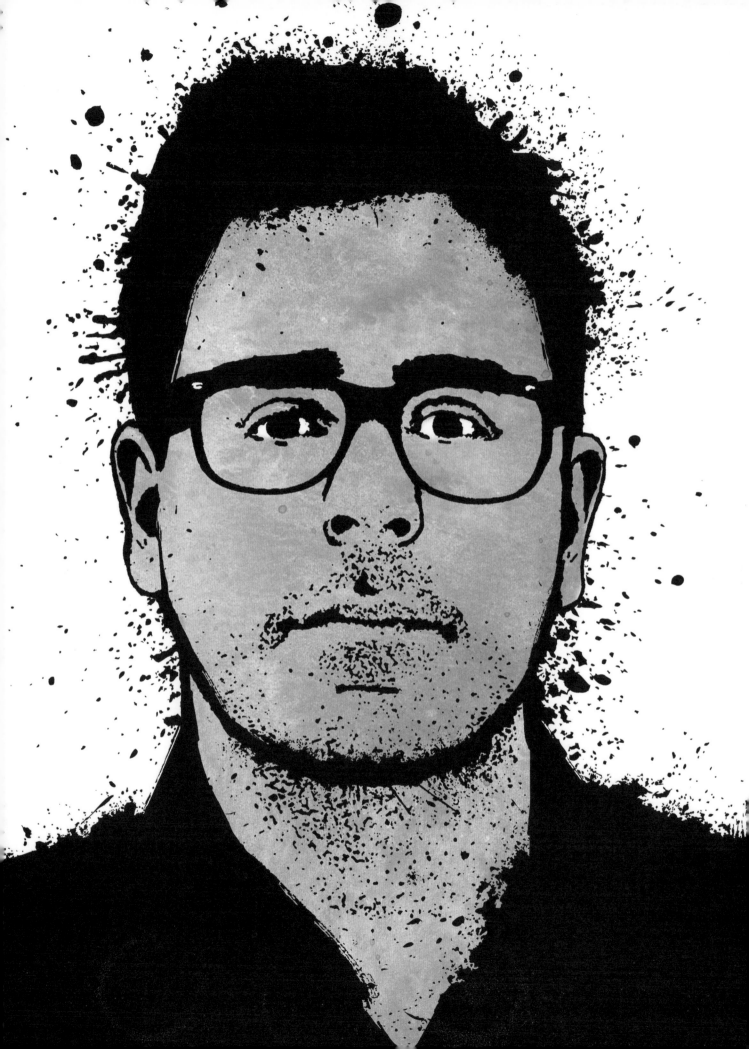

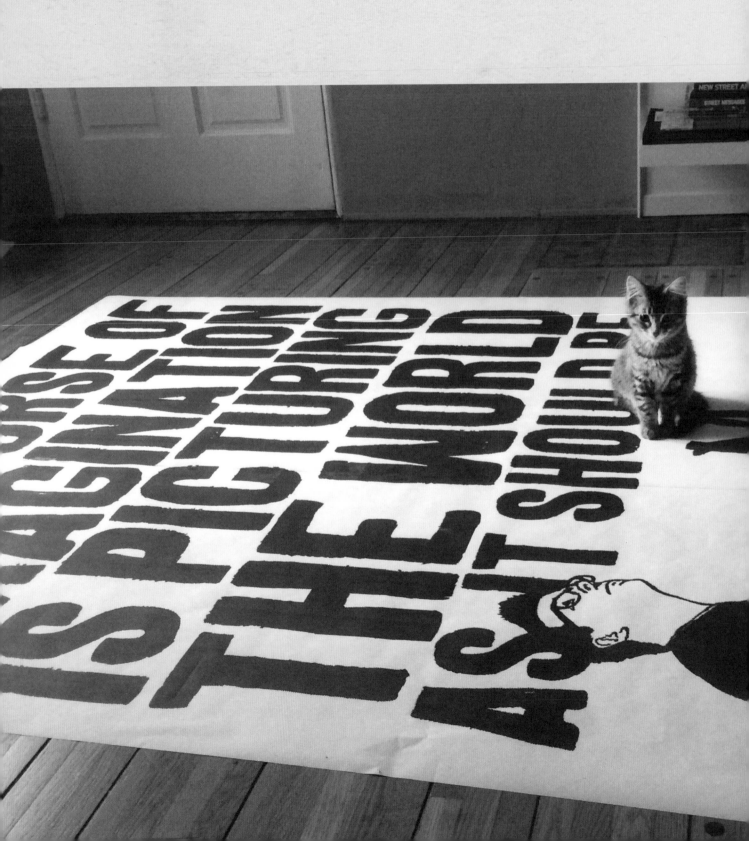

ACKNOWLEDGMENTS SPECIAL THANKS TO

ADDITIONAL PHOTOGRAPHY:
Pol Cosmo (page 2)
Ewkuks (pages 12, 234)
Bryan Snyder (pages 78–81)
Anna Ezequel (page 121)
Will Teran (page 159)
TK Anderson (pages 160–165)
Kate Ryan (pages 115, 169)

Matt Ackerson, Cici Anderson, Art Alexakis, Kirsten Ames, Lonnie Angle, Nicole Albers, Greg Auerbach, Eric Bachmann, Scott Bailey, Joy Baldwin, Bandit, Steve Beale, Allison Binder, Chris & Dana Bobik, Dana Boratenski, Andrew & Emily Bowser, Josh Bratman, Jordan Bratman, Greg & Lauren Breiding, Ian & Trilby Brennan, Yana & Chris Brink, Alice Brinkman, Phil Brody, Douglas Brundage, BumblebeeLovesYou, Adam Campbell, Pete & Alana Campbell, Leigh Carapetis, Daniel Cetina, Robert Carpenter, Anne & Ryan Cartwright, Tim Chaddick, Common Cents, Ed Choi, Pietro Clemente, Andrew Cleary, Elizabeth Conley, Pol Cosmo, Rob Cosnahan, Claude Crommelin, Kathryn & Brian Crowley, Cyrus the Virus, Hannah Cusack, Emily Dahlquist, G. James Daichendt, Leena Danan, Lizy Dastin, Joanne Dinken, Martha De Perez, Maureen Dewald, G.D. Dionne, Dog Byte, Rob Dolgaard, Molly Dowd, Thomas Dutton, Mike & Chelsea Eller, Tim Eller, Broderick Engelhard, Anna Ezequel, Ben Feldman, Joey Feldman, Adam and Jaye Fenderson, Rachel Ferrell, Alexandra Field, Nathan Firer, Marielle Firer, Mark Fite, Ed Flint, Hannah Flint, Jenny Foulds, Chris Franjola, Dia Frampton, Daniel Friedman, Ed Fuentes, Patricia Hurley, Nicholas Ganz, Nat George, Michael George, Jose Gonzalez, Pedro Gonzalez, Mark Gravender, Dawn Gregg, Alan Griswald, Chris Gruener, Nina Gruener, Ben Hagarty, Dan Hagarty, Jim Hanft, Hugh Hart, Will Hines, Shaun Hoff, Dave Holmes, Jan Hughes, Kara-Leigh Huse, Scott Hutchison, Alexis Hyde, Howie & Hattie, ImpermanentArt, Elena Jacobson, Ashley Jones, Chris Jones, Ran Jones, Casey & Amy Johnson, Tanya Johnson, Shirley Ju, Emma Kallok, Kris Kaiser, Joe Kapp, Armen Karaoghlanian, Chris Kennen, Kate Kelton, Camille Knox, Shana Kohen, Gary Kordan, Sasha Knezevic, Joshua Kopel, Jennifer Korsen, Joseph C. Krause, Marcus Kuiland-Nazario, Valda Lake, Jeremy Lambert, David Kalani Larkins, Bryan Laurenson, Earl Lee, Thomas Lessler, Greg Linton, Gino Burman-Loffredo, Pharida Long, Amanda Loso, Jordan Lovato, Adam Lucas, Luxe Paws, Eric Lyons, Brian Maillard, Jessica Maillard, Meiko, Stone Malone, Savannah Mark, Aaron Marsh, Alex & Roni Martin, Jayma Mays, Fiona McDonald, Lindsey Meyers, Jera Mehrdad, Rich Michalowki, Marty Miller, Hector Mojica, Moncho1929, A. Moret, Brent Morley, Iain Morris, Zach Morrow, Andrew Mueller, David Nadelberg, Jose Navarrete, Jacquie Navratil, Vi Nguyen, Andrew Nixon, Hank O'Neal, Jason Ostro, Ovation TV, Brittney Palmer, Dennis Pascual, Colette Patnaude, Michael Pederson, Robin Pelleck, Emmerson Petrick, Nelson Petrick, Ani Petrosyan, Phobik, Plastic Jesus, Tim & Diana Price, Jena Priebe, Sophie Pujas, Sigrid Ranu, REACH Studio Art Center, Alex Jenkins Reid, Taylor Jenkins Reid, Leo Resig, Tom Rice, Ian Rick, Gus Riker, Jonnie Rojas, Luca Rojas, Davy Rothbart, Bob Royer, Alicia Ryan, Kate Ryan, Kristen Ryan, Marie-Terese Ryan, Mary Ryan, Andrea Russett, Frankie Sanchez, Charlie Sanders, Phil Santos, Frankie Sanchez, Adrianne Schustz, Septerhed, Ron Shawler, Neely Shearer, Beth Signorile, Kristi Silver, Slinkachu, Kyle Smurdon, Bryan Snyder, Kim Soleau, Mai-Ly Spiller, John Satterfeld, Tomas Staub, Ash Steffy, Matt Steingard, Annie Steingard, Jessica Steingard, Jon Steingard, Jennifer Leigh Strauss, Larry Struber, Sandy Steinbrecher, Joanna Suhl, Lindsay Sunada, Blaine Swen, Carolyn Swen, Kelly Taylor, Elliott Teran, Julian Teran, Victor Teran, Will Teran, Teachr, Sara Thompson, Charlie Todd, Tiffany Tomaszewski, Michael Tome, Alex Torterotot, Jeremy Treat, Jim Turner, Matt Valerio, Joan Varitek, Jeff Victor, Tim Venable, Olly Walker, Frank Warren, Lauren Wasilewski, Joey Waterman, Corinne Weber, John Wellington Ellis, David Wendell, Ruby Wendell, David Wideroe, Ross Willet, Rachel & Austin Wilkin, Jenn Witte, Samantha Yonack, Adrian Todd Zuniga, all of my friends, family, anyone who's been kind, helpful or generous to me and I stupidly forgot, and all the artists I share the streets with.

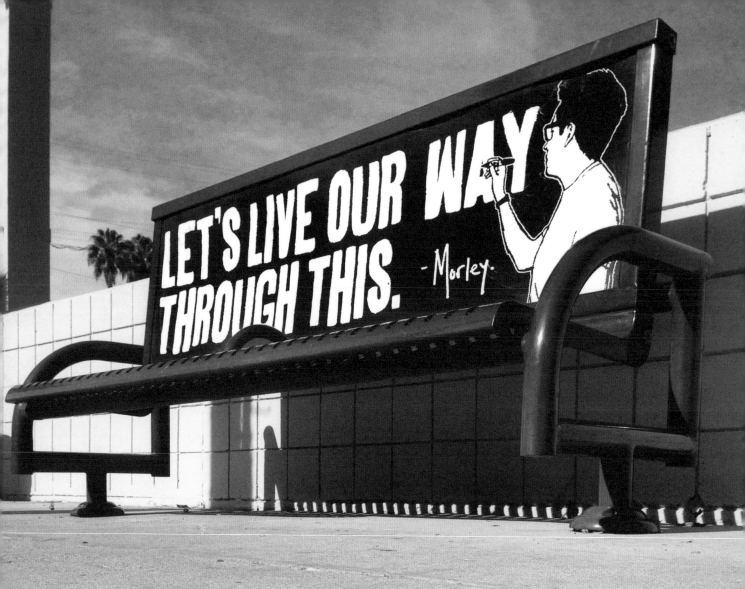

CAMERON + COMPANY

149 Kentucky St, Suite 7
Petaluma, CA 94952

www.cameronbooks.com

Publisher: Chris Gruener
Creative Director: Iain R. Morris
Managing Editor: Jan Hughes
Editorial Assistant: Mason Harper
Proofreaders: Lucy Walker, Elizabeth Hayt

The publisher would like to thank Morley for the opportunity
to provide another medium for his message; Art Alexakis for
his personal and thoughtful foreword; Iain Morris for his expert
design eye; and Jan Hughes and Mason Harper for their keen
editorial oversight.